BLINDNESS

Moshe Barasch

BLINDNESS

The

History of a

Mental Image in

Western Thought

ROUTLEDGE

NEW YORK LONDON

Published in 2001 by
Routledge
29 West 35th Street
New York, NY 10001

Published in Great Britain by
Routledge
11 New Fetter Lane
London EC4P 4EE

Routledge is an imprint of the Taylor & Francis Group.

Figure 1 courtesy Pierpont Morgan Library/Art Resource, N.Y.
Figure 8 courtesy Foto Marburg/Art Resource, N.Y.
Figures 18, 21, 22, 27, 28 courtesy Alinari/Art Resource, N.Y.

Library of Congress Cataloging-in-Publication Data

Barasch, Moshe.

Blindness: the history of a mental image in Western thought / Moshe Barasch.
p. cm.
Includes bibliographical references and index.
ISBN 0–415–92742–0 (hb) – ISBN 0-415-92743-9 (pbk)
1. Blind—History. 2. Blind—Public opinion. 3. Blind in art. 4. Blind in literature. I. Title.

HV1581.B37 2001
305.9'08161—dc21 00–044641

Printed in the United States of America on acid-free paper.

10 9 8 7 6 5 4 3 2 1

For Jan Assmann

Contents

Illustrations

Gallery appears following page 84.

Acknowledgments

In preparing this study I enjoyed the continuous assistance of librarians in several countries. Though I cannot mention all of them individually, I should at least express my profound gratitude to them as an irreplaceable pillar of scholarly work. The assistance of Mrs. Mira Reich was significant in writing this book, as it was in all of my previous books. Dr. Luba Freedman, my colleague and former student, was always ready to help. My greatest debt of gratitude goes to my wife, Berta, who read the whole text with a critical mind, and helped correct shortcuts of thought and obscurities of expression. For the remaining ones, I am responsible.

Introduction

One of my earliest encounters with art was when, as a young and curious child, I was leafing through the pages of an old illustrated journal. There I found a reproduction of Rembrandt's etching of 1654, representing Tobit, Tobias's father (fig. 1). The apocryphal story tells of the old and blind Tobit whose son went on a long and dangerous journey. The father, preoccupied with thoughts about death, doubts whether the son will return from the journey and whether he is still alive. When Anna, Tobit's wife, "espied him [the son] coming," she tells the good news to the blind father. Tobit hastens to the door to meet his son. But he is blind. "And Tobit went forth toward the door, and stumbled," says the Book of Tobit (11:11). The Dutch Bible, as Julius Held has noted, is even more explicit. It reads: "And Tobias went to the door and hit himself against it."[1] When I first saw the etching, on that early day in my life, I did not know the story. Nor had I seen a blind person from nearby, though some uncanny stories about blindness had been told to me. Unprepared, then, as I was, the image struck me so powerfully that I still remember that first encounter.

What was it in the engraving that so struck me? The etching is, of course, a moving representation of human infirmity, the manifestation of an old man's pitiful weakness. Yet there was also an additional dimension to it. Rembrandt's figure did not appear to me only as that of a shaky old man, for whom one can feel only sorrow and compassion. Though he was stumbling, the old man struck me as a venerable figure; he was surrounded by an aura, and an inherent dignity lifted

him up from the level of old and feeble men that one could perhaps see in the street. His raised head, as if watching a vision within himself, did not ask only for sympathy. In my childish fantasy I called him a "prophet." In sensing the figure's ambiguity—infirmity and dignity, evoking both compassion and awe—my naive reaction was probably correct. Using the language of modern criticism and philosophy, I could say that I "understood" Rembrandt's figure.

Rarely did I see, in those distant days of childhood, a blind person, and even then only from a great distance. We children dreaded the blind and hesitated to get near them. The blind, it was whispered, know what you think; they can even know what you dreamt. The belief in the blind man's ambiguous nature had penetrated even the world of children.

Many years later I chanced upon representations of blind musicians, especially of blind harpists, in Egyptian art. In tomb paintings, and occasionally also a stele, the blind harpist is shown squatting on the ground, altogether immersed in the melody he is resounding by pluck-ing the strings of a large harp (fig. 2). An uninitiated spectator, as I was, reacts to the subject of these images with pity and compassion. Here was this wretched blind man, placed, so it seemed to me, in a humili-ating posture, perhaps making music for the pleasure of an audience he cannot see. The conflicting, contorted condition of the figure—blind and making music—seemed to be an emblem of the unfortunate's fate and condition. And yet, so I felt, these figures express some intrinsic grandeur. Even an uninitiated spectator will not compare them to the blind musicians one could sometimes see at a street corner of a Mediterranean city. Once again one sensed, however vaguely, that the figure conveys an ambiguous message.

This impression is confirmed by what students of Egyptian culture and art tell us. The blind harpists, they say, actually were of an elevated status, and this is conveyed by the images themselves (see again fig. 2). The bulges of the stomach suggest that the musician is well nourished; his garment indicates a distinguished social position; his bald head des-ignates physical purity.[2] The very act of playing music endows the harpist with an aura: while he was playing his instrument, so it was believed, "he was in direct communication with the deity."[3]

Once again, then, a certain ambiguity or ambivalence characterizes the image of the blind. On the one hand, he is the unfortunate creature, deprived of what is often considered man's most precious gift, the ability to see the world and to find his way without the help of others. On the other hand, he is endowed, however vaguely, with an ability given to no other human being—to be in direct communication with a deity. He dwells in two worlds or hovers between them. These undefined, intuitive impressions suggest how complex people's understanding of the blind person was in premodern times. Blindness was a riddle. Throughout the centuries, with the memory of it remained the sense of mystery, the feeling of anxiety that accompanies it, but also the entreating fascination of the song's rhythm and rhyme. Many ages after ancient Egypt and its culture disappeared, we perceive an echo of it in Shakespeare's verses:

> O, never will I trust to speeches penn'd,
>> Nor to the motion of a schoolboy's tongue,
> Nor never come in vizard to my friend,
>> Nor woo in rhyme, like a blind harper's song![4]

In the present slim volume I attempt to analyze some aspects of this puzzle. To comprehend the mystery of, and the attitude toward, the blind I have asked three main questions. The first is a rather simple one: Does the understanding of blindness have a history? That is to say, did the views of what blindness is and what it "means" change in the course of time? Blindness itself is, of course, a natural condition, and as a natural condition it knows little change. (It goes without saying that the rapidly changing developments in the medical treatment of blindness are not part of the condition itself.) But while blindness as such remains unchanged, our understanding of blindness, our views concerning its "meaning," are matters of culture. So is the attitude toward the blind that is largely a result of what people believed that blindness meant. As matters of culture, the interpretation of blindness and the social attitude toward the blind are, of course, prone to historical change. To be sure, in the following chapters a continuity of certain components in the approach to the blind will become obvious;

yet I shall try to show that our interpretation of blindness does, indeed, have an eventful history. Successive ages offered different interpretations of blindness, and these explanations of a physical condition sometimes reflect the broad themes and beliefs at the center of each period.

The interpretation of blindness, as that of so many other phenomena, depends on the context within which it is seen. This brings us to the second question. While at no time was the understanding of the blind uniform, each of the great historical periods was dominated by one or two particular explanations of blindness. What were these interpretations, specifically, and what brought them about? I shall try to show that it is the comprehensive cultural context, the encompassing world of ideas and beliefs, that conditions the attitude toward even such a marginal phenomenon as blindness.

My last question concerns the visual semblance of the blind and their representation in art. How was the blind person imagined? Is there a specific feature or quality that characterizes him, that makes us instantly recognize him as blind? The shape of the eyes cannot generally account for our understanding of the subject's blindness. In Rembrandt's etching the eyes of the old man can hardly be made out, even if we are looking at an original print. A shadow is cast over the old man's eyes, but shadows covering the eyes are frequently seen in Rembrandt's work, and they do not necessarily indicate blindness.[5] My recollection from childhood suggests that it was the old man's overall stance and movement that made me understand that he was blind. His head is raised a little more than would seem necessary for what he is doing, he feels the floor with a stick (note that the tip of the stick does not actually touch the floor) and his hand, hesitantly stretched out, is fumbling. It was the gestures that told me that Tobias was blind.

In the Egyptian images of harpists the identification of blindness is even more difficult. In the usually small-scale figures in Egyptian tomb decoration the area of the eyes is often hardly visible, and no formula of the blind eye can be clearly distinguished. In the workshops of tomb decorators formulae for the depiction of deformed eyes were probably available to the artists.[6] However, even if such formulae were

employed, they could not influence much the images of the blind as we now see them because of the tiny size of the eyes. Moreover, the shapes of the eyes, whatever they originally looked like, have now faded. As we see them now, they hardly play a significant part in our perception of the figures. There must have been other ways to convey to the spectator that the figures depicted are those of blind people. What are they, and what is their history?

In the present study I have approached the various ways blindness was understood and represented by looking at their history. Yet, though the study follows, more or less, a chronological order, I do not intend to offer a continuous history of how blindness was interpreted. Nor had I any intention to be exhaustive. For this reason I have resisted adding an amorphous mass of bibliographical references to points that are marginal to our discussion. The present study is meant to be a readable account of a phenomenon that, strange as it may seem, has not received the attention it merits.

Few periods in history, if indeed any, have been so fascinated with various figures of the blind, and have so deeply and vividly experienced the complexity and intricacy of blindness, as antiquity. The testimonies that have come down to us from the ancient world—texts and images, records of performances, rituals, stories—clearly suggest that blindness struck people both as a disaster and as an uncanny condition shrouded in mystery. Many explanations, sometimes contradictory, were offered to account for a mythological figure's loss of sight. Though living blind people hesitatingly groping their way

1

Antiquity

must have been a common sight in everyday life in Greece and Rome, the explanations recorded in classical literature seem only to have deepened the sense of mystery that surrounded the sightless.

Blindness, needless to say, is a universal condition, and so also seems to be the reticence of society before the blind. So far as our knowledge and imagination can reach back into past ages, we find that there was probably no time and no society in which the blind were not tinged with some mystery. In many cultures, which need not detain us here, they were believed to have some contact with other worlds, with a reality different from the one in which we regularly live and altogether beyond the reach of other human beings. What precisely these "other" worlds' realities actually were was not always clear, and views concerning their nature changed in the course of history. Yet whatever these invisible realities were believed to be, they determined how the blind were perceived and had an important effect on the understanding and classification of blindness. It is therefore necessary for the student to ask what were the particular contexts in which a given culture approached the blind.

In most societies and religious groups the approach to the blind and the interpretation of blindness reflect a coalescence, and even complete fusion, of attitudes that originally may have been distinct from each other. However, in the high cultures of antiquity these different attitudes in the experience and explanation of blindness remained more or less separated, each retaining its specific character.

In antiquity's experience and explanations of blindness, three different levels can be discerned tentatively. Levels of experience, as the student of cultural history need not be told, are never neatly separated from each other. Any attempt to make out watertight "levels" in a multifaceted, involved, and dynamic phenomenon will not enable us to grasp the amplitude and interaction of multilayered social and cultural phenomena; in the end, it will inevitably turn out to be an arbitrary construction. Yet the historian cannot abstain from trying to distinguish some structure, even in a phenomenon as fluent, and sometimes contorted, as antiquity's attitude to blindness. The attempt to uncover an underlying, hidden structure helps us to see more clearly what, in fact, were the major components and aspects of that period's view of the blind. Three levels of experience and explanation should be considered here.

On the level of direct, immediate experience, blindness is naturally perceived as a grave physical injury, the impairment of one of the body's essential functions. As such it is the subject matter of emotional and social attitudes, and to some extent, though a surprisingly small one, also of medical science. It is of interest for us to note that on the level of immediate experience in antiquity the external appearance of a blind person was carefully observed and recorded. The posture of his head and body, his hesitating movements, the stick he holds in his hand, or the people who guide and help him—all this was noted and described in detail. These features became marks identifying a figure as blind, even if one could not see the face. Such observations were cast into visual formulae and became configurations that were to persist for long periods. Expressions of emotional reactions, of pity and compassion for the blind one's unfortunate condition, are often encountered. They permeated the visual outlines of the blind person's image in

antiquity, and thus determined how he was represented in art and retained in cultural memory.

A second level of antiquity's approach to blindness is the concern for the causes that bring about the condition. Here one does not ask, How do the blind look? but, Why are they blind? The direct, immediate experience of blindness, even in the forms we know from antiquity, is not specific only to this period. The appearance of the blind is intuitively grasped in all ages. The quest for the reasons of blindness, however, and the explanations offered in the ancient world, are specific to antiquity. At the least, they make the distance between the ancient and the modern approach instantly manifest. In ancient culture, natural causes are sometimes suggested to explain blindness, but most explanations go beyond this realm. It is supernatural forces, gods or demons, and their intervention in human affairs, that strike some people blind. The intervention of gods or demons in blinding a person is usually understood as a punishment for the transgression of a basic natural, moral, or religious law. In some way, then, the blind one is a delinquent, and his blindness always reminds us of his grave guilt.

A third, and final, level is the belief, common in classical culture, that blindness as such has some inherent meaning of its own. Though the meaning of blindness could perhaps not be totally separated from what the blind person has done in the past, or from the guilt he inherited, the meaning of blindness was not fully identical with the events that caused it. In most ancient cultures one could therefore ask: What does blindness mean? The quest for this meaning is the third level on which antiquity attempted to unriddle what appeared to the period as the mystery of blindness. To be sure, the "meaning" of this condition was never clearly defined; on this level, vagueness and ambiguity are more prevalent than on the others. But the belief that blindness as such, whatever its causes in a particular case, has a meaning was strong enough to persist for centuries. It was a belief that had a lasting influence on reflections and imagery associated with the blind.

One of the important, though not intentionally sought, effects of the beliefs in the inherent meaning of blindness was the blurring of the division between physical and metaphorical blindness. Already in

Greek culture the obfuscation of the division between the physical and the metaphorical senses of blindness became a great theme and had a powerful afterlife in European imagery. We begin our discussion with a glance at what was thought about the causes and meaning of blindness, and only later shall we return to the external appearance of the blind.

As in so many fields, the legacy of antiquity, both that of the biblical and of the Greco-Roman world, was a significant factor in shaping the mental attitude toward the blind in later stages of Western thought and imagery. In briefly discussing some testimonies of the ancient world, we should, therefore, ask not only how in ancient times people actually approached the blind on the street but also, perhaps first of all, what was the mental image of the sightless that antiquity bequeathed to later ages.

The essential characteristic of the blind person's figure, as it appeared to the ancient mind, is his ambiguity. He is not perceived as either good or bad, trustworthy or suspicious, unfortunate or blessed; he is all that at the same time. On the one hand, he is the unfortunate person deprived of sight, the most valuable of senses; on the other, he is often endowed with a mysterious, supernatural ability. This ambiguity of the blind person's nature may explain how it was possible for audiences to have pity and compassion for him, but at the same time also to sense awe and perhaps anxiety in meeting him. Later periods, as we shall see, stressed more the one or the other side, but the blind man's double face had a long lease on life.

Ambiguity itself is elusive, and it does not capture the image of the blind with sufficient distinctiveness. In the Bible the blind evoke compassion, but because of their "blemish" they cannot participate in rituals. In Greco-Roman antiquity attempts were made to give them a more distinct character. A brief discussion, in the course of this chapter, of some ancient texts and some pieces of ancient art will show that the two sides of the figure, the guilt as well as the prophetic gift, are of sublime origin. As far as we can see from ancient literature, the blind person's guilt is not a humiliating one. He is not imagined as a liar or a thief or as committing a mean crime. His culpability is mainly the fault of having seen the gods when mortals are not supposed to see them. In

other words, it is an offense to the gods, even if without sacrilegious intention. Such transgression implies that the guilty one had some contact with the divine, whatever the nature of that contact might be. The guilt may be inherited, thus suggesting that the blind person's forefathers already had some contact with the gods. Other maimed people were sometimes also believed to be guilty of a crime, but only the guilt of the blind is derived from an encounter with the divine. This unique, elevated origin of his guilt sets the blind man apart from all other people punished by suffering a physical deprivation. Later ages, as we shall see in the following chapters, took over the belief that the blind are burdened with some kind of culpability. The noble nature and elevated origin of that guilt were forgotten. The stories of the blind once having met, or at least seen, a god or a goddess were no longer recalled by periods for which gods or goddesses were devoid of any reality. What remained was the belief that the blind are persons that are not trustworthy and are to be treated with suspicion.

Further significant testimony to the blind person's particular status was the belief, widespread in the ancient world, that he had been granted the ability to communicate with worlds that are outside the reach of mortal human beings. Nothing has made the blind into such a mysterious, uncanny figure in the cultural imagery of Europe as the belief that he can reach where others cannot. As we shall see in the present chapter, Greek antiquity itself tried to account for this unusual gift of the sightless, or at least of some of them. The power to reach into worlds beyond our regular experience was explained as a gift, a particular favor granted by the gods. Since it is a divine gift, it is in itself mysterious and without explanation. One notes that, as the guilt of the blind often originates in the contact with the gods, so the unique ability of some of them is also directly given by the gods. The blind's proximity to the gods, whether intentional or fortuitous, hidden or explicit, remains part of their fate.

Tracing the intrinsic boundaries of this mysterious ability sheds light on its nature. Other periods and cultures have also singled out some individuals and believed that they could have contact with the divine. The use to which this power is put, however, varies. From

Christian lore, for example, we are familiar with the belief that the saints (some of whom have such mysterious power) can intercede for believers. This is altogether different in antiquity. Here the blind do not even attempt to intercede. The gift they have received from the gods is not the power of intercession; it is the power to see what will happen, that is, to know the future. It is a sublimated, spiritualized form of vision. What the blind person has lost in his body, the sight of his eyes, he is, at least in some cases, given back in spirit.

We now turn to an analysis of some individual aspects of this image of the blind.

Attitudes of the Bible

For an understanding of the mental image that European culture formed of the blind, and particularly the moral and religious connotations that blindness carried from the early Middle Ages to the beginning of the modern period, we have to begin with the Bible. Whether or not the Bible fully reflects the views of the blind that were current in ancient Near Eastern societies and cultures is not our concern here.[1] In the minds of European writers and artists between the disintegration of the ancient world and the baroque period the Bible was the beginning of explicit attitudes toward blindness, and it was invested with supreme religious authority.

The biblical corpus deals with the blind in two different thematic spheres, and they are clearly separated into two classes of texts. The aspect from which the blind are approached in one class is slightly different from that of the other. For our present purpose, one sphere may be termed "narrative," the other "prescriptive." The former pertains to the domain of stories, whether mythical, symbolic, or historical. The latter belongs to the realm of ritual custom and religious law. In the first group of texts, the views about blindness are implicit; they are conveyed by the context of the story and the general character of the figure. A good example is the blindness of old Isaac, who has to touch his sons to distinguish between them. Though even here the ideas about the blind and blindness sometimes emerge rather clearly from

the events narrated, they are not stated directly. This is altogether different in the prescriptive texts. In the sphere of ritual and legal prescriptions views about blindness are stated directly and explicitly. Though here, as a rule, little is said about the individual blind person, about his character, motives, or fate, his status in society is sharply defined, and it is made abundantly clear what he may, or may not, do and what functions he may, or may not, fulfill. It is natural, therefore, that the evaluation of the blind personage emerging from the stories narrated is sometimes vague in meaning; in some cases it may even be thoroughly ambiguous. On the other hand, the attitude recorded in the prescriptions is explicit, and as a general rule it does not allow for differing interpretations.

The nature and context of blindness that emerge from the narrative texts of the Bible are not uniform. Blindness neither has a single cause, nor does it necessarily bear testimony to a single reason (though often it does). In its most dramatic form, it is one of the most severe punishments that can be thought of. As such it is highlighted in the act of blinding. None of the biblical stories of blinding indicate anything mysterious. It is worth noting that most of those blinded are not punished by God, but by their enemies. The blinding of Samson, the best-known story of this type, is not the only one. In some stories, blinding is presented as reflecting a widely accepted norm of political and social procedure in certain exceptional conditions. Thus Zedekiah, the king of Jerusalem who rebelled against the ruler of Babylon, is defeated by the great military power of the Babylonians and cruelly punished. After defeating the rebellious leader, "they [the Babylonians] took the king [Zedekiah] and brought him up to the king of Babylon to Riblah; and they gave judgment upon him. And they slew the sons of Zedekiah before his eyes, and put out the eyes of Zedekiah, and bound him with fetters and brass, and carried him to Babylon."[2]

Though it is said that Zedekiah "did that which was evil in the sight of the Lord" (2 Kings 24:19), the text does not suggest that his blinding is understood as a punishment by God. It is the conduct of a mighty ruler, the king of Babylon, who thus punishes the defeated commander who dared to rebel against him.

As a component of manifesting victory, the total or partial blinding of the defeated enemy also explicitly carries the connotation of the lowest, most offensive degradation that could be inflicted upon man. In dictating terms of surrender, the stronger Nahash the Ammonite demanded that the right eye of every man of Jabesh-Gilead, as "a reproach upon all Israel" (1 Sam. 11:2), should be thrusted out.

Another type of blindness brought about by "natural" causes is not presented as a punishment. It is the "dimming of the eyes" frequent in old age. "And it came to pass, that when Isaac was old, and his eyes were dim, so that he could not see" (Gen. 27:1). Isaac's blindness is not a punishment. A similar idea is conveyed in the story of Jacob. "Now the eyes of Israel were dim for age, so that he could not see" (Gen. 48:10). The reference to the dimming of eyesight in old age is found frequently in the narrative books of the Bible. In his old age Eli's eyes "began to wax dim, that he could not see" (1 Sam. 3:2; see also 4:15), and so did the eyes of the prophet Ahijah (1 Kings 14:4).[3] In theological theory we could say that all these cases of blindness in old age are attributed to God (see Exod. 4:11). In fact the blindness coming with old age is described, and must have been accepted, as what we would now call a "natural process," free from any moral or religious connotations. It is not a punishment for sins committed. This is also how later generations, especially in the Christian world, would read the stories.

In other conditions, however, supernatural interventions are not altogether excluded. Sometimes divine intervention leading to blindness, temporary or permanent, is solicited. The temporary blindness of the wicked is a means of miraculous salvation from danger. In the story of Sodom and Gomorrah we learn that when the inhabitants of the wicked city endangered the angels who came to Lot's house, "they [the angels] smote the men that were at the door of the house with blindness, both small and great: so that they wearied themselves to find the door" (Gen. 19:11). A similar story is told about the prophet Elisha surrounded by threatening Syrians. "And when they came down unto him, Elisha prayed unto the Lord, and said, Smite this people, I pray thee, with blindness. And he smote them with blindness according to the word of Elisha" (2 Kings 6:18).

From the excerpts adduced, incomplete as they are, we can learn that in the narrative books of the Bible blindness is conceived in different ways. It has neither one single cause, such as punishment, nor is it limited to one kind of people, such as sinners. This changes radically in the other parts of the Bible, the prescriptive texts. In the sphere of ritual prescriptions the attitude to the blind has fewer variations, but it is more outspoken in evaluation. The ambiguities we have seen in the narrative descriptions of blindness completely disappear.

The basic idea informing the prescriptive texts is narrower than the questions intimated by the stories told in the narrative parts. The thematic realm is limited to ritual performance. Is a blind person allowed to participate in the sacred ritual? Can he fulfill a function such as the offering of sacrifice? The answer, offered mainly in Leviticus, is unequivocal.

> And the Lord spake unto Moses, saying,
>
> Speak unto Aaron, saying, Whosoever he be of thy seed in their generations that hath any blemish, let him not approach to offer the bread of his God.
>
> For whatsoever man he be that hath a blemish, he shall not approach: a blind man, or a lame, or he that hath a flat nose, or any thing superfluous,
>
> Or a man that is brokenfooted or brokenhanded,
>
> Or crookbacked, or a dwarf, or that hath a blemish in his eye, or be scurvy, or scabbed, or hath his stones broken; . . .
>
> He shall eat the bread of his God, both of the most holy, and of the holy.
>
> Only he shall not go in unto the veil, nor come nigh unto the altar, because he hath a blemish. (Lev. 21:16–23)

A blind man, then, even if by descent belonging to the class of the priests, is forbidden to approach the altar. The defilement by the blemish of blindness outweighs the standing inherited by belonging to the priestly caste. A blind animal, or one that has any other bodily blemish, is also forbidden to be offered as sacrifice.

> And whosoever offereth a sacrifice of peace offerings unto the Lord

to accomplish his vow, or a freewill offering in beeves or sheep, it
shall be perfect to be accepted; there shall be no blemish therein.

Blind, or broken, or maimed, or having a wen, or scurvy, or
scabbed, ye shall not offer these unto the Lord. (Lev. 22:21–22)

A variation of this prescription is found in what is said concerning
another ritual, the consecration of the firstlings.

All the firstling males that come of thy herd and of thy flock thou
shalt sanctify unto the Lord thy God: thou shalt do no work with
the firstling of thy bullock, nor shear the firstling of thy sheep. . . .

And if there be any blemish therein, as if it be lame, or blind, or
have any ill blemish, thou shalt not sacrifice it unto the Lord thy
God. (Deut. 15:19–21)

The basic concept informing the ritual commandments is evident:
what comes into contact with God, both the priest offering the sacri-
fice and the sacrificial offering itself, must be perfect. Perfection is here
understood as bodily perfection. There is a total incompatibility
between God's presence and the corruption of the body.[4] This is the
reason for the biblical prohibition on the priest's coming into contact
with a corpse or being defiled in any way. It is interesting to note that
at a somewhat later stage in the history of Jewish interpretation of the
Bible this idea was further developed. A single quotation may serve as
an illustration. In the *Midrash Rabbah* we read: "R. Simeon b. Yohai
taught: When Israel stood before Mount Sinai and said 'All that the
Lord hath spoken we will do, and obey' (Exodus 24:7), at that moment
there were among them neither persons with issue nor lepers nor lame
nor blind, no dumb and no deaf, no lunatics and no imbecils, no
dullards and no doubters."[5]

In these stages the blind are also explicitly compared to the dead.
Interpreting a sentence in Lamentations (3:6) which reads "He hath set
me in dark places, as they that be dead of old," R. Samuel saw here a
reference to the blind.[6] The affinity of the blind to the dead naturally
reinforces the view that the sightless are defiled. The idea of ritual per-
fection had a long and complex life.[7] In all variations, however, the
demand for bodily completeness and regularity, for having everything

necessary and nothing superfluous, is maintained as a basic condition for allowing a person or an object to form part of the ritual act.

The conclusion to be drawn for our subject is obvious. The blind person, one who carries in his body one of the gravest bodily deformations, is a person defiled. For this reason he is totally excluded from ritual.

Does the exclusion of the blind, and of all the other types afflicted with blemishes of the body, from ritual also suggest that they carry a moral flaw or betray another emotional condition? In other words, is the exclusion of the blind from sacrifice a "value-free" commandment, as it were, or does it involve some emotional reactions? Is this ritual commandment also meant to degrade the blind and the people with other corporeal blemishes? If we base ourselves only on the prescriptive texts in the Bible, it will not be easy to give a simple and clear answer. On the one hand, we have expressions of compassion for the blind and the call to have consideration for their unfortunate condition: "Thou shalt not curse the deaf, nor put a stumbling block before the blind, but shalt fear thy God: I am the Lord" (Lev. 19:14). This often-quoted command does not suggest disdain or implied accusation. Had the blind, and other cripples, been considered as sinners, one cannot help concluding, it would be difficult to understand the requirement (with the emphasis on "I am the Lord") to be compassionate toward the affliction of blindness that is the result of guilt. The same thoughtful attitude is expressed also in other parts of the Bible. Thus Job, when he speaks of his good deeds, says, "I was eyes to the blind, and feet was I to the lame" (Job 29:15).

On the other hand, however, we also find in the Bible emotionally charged expressions of scorn, derision, and violent rejection of the blind. In a passage no less prominent than the record of David's capture of Zion we read:

> And the king and his men went to Jerusalem unto the Jebusites, the inhabitants of the land: which spake unto David, saying, Except thou take away the blind and the lame, thou shalt not come in hither: . . .
>
> And David said on that day, Whosoever getteth up to the gutter, and smiteth the Jebusites, and the lame and the blind, that are

hated of David's soul, he shall be chief and captain. Wherefore
they said, The blind and the lame shall not come into the house.
(2 Sam. 5:6–8)

No explicit accusation is made here against the blind and the lame,
no guilt is attributed to them, whether open or concealed. Yet it is
obvious that they, the "hated of David's soul," are strongly detested and
are placed on the lowest level of the social hierarchy. The exclusion
from ritual, then, if not openly as punishment, is not free from emo-
tional connotations.

Classical Antiquity: Causes of Blindness

In attempting to survey, even if only in broad outline, a subject like
blindness in Greek and Roman culture, one cannot disregard the
doubts that almost necessarily arise. What we call classical antiquity
not only lasted for a very long time but was also a culture that spread to
different parts of the then known world, and integrated, or otherwise
had to come to terms with, regional cultures that differed widely from
each other. Can we, under such conditions, speak of *the* attitude
toward blindness that prevailed in the classical world? It is not for us
here to deal with the question, dear to both philosophers and histori-
ans, whether that portion of history we call a "period" has an intrinsic
unity, and what that unity actually means. Restricting our comments
to our specific subject, the image of the blind, we can say that there *was*
indeed a continuous tradition from Homer to Nonnus, from early
archaic Greece to the final stages of the ancient world. It is this cultural
tradition that we can treat as a unity.

When moving to classical antiquity from the cultures of the ancient
Near East, primarily as reflected in the Bible, we enter a perceptibly
different atmosphere. In the ancient Near East, we have seen, the blind
person was viewed largely from the point of view of ritual prohibitions
and commands, and from the function he might, or might not, per-
form in society and religious ceremony. In the Greek and Roman
world these aspects, the rules concerning the blind one's part in ritual,
played a minor and marginal part. At some stage, rules of this kind

receded, almost vanished. On the other hand, the question of what caused a person to become blind gained in significance and sometimes moved to the focus of attention. This shift of emphasis in the attitude toward the blind from the oriental to the classical world is one of the major developments of our subject in antiquity.

How did classical antiquity explain the loss of sight? The causes bringing about the "eternal darkness" in which the blind person lives often permeate his image with a distinct moral and religious character, and thus determine the nature of his figure in literature and art. It is, therefore, necessary for us first to look briefly at the causes of blindness.

There are many reasons for blindness. Perhaps a word should be said here about the sources from which we derive our knowledge of what the ancients thought about the subject. Very little of what we know is derived from texts of medical science or healing practice. Our main sources are works of literature and art, and they draw from mythological traditions rather than from those of natural science. This does not mean, of course, that classical culture knew no natural explanation of blindness. In some works of history and rhetorics we occasionally come across records of widely held opinions concerning natural causes of blindness, as well as empirical observations of the reasons and development of various types of blindness. Two explanations figure large among the natural causes for blindness: inherited predispositions and old age.

The belief in inherited inclinations as a natural cause of blindness must have been widespread, and it is occasionally referred to as a matter of course. We recall, for example, what Diodorus Siculus tells his readers about the Egyptian king Pheron Sesostris who, like his father, went blind. This, the author says, happened "because of the common natural predisposition."[8]

Another example is the story that Plutarch tells about Timoleon. He gradually lost his sight, until eventually he went totally blind. The reason for Timoleon's blindness, we learn, was a natural, inherited predisposition. Many of his relatives, it is explicitly said in the story, similarly lost their sight in old age.[9] Yet the link between blindness and fault was so profoundly impressed upon the thoughts and beliefs of the

time that even in this case Plutarch felt it necessary to declare explicitly that Timoleon's blindness was not the result of any fault he had committed but of the inherited predisposition that prevailed in his family.

In the spiritual world of classical antiquity the deeply ingrained belief in the inevitability of the laws of nature also assumed the form of the supreme power of fate. Loss of sight in old age is part of man's fate. The gradual losing of eyesight is as inevitable as the gradual losing of life power; the death of the eye precedes the death of the person. It is worth recalling the lamentation pronounced by the choir in Euripides's *Hercules Furens* (637):

> Youth is dear to me, but age ever,
> > lies upon my head,
> A heavier burden than the rocks of
> > Aetna,
> Dimming mine eyelids with sable
> > veil.

In addition to predisposition and old age, antiquity recognized still another natural cause for blindness—disease.[10] In classical literature we do not have many theoretical explanations of disease. It is also remarkable that in the few references to sickness as a cause of blindness there is no particular mention of diseases of the eye. Affliction of the eyes may, however, be one of the symptoms of a general disease. A good example is Thucydides's classic description of the plague in Athens.[11] The disease, Thucydides tells us, begins with a "redness and inflammation of the eyes." Not many survived the plague, and some of those who did, "escaped . . . with the loss of their eyes." Thucydides's story is echoed by many followers, among them Ovid and Lucretius.[12] There are some differences between the versions, but whatever they are, and whether or not they are free from implicit connotations of religious value judgments, none of them describe the plague, including the blindness that sometimes resulted from it, as the effect of an immediate divine intervention. The disease, be it plague or something else, is conceived as a physical phenomenon, a failure of the body's function or of some of its parts.

Yet while some diseases, including those causing blindness, may be understood as deriving from natural causes, the beliefs common in classical culture have it that maladies, whether plagues affecting crowds or illnesses attacking individuals, are caused by super- or extranatural forces, whether divine or demonic. In general, illness was understood as an intrusion from the outside upon the integrity of the body. That this intrusion comes from the gods or from demons may explain why it seemed inescapable, and resulted in the fatalistic attitude that we find time and again in classical literature. "There is no escaping a disease sent by Zeus"—this is what the Cyclopes, supposing Polyphemus's cries to be due to an acute internal disease, have to say.[13] Yet while diseases, as some other afflictions, come from the gods, they are not altogether detached from man's own actions and behavior. The very emergence of disease in general is a "historic" event, as it were, and one that was brought about by man himself. Hesiod knows the precise moment and the specific conditions when disease as such came into being. There was a time, he says, when man lived free from all evil, labor, and disease. Then Pandora's box was opened, and now "The land is full of evils, and so is the sea."[14]

Blindness and Guilt

Did the ancients see a connection between blindness and guilt? Perhaps a brief comment about the sources from which we draw our knowledge should be made here. As already noted, very little of our knowledge of what antiquity thought about blindness is derived from what, using modern terminology, might be called scientific sources, particularly medical science and practice. The virtual nonexistence of medical testimony about blindness is particularly remarkable in view of the fact that in Greek and Roman literature the eye played a central part in the mental imagery of classical culture.[15] Does this lack of discussion indicate that blindness was considered incurable, one's unavoidable fate? No positive answer can be given, but one notes that the absence of treating blindness seems to be comprehensive. The state of testimony from medical theories is paralleled and supported by testimonies from

other sources. In this context, the evidence implied in the votive gifts that have survived from ancient temples deserves to be taken seriously. As is well known, during long periods in antiquity sick people sought divine cure in the temples, and offered portrayals of their ailing limbs to the gods. It is interesting to see which limbs were represented in those votive gifts. While we have many images of arms, legs, and breasts, of ears and genitals, and of other parts of the human body, there are surprisingly few representations of eyes among the surviving votive gifts.[16] When an eye is portrayed on one of these, it is cross-eyed rather than blind.[17]

Another archaeological source supporting the impression derived from the study of votive gifts is that of the votive inscriptions found in the temples of Asclepius. Here a great variety of ailments are mentioned, and some are described in detail. Now, we note again that, as far as we can see, the impairment of eyesight and the prayer to restore sight to the blind are surprisingly rare. Even the healing of sick and anomalous, but not blind, eyes is seldom mentioned. When the healing of blindness is recorded, the event is presented as a pure miracle, altogether incomprehensible to the regular mind. Thus we learn that sight may be miraculously returned even to those who had not a single eyeball left.[18] The very emphasis on the supernatural, miraculous nature of healing an eye that had lost its sight may perhaps be an implicit admission that a cure for blindness was not considered possible.

In striking contrast to the scant information about blindness that can be drawn from medical sources, scientific theory, or temple practice, we have ample testimony from the other source, namely, myth and its various literary and artistic formulations. In fact, most of what we know of the mental image that classical antiquity had of the blind is derived from mythography. The testimonies derived from myth are such that they allow us to pose specific questions. Two, of direct concern for our subject, immediately come to mind. First we ask, Who are the blind? Is there a specific type of mythological figure that is usually, or most often, struck with blindness? And do all these blind figures have some essential elements of character in common? Second, Why, for what specific reasons, do those mythical figures that are

imagined as blind lose their sight? What are the causes of blindness as presented in myth?

Attempting to answer the question of whether the mythical figures who lose their sight have a common character is apt to cause bewilderment. The student cannot help noting the utter diversity in character of those blind figures. Already in antiquity it seems to have been noted how heterogeneous the mythical blind are. This insight may well have been the reason for listing them together as a group. One such list is found in Ovid's *Ibis*.[19] From this classical text we may draw an important conclusion. The figures named here manifestly differ from each other in character, in moral nature, and in motivation. Among them there is the noble, heroic Oedipus, but also Polyphemus, who monstrously violated the laws of hospitality; there is the divinely inspired seer Teiresias, but also Polymestor, who murdered his guest-friend. Neither in psychic nature nor in relation to the gods, or in social position, do they have anything in common. Even a brief glance at such a list shows that in the cultural memory of antiquity blindness does not follow from, and is in no way linked to, the blind person's character; there is no affinity between a figure's nature and the loss of sight.

Our second question leads to a different conclusion. When we ask what the causes of blindness are, the mythical stories suggest that the loss of sight is usually the immediate result of a grave fault committed by the blind person. The fault leading to blindness may have been intentionally performed, a crime in our sense, but it may also have been a pollution unintentionally, even unknowingly, attracted or inherited from former generations.[20] Whatever the causes, the "fault" that results in blindness is a serious, grave offense, and it plays an ominous part in the blind person's fate. Once committed or acquired, nobody can escape its effects. Blindness, then, is an essential part of some figures' fate.

The link between a figure's guilt and his blindness is shown in many ways. It is most strikingly manifest in the blinding of a hero as the punishment for the crime he has committed. Striking blind in punishment is a primordial act, found in the myths of many cultures. In classical culture stories presenting blinding as the punishment for a crime

abound. Among the best known of these is that of the blinding of Poly-mestor, especially as Euripides told it in his play *Hecuba*. Polymestor, the Thracian king, had slain Hecuba's son Polydorus, and Hecuba takes revenge by blinding him. Even before she carries out the act, she sees in her mind the sightless king and understands his blindness as a punishment for his crime (1050–55):

> Watch him as he stumbles and staggers out
> of his tent
> stone blind.
> See the bodies of his sons
> killed by my women and me.
> His debt is paid
> and I have revenge.

When Polymestor is actually blinded, every figure in the play, including the Thracian king himself, understands the destruction of his eyes as punishment for the evils he committed against his guests.

The story had a long life. Almost five centuries after Euripides wrote his play, Ovid described the blinding of the Thracian king in cruel detail. With her fingers Hecuba dug out Polymestor's eyeballs. "Then, horribly stained with his guilty blood," she plucked out his eyesockets.[21] In both the Greek and the Latin versions there is never any doubt as to the connection between guilt and blindness.

The theme of blinding as the punishment for an outrage persisted vigorously throughout ancient culture. Thus, to mention only one more example I shall recall the blinded Cyclops, who, from Homer to Euripides to Ovid, is told that he is paying with his sight for the "unholy banquet" in which he devoured Odysseus's comrades. The link between punishing an outrage, or a mortal enemy, and blindness so profoundly impressed itself upon the ancient mind that the destruc-tion of the eyes could become a symbolic act of punishment, even in conditions in which it does not have any real meaning. Alcmena, the mother of Hercules, "gouged out the eyes" of the severed head of Eurystheus, her son's great enemy.[22]

We should remember, however, that while blinding bears testimony

to a grave fault, it does not say anything about the figure's character. Not only cruel and treacherous criminals like Polymestor or savage creatures like the Cyclops are blinded. A noble hero like Oedipus[23] blinds himself for committing acts whose significance he could not have known and for a guilt of which he originally was not aware. His blindness, or self-blinding, does not in any way diminish, but perhaps even stresses, the intrinsic nobility of his nature as a human being.

Blindness, then, is the punishment of faults. But are all grave and terrible crimes punished by blindness, or is this a punishment reserved for specific crimes? What we can learn from Greek and Roman mythography is that it is mainly two kinds of violations of basic laws that carry blindness as punishment. One is the transgression against primordial sexual taboos, and this means mainly incest and related crimes that carry sexual connotations. The other is sacrilege, offences against the gods, whether or not intentionally committed. Often two types of crime cannot be entirely separated from each other. In many cases they overlap, and we can only speak of two aspects of the same act. In essence, however, they are two different groups of actions.

The mythical stories of blinding as punishment for real or alleged incest, for the breaking of basic natural and social taboos, and for offending the gods are well known, and it will be sufficient to mention only a few examples. An interesting story, illustrating the continuous life of such motifs, is the legend of Phoenix. According to the original version, as told in the *Iliad* (9:437–84), Phoenix is tempted by his father's concubine and, when he rejects her advances, is falsely accused of raping her. The enraged father threatens to punish him by blinding, but Phoenix escapes the punishment by flight. In the literature of the high classical age, especially in fifth-century tragedy, the story seems to have played an important part. Both Euripides and Sophocles wrote tragedies on the subject, and Euripides's play particularly seems to have enjoyed considerable success in Athens. Both plays are lost, but as far as we can judge from surviving fragments and other sources, the actual blinding of Phoenix played a central part in both. Several centuries after Euripides, the blinding of Phoenix is related by the mythographer Apollodorus. "This Phoenix," he says, "has been blinded by his father

on the strength of a false accusation of seduction preferred against him by his father's concubine, Thtia."[24] The story was thus still alive at the very end of antiquity. A text in the *Anthologia Graeca*, presumably copying an inscription in the temple of Apollonis in Kyzikos, tells the story, and only adds that the father wanted to destroy the son's eyes by fire.[25]

A similar motif is employed for other figures, such as Phineus and his sons, as the story was recorded by the main mythographers of antiquity, Apollodorus and Hyginus. Idaea, they tell us, the daughter of Dardanus, whom Phineus married after having had two sons by Cleopatra, "lied to Phineus that her stepsons raped her, and he [Phineus], believing her, blinded both of them."[26]

The other kind of faults punished by blindness are offenses against the gods, or sacrileges. But one notes once again that not all such offenses are punished by blindness. Some of the best-known offenders retain their eyesight, though they are gravely punished in other ways. Think, for instance, of Prometheus. However we may now understand the nature of his deeds, in antiquity already he served as the model image of a rebel against the gods.[27] He offended the gods, he rebelled against the divine order; yet his punishment, agonizingly torturing as it was, did not affect his eyes. It is obvious, then, that not all offenses against the gods are punished by blindness, only certain ones. What are they?

These offenses are not easily defined and set apart from other faults against the gods. In antiquity they were never described as a particular type. We do not know whether there was an awareness of their specific nature. Yet two aspects of offenses against the gods that are punished by blinding emerge from mythography. One is that most, perhaps all, the faults so punished involve in some way, though often vaguely, sexual taboos. The other is that almost all of these offenses are committed by the eye; they are sins of vision.

The ocular trespass consists mainly in men seeing a goddess in her nudity. Throughout antiquity the belief was held that men are forbidden to watch, even to briefly glance at, women's rituals, particularly if these rituals were performed naked. Transgressions, it was believed, were punished by instant blindness. In Rome men were not allowed to

be present at the ritual ceremonies of the Roman goddess of fertility, the Bona Dea. It was a common popular belief that a man who watched these rituals would instantly be struck blind.[28] Cicero wonders how Clodius, who crept into such a ceremony in the guise of a female slave, did not instantly lose his eyesight.

The theme of a man blinded because he saw a goddess naked is known in several versions. They all have a common core. Best known is the story of Teiresias, to which we shall revert in the next section. Among the others, perhaps less well known, is the tale of Eurymanthos, the son of Apollo. When Eurymanthos saw the goddess Aphrodite, after she rose from Adonis's embrace, bathing in the nude, he was immediately blinded.[29] Philip of Macedonia, Plutarch tells, went blind in the one eye by which he watched, through a slit in the door, the god Ammon, disguised in the shape of a snake, make love to Philip's wife, Olympia.[30]

While seeing the naked goddess may still carry some sexual connotations, these overtones fade where we learn that the very act of seeing the gods as such, whether naked or dressed, is punished by blindness. What sacred dividing line is here transgressed? It must be a borderline, a distinction, so primordial that it is equal to the basic taboo of incest, and grave enough to be punished by blinding. Here, it seems, we come across the impact of a basic concept of religion, namely, the experience of the gods' complete otherness, the total transcendence of the divine. The invisibility of the divine may be an expression of its transcendence.[31] It is dangerous to see the gods in their bodily appearance—this is Homer's general warning.[32] Though in Greek and Roman culture the invisibility of the gods is an assumption perhaps open to doubts, it does exist and have its effect.[33] Without attempting to trace this specific motif, I should like to mention an important document from a later stage in antiquity, Plutarch's famous description of the statue of "Athena, whom they believe to be Isis," in the temple in Sais. It is a statue that bore the inscription "I am all that has been, and is, and shall be, and my robe no mortal has yet uncovered."[34] Seeing the god may well have been understood as an attempt at obfuscating the line dividing the divine from the human, and hence it is a grave sacrilege.

To the student of the visual arts it is of particular interest that the mere seeing of a god's image could also be considered a grave fault committed by the eye, and hence be punished with blindness. Interesting testimony is provided by the story of the Palladion, the sacred image of Pallas Athena which miraculously descended from heaven. It was twice saved from destruction by fire, once by Ilus at the original spot where it fell from the sky, then again by Metellus in Rome, where it was brought by Aeneas. Both savers of the divine image were blinded because they saw it in the course of rescuing it from the flames.[35]

It may be concluded, then, that whatever the explanation of a specific case of blinding—the transgression against a sexual taboo or an insult to the gods—blinding is the outcome of an offense committed by the eyes, and it is a symptom of guilt.

The Blind Seer

Guilt, important as it is in the mental image of the blind, is not the only connotation that blindness carried in the ancient world. In addition to guilt, which always brings to mind the transgressing of a primordial prohibition, blindness may also indicate a gift: the blind may have contact with another reality, different from the one in which we live. For some figures blindness may be the external appearance that conceals a mysterious, numinous interior. There is only one type of the sightless—the blind seer or bard—to whom both highly educated authors and popular audiences in antiquity ascribed such a hidden nature. Yet this type, rare as it is, made a profound and lasting impact on the culture of the classical world, and made the blind seer's numinous nature an important component in the image of blindness. I shall briefly mention some essential characteristics of this type that are of particular significance for our subject, and shall then discuss a single example.

The first and most obvious issue is that of the different, and even totally conflicting, estimations of what the blind person is, that come to the fore in the figure of the blind seer. On the one hand, he carries the heavy burden of fault, as is made manifest in his being deprived of one of the basic organic faculties of man; he is utterly helpless and

depends on the assistance of others, even of young boys. Even when he evokes compassion, he always reminds one of the vice or of the fateful fault he has committed. On the other hand, however, some blind persons are endowed with the gift of supernatural vision. They have some knowledge that goes beyond the reach of humanity. But as opposed to this combination of compassion, suspicion, and rejection, the blind person is also approached with the feeling that he has the uncanny ability to communicate with the world beyond us. This belief necessarily results in a double and different estimation of the blind.

The other issue, closely related to the first one, is the disjunction of two sides or images of man, the outer and the inner. The blind seer is an early embodiment of this disjunction of man's two aspects. This uncanny personage is of particular significance in the culture of antiquity. We should remember that in Greco-Roman culture the physiognomic approach played an important part. It was based on the assumption that there is an intrinsic similarity that makes it possible to "read" a person's inner nature from his or her outer appearance. The blind seer is a striking contradiction to the physiognomic approach. What you see in the blind seer's outer appearance—his blindness—is explicitly not what is hidden within him. The blind seer endowed with inward vision is an early and powerful crystallization of what has in the modern world come to be known as the "inner person" (*innere Mensch*) as distinct from external appearance.

A third issue is the double meaning of "seeing" itself, of the word as well as of the visual experience it denotes. The most striking external characteristic of the blind bard is his blindness, that is, his destroyed eyes and his inability to see the world around him. Yet throughout antiquity the numinous blind one is imagined as seer, as a man perceiving secret revelations by means of inner visual experience. The words by which he is described always have something to do with seeing.[36] His blindness, it seems, is not the abyss of eternal darkness that is the lot of the blind in general. He thus becomes the personification of the dialectic tension inherent in vision, the inbuilt provocative contradiction of seeing with an inner eye. As such, the figure had a great history in European culture.

In the imagination of classical antiquity the blind bard or seer is not a homogeneous, unified figure. The mythographic tradition tells of several blind seers, and in each of these numinous figures a different aspect is emphasized. In the stories of some blind bards their guilt is more strongly stressed; in those of others it is their inner vision that is made the main theme. Thus Thamyris, the Thracian bard who frivolously challenged the muses, embodies the singer's arrogance and insolence. His story naturally focuses on the period preceding his blinding as punishment.[37] In the story of Teiresias, on the other hand, the guilt plays a minor part; what is stressed is his visionary faculty. This is also reflected in the fact that the main emphasis is placed on the role he plays, and the experiences he perceives, after losing his sight. Teiresias is the fullest and most typical embodiment of the blind seer, the symbolic figure we have here in mind.

The story of Teiresias was told many times, from the *Odyssey*, at the very dawn of Greek poetry, to Nonnus's *Dionysiaca* in the fifth century and the bishop Fulgentius's *Mythologiae* in the sixth century A.D., in the very dusk of the ancient world. Already in antiquity people were aware that Teiresias's image and story are many-sided and intricate, and that they lend themselves to different interpretations. This awareness is perhaps reflected in the words of the Hellenistic mythographer Apollodorus, who introduced the story of this blind seer with the following sentences: "Now there was among the Thebans a soothsayer, Teiresias, son of Everes and a nymph Chariclo, of the family of Udaeus, the Spartan, and he had lost the sight of his eyes. Different stories are told about his blindness and his power of soothsaying."[38]

There are, then, two parts to his story. The first, including what is told about his family and how he lost his sight, seems to have been clear. So far there are no different versions among the mythographers. The other part consists of what is told about his blindness and his power of soothsaying, and here the stories diverge, thus probably indicating that there were different interpretations of his condition.

Without attempting to trace the outline of Teiresias's story as it lived in the cultural memory of antiquity, I shall briefly mention some of the versions that are of particular significance for our subject. From the

earliest appearances of Teiresias in Greek legend he is a numinous and liminal figure. Already Homer, endowing him with an air of mystery and supernatural power, tells that in Hades, among the "shadows flitting to and fro" that have lost their consciousness, Teiresias's mind remains unharmed. Even when his body has disintegrated, his soul continues her life.[39]

Two versions of Teiresias's blindness, differing in emphasis though not in simple facts, emerged between the fifth and third centuries B.C., the one represented by the great tragic poets, the other by Alexandrian scholars and poets. Both versions are not so much concerned with Teiresias's life in the beyond. Hades is less important to them. They are fascinated with what he does on earth, with his involvement with the fate of living people, and with what he adumbrates in this world. When seen next to each other, they bring out the intrinsic tension of what the prophet's blindness means.

It was mainly the tragic poets who shaped the image of Teiresias as it lived on in European memory. In their plays Teiresias appears as a dignified old sage, dependent as every blind man on his staff or the boy who leads him, yet in another sense lifted up above all people. Two main features form the basis of the image of the sage with his mysterious vision. One is his liberation from human passions. To the threats of Oedipus and Creon he responds with untroubled quiet. The other, and the crucial, feature that makes him a mysterious wise man is his insight into secrets that are obscured to the knowledge and understanding of all mortal human beings. Both his detachment from human passions and his insight into supernatural secrets enable him, in a sense, to communicate between men and the gods.

In both versions of the story Teiresias's supernatural knowledge is inseparable from his blindness. He pays with his eyesight for his prophetic gift. Most explicit is Callimachus. The goddess Athena, after blinding the young Teiresias because he inadvertently saw her naked, is implored by his mother to restore his eyesight. "The thing that is done can no more be taken back," the goddess says, but "I will make him a seer to be sung of men hereafter, yea, more excellent far than any other. He shall know the birds—which is of good omen among all the countless

birds that fly and which birds are of ill-omened flight. Many oracles shall he utter to the Boëotiians and many unto Cadmus."[40]

The other version, told mainly by later authors, explains Teiresias's blindness as the result of Juno's rage. In the words of Fulgentius, one of the last ancient authors to tell the story, "Juno and Jove had an argument about their respective degree of love pleasure." Teiresias, asked to be their arbiter, said "that a man has three-twelfth of love pleasure, and a woman, nine. In a rage Juno deprived him of his sight, but Jove granted him divinity."[41]

Teiresias, then, reads the will of the gods, and thus knows the fate of humans. But precisely how does he get to know these secrets? By what means does he acquire the insight and knowledge of what the gods want, what the future holds for men? For our investigation this is a crucial question.

The gods, as people in the classical world believed, announce their will by natural signs. Some of these are manifest to everyone, but others are hidden and can be understood only by those who are specially favored by the gods. But both the crowd and the chosen must first perceive those signs before they can unriddle their meaning. Some of the authors who told Teiresias's story tried to explain his understanding of natural signs without contradicting the fact of his blindness. To some extent hearing instead of seeing is made the main channel of perception. Thus Apollodorus, in the passage quoted above, relates that Athena, after blinding Teiresias, "by cleansing his ears she caused him to understand every note of birds." Sophocles makes Teiresias describe how he derived from birds' screeches "goaded by madness, inarticulate" that they were "tearing one another with claws of murder." That no fire catches the sacrifice he offers he learns from his boy "who is my guide as I am guide to others."[42] But in addition to stressing the sense of hearing as the source of Teiresias's knowledge, ancient audiences must have felt that some kind of seeing is also assumed. Pliny suggests that Teiresias is the founder of presaging "from the entrails of birds,"[43] an action that was certainly not understood as carried out by hearing only. In later antiquity, it seems, it was believed that there was an "observatory of Teiresias" at Thebes.[44] It was also said that Teiresias read the

stars. All these prophetic actions can perhaps technically be accomplished "with the eyes of others," at least as far as the requirements of folktale go. But they strongly suggest a kind of seeing, of visual perception, however strange and unusual it may be, of shapes, compositional orders, and other qualities we normally learn through our eyes. In some way, blind Teiresias could see.

Teiresias's story is a particularly distinct one, but it does give us some insight into how blindness may have been understood in antiquity.

Ate

The blindness we have spoken of so far is plain, physical blindness. All the figures mentioned—Polymestor and the Cyclops, Thamyris, Oedipus, and Teiresias—were unambiguously, bodily blind; their eyeballs were destroyed, their eyesight gone. The blind seer may have a mystical kind of vision, one that is not physical and material; in a physical sense, however, he is fully blind. Yet in the mental world of antiquity blindness played an important role also in a different sense, one that is not bodily and material like that of the figures mentioned. It is not certain that we always can describe this nonbodily blindness as a metaphor in the free, somewhat noncommittal way in which this term is now often used. Yet however we may call it, for an understanding of blindness and the blind in the ancient mind we should recall that in classical culture a cluster of various, intricate mental images in which blindness, even if it is not explicitly physical, occupies an important place. In these complex images blindness is neither fully physical nor completely metaphorical. Blindness is here in a twilight. The fullest embodiment of this blindness in the twilight is the Greek concept of *ate*.[45]

What precisely is *ate*? The term is frequently used in Greek poetry, and *ate* is even known as a mythological figure.[46] Nevertheless scholars have not found it easy to offer a simple definition. Literally, *ate* should be translated as blindness, and this was probably the original meaning of the word. In at least one Homeric passage it almost certainly means physical blindness. When Patroclus is struck from behind by Apollo,

just before his death at the hands of Hector, his eyes are whirling, he is without a helmet, his spear is broken, his shield is gone; and at that moment *ate* overcomes him.[47] When Agamemnon blames his erroneous judgment on "Ate, the eldest daughter of Zeus, who blinds us all," the connotation of physical blindness is also present.[48]

In most other passages, however, some in Homer and almost all that occur in the works of later poets, *ate* does not have such an explicitly physical condition; it is not restricted to only physically losing one's eyesight. A whole complex of conditions, psychological, social, and religious, is evoked by the term. While the sense of physical blindness, permanent or temporary, is never altogether excluded, more often the term denotes mental blindness, infatuation, folly. It may also mean actual ruin, calamity, or disaster. Richard Doyle, who has traced the occurrence and the contexts of the word in Greek poetic literature, adopts for the first group of meanings (mental blindness, infatuation, folly) the term *subjective ate*, and for the second group (ruin, calamity, disaster) the term *objective ate*.[49] It goes without saying that the two groups cannot be neatly separated from each other, but it is of interest to see where the main emphasis is placed.

Already in Homer *ate* may mean a particular kind of blindness, the clouding or bewildering of consciousness. Thus Helen says to Menelaus that she is "repenting the infatuation with which Aphrodite has blinded me."[50] It was, however, mainly in Greek classical poetry, primarily in tragedy, that *ate* was consistently, though not exclusively, employed to indicate a particular kind of blindness, namely infatuation or folly. The term is so used in two main contexts—one is the erotic, the other the activity of a demonic power.

Whatever the specific context, *ate* as a passion, as an inner human experience, is characterized by its imposing itself by force on the mind. This event is often described in terms of battle, and the imagery of overpowering, of overwhelming, often even with the use of weapons, is evoked to illustrate the process. A person's consciousness is imagined as a trussed animal hopelessly mastered by passion. Frenzied Phaedra is told, "Some god ropes you back and strikes your *phrenes* aside." Ajax, maddened by Athene, is "yoked to a terrible *ate*."[51] In Sophocles's *Ajax*, Odysseus says about the unfortunate hero of the play (121–23),

> Yet I pity
> His wretchedness, though he is my enemy,
> For the terrible yoke of blindness
> [*ate*] that is on him.

Ate is a violent force, powerfully overwhelming the individual who is exposed to it, and it does not depend on the context in which it appears. Both in erotic attraction and in a demon's action, *ate* turns the person attacked into a helpless victim, delivered to its uncanny power.

Expressions of this kind, and particularly the sense that we are at the mercy of invisible powers, suggest still another important dimension of the emotional connotation of blindness in ancient culture. It is the intrinsic affinity of blindness to *ate* and madness. In classical literature this affinity did not become an explicit topic; it would be difficult to adduce quotations openly stating that blindness is madness. Yet the character common to both blindness and madness is strong enough to link them to each other and to tinge both with the same sense of the desperate insecurity of the human condition. It is particularly in the language of images that the intrinsic affinity of these extreme conditions are made manifest.

A characteristic feature common in imagining blindness and madness, and thus linking them to each other, is that they are dark. Darkness is an obvious hallmark of blindness, and it is intuitively grasped as such. Time and again was the loss of eyesight perceived as a descent into eternal darkness. Blindness is so horrible because it is tantamount to darkness.[52] Although the connection between madness and darkness is not as obvious as that between blindness and darkness, in many images in Greek literature heavy shadows, blackness, and dark appearances are evoked to convey the emotional sense of madness. The supposed organic basis of the link is well known. Black bile is the cause of melancholy as a disease, as has been carefully studied in a classic investigation.[53] For our purpose it is even more important that temporary madness, that is, fits of anger and passion and thus the temporary clouding of consciousness, are somehow imagined as a darkening. Greek poetry generally speaks of passion, especially anger, as dark boiling turbulence.[54]

Darkness, in antiquity, is also the outstanding characteristic of death. Hades is placed in the dark depths of the earth, and when a hero feels that his death is approaching, he bids farewell to the light. So closely are light identified with life and darkness with death that even the blind Oedipus bids farewell to the light when the hour of his death approaches.[55] Blindness is viewed as death because in Greek culture light is viewed as life itself.

We should further remember that madness, like blindness, is god-sent or results from intervention by demons. Moreover, like blindness, madness is often explained as punishment for some evil perpetrated in the past. Thus Herodotus tells his readers that most people in Sparta saw the madness of their ruler, Cleomenes, as the god-sent punishment for a sacrilege he had committed.[56] Moreover, madness, particularly a temporary fit of it like epilepsy, could have been considered as a cause of blindness.[57] More important, however, is the belief that both blindness and madness, being either god-sent or the outcome of the intervention of demons, have something of a numinous, supernatural character. It is well known that madness, especially in its most manifest form, epilepsy, was considered a "sacred disease."[58] The same would seem to apply, even if less explicitly, to blindness.

What can we learn, for the purpose of the present study, from the affinity between blindness and madness? It is mainly two points that are significant and should be stressed here. First, both blindness and madness are god-sent, or result from the intervention of demons. Second, because of their origin, both have something of a sacred, or at least supernatural, character. Blindness and madness alike, then, are characterized by a profound ambiguity, or ambivalence. Perhaps alone among all the physical ills, they are both a curse and a blessing, a punishment and a grace. This ambivalence becomes particularly manifest in the *ate*, the personification of both.

Visual Representations

So far we have been concerned with the mental image of the blind in antiquity. We now turn to actual images, to the rendering of the blind

in the visual arts of the period. How did the artists of antiquity show the blind? Did they find formulae to convey the ambiguous nature of blindness, and the ambivalent attitude to the blind? To answer these questions, we shall focus on two issues. One is quite simply that of the obvious formal and iconographic models of representing the blind. By what means did painters and carvers of antiquity show that a figure is blind? For the painter and sculptor it is difficult to characterize the blind by the shaping of the eyes. The eye is a tiny detail in a figure, particularly those of small size, and in many works of art it is hardly visible, certainly not at a first glance. Blindness therefore had to be shown by other means. The other issue is the expressive character and connotations of figures of the blind in Greek and Roman art. Next I analyze a few examples that represent the major types of depicting the blind in the arts of antiquity.

A particular condition prevailed in the shaping of narrative scenes in which blind figures were depicted. The pictorial representation of these narrative scenes is based on a distinct interaction between the artists and their audiences, on the fact that they shared a common treasure of myth and legend. The artists were aware that patrons and audiences were thoroughly familiar with the narrative, and this awareness of the common acquaintance with the stories determined what the artists had to show in order to characterize a figure as that of a blind person.[59]

Among the earliest renderings pertaining to our theme are scenes of blinding. In a precise sense of the terms employed these scenes do not represent blind figures, but rather the dramatic, violent act of blinding. Among the earliest is probably the blinding of Polyphemus. We find it already in the seventh century B.C., at the beginning of vase painting. In these early stages the representation of blinding forms part of an exuberantly thriving iconography characterized by a striking directness. On the neck of a huge amphora (which contained the skeleton of a ten-year-old boy) an Athenian artist painted, in 670–650 B.C., a vivid scene of the blinding of Polyphemus (fig. 3).[60] Odysseus with the aid of two companions thrusts the stake into the eye of the Cyclops, who emits a cry as he tries to hold it back with one hand. In his other hand he still has a wine cup, to show what had happened earlier in the story.

The representation of blinding is not limited to the punishing of delinquents. Not only evil monsters, such as the Cyclops, are shown as they are blinded; a noble hero may also experience this terrible fate. A single example will suffice: the blinding of Oedipus, on an Etruscan urn from Volterra, now in Florence (fig. 4).[61] The Oedipus story was known in several versions. In a lost play by Euripides, Oedipus did not blind himself, as the Sophoclean version has it, but was blinded by his enemies who defeated him.[62] This precisely is what is represented on the Volterra urn. Oedipus, draped in royal garb, is forced to his knees; two enemy warriors twist his arms backward, dramatically showing that he is helpless. A third warrior is pushing his sword into Oedipus's eye. The student of art cannot help noting that the eye, a small detail in the face of one of the several figures represented, is hardly visible; were the blindness to be indicated by shaping the eye, it would have been altogether lost. It becomes clear, and visually central as it is in the narrative, by the placing and movements of the executor's mighty figure. He is placed exactly in the center of the scene, behind the kneeling king, and the gesture of his arm, overshadowing all other movements, leads the spectator's gaze to Oedipus's eye.

The directness of gesture and movement leading to the victim's eyes recurs in the early Christian scenes of healing the blind, a subject to which we shall revert in the next chapter. In those scenes, Christ places his finger on the blind one's eye. By so doing Christ again leads the spectator's gaze to the eye, a detail that otherwise would have remained invisible. It is interesting that in both polar themes—the destruction of the eye and its full restitution—such similar artistic patterns are employed. This is a further example of what Aby Warburg called "energetic inversion."[63]

Blinding is a dramatic act and, as just noted, in scenes of blinding it is the act itself rather than the condition of blindness that is represented. But how did the ancient artist proceed when he had to portray the condition of blindness rather than the act of blinding? Perhaps nowhere can the artist's attitude be so clearly seen as in the representations of Teiresias.

In Greek art Teiresias is always depicted as an old man. The event of

his youthful blinding did not attract the interest and attention of artists and patrons. As the old prophet, Teiresias evokes a mood altogether different from the one prevailing in blinding scenes. While blinding is a climax of violence and cruel drama, the old Teiresias is an inward-looking figure, usually standing still, perhaps altogether motionless. How is the figure's blindness shown? Two questions attract our attention. First, one wants to know what the pictorial means are by which the blindness is made visually manifest. Second, one asks whether the artists found ways to make manifest in the realm of the visual arts the ambiguity of blindness.

An illuminating model of how the soothsaying old Teiresias was portrayed is provided by a crater from Southern Italy. The original is lost, but we know the composition from an early modern line drawing (fig. 5). The painting on this vase probably illustrated scenes from the Oedipus tragedy as told by Euripides.[64] Here we are concerned with the group in the lower right: Teiresias, standing upright, clad in ornate dress befitting a figure of high dignity, turns slightly to the king who is seated on his throne, and obviously speaks to him. It is clear that he is making his ominous pronouncement. In his right hand Teiresias holds a richly decorated staff topped by a tiny model of a temple, his head is crowned with a wreath (note that only the king wears a similar wreath) and covered with a veil, his left hand is held by the little boy who is leading him. If we can trust the line drawing, Teiresias's eyes are slightly opened, but otherwise normal. His blindness, then, is not shown by a deformation of his eyes, but by the attributes of the blind, the staff and the boy guiding his steps.

The staff as an attribute of the blind appears frequently not only in paintings but also in literary descriptions. Thus Callimachus relates that the goddess Athena replied to the nymph Chariclo, the young Teiresias's mother, that the blinding could not be undone, and added that in recompense she would give him the gift of prophecy, a long and glorious life, and "a staff with which to guide his way."[65] In relating the story of Teiresias Apollodorus says that Athena cleansed his ears so that he could understand every note of the birds, "and she gave him a staff of cornel-wood, wherewith he walked like those who see."[66]

The other attributes of the blind are the assistants, often children, who help them guide their steps. In *Oedipus* they play an important part.[67] But they are also conspicuous in works of the visual arts. We have already seen such a figure in the drawing after the lost crater. We know these helpful figures also in other versions. An interesting example may be seen in the carving of a small ivory fragment now in the Hermitage. This fragment of a late antique work, probably done around A.D. 500, also illustrates the powerful afterlife of both the Oedipus story and the visual models representing it.[68] The fragment shows two scenes from the tragedy. In the upper half a young actor, holding a large mask with a high *onkos* in his hand, is represented. In the lower scene (fig. 6) the actor representing the now blind Oedipus is leaning heavily on two boys who are leading him. Additional figures, possibly those of Oedipus's daughters, are seen behind the main group. Even a brief comparison between the painting from the lost vase and the fragment in the Hermitage clearly reveals the wide scale of compositional patterns and expressive character that could be conveyed by the simple motif of a young boy assisting an old blind man. In the lost vase painting the spiritual independence of the noble prophet is dominant, the boy barely grasping the blind seer's hand. In the Hermitage fragment blind Oedipus props himself heavily on the boys, clutching their shoulders tensely. Thus, in the painting on the lost crater the numinous character of the blind man is expressed, whereas in the Hermitage fragment the stress is on his utter helplessness.

Perhaps less unequivocally readable than the attributes mentioned, but not less characteristic, is the blind person's reliance on the sense of touch as a contact with the material objects around him. The outstretched, fumbling hand of the blind man, touching his way in a world he cannot see, has become an emblematic gesture that reappears in the art of all ages. In a fragment from a Homeric cup, now in London, high artistic achievement is reached in the rendering of this gesture. We have here another piece of iconography derived from Euripides's texts, illustrating a scene from *The Phoenician Women*. On this fragment (fig. 7) the bent figure of the old Oedipus is represented, his slightly raised head suggesting blindness, one hand holding the

staff, the other hesitantly stretched out as he gropingly searches his way. The fragment illustrates the last scene of the play, particularly Oedipus being led to touch the corpses of his slain sons. [69] The inscription on the upper part of the fragment is a slight paraphrase of Euripides's verses in *The Phoenician Women* (1697ff.). The unknown artist who produced the image we see here made Oedipus's fumbling stretching out of his hands in search of the dead bodies of his sons a moving image. He shows how powerfully expressive the outstretched hands of the blind can be.

The most famous blind figure in antiquity is, of course, Homer. In the literary tradition Homer's blindness is attested at least since the fifth century B.C. Thucydides, quoting the Homeric hymn to Apollo (lines 165–72), identifies Homer as the "blind man, dwelling on the rocky island of Chios" (172).[70] There is also an old literary tradition of *ekphrasis*, of describing in words Homer portraits, actually or supposedly executed in the media of the visual arts. In this tradition, the poet's blindness is not explicitly stated.[71] In the visual arts themselves, there was, however, a lasting tradition of rendering Homer as a blind, wise old man.

In portraying Homer as blind, the need to convey by means of the visual arts the intrinsic tension and ambiguity of blindness must have been present in the minds of both artists and spectators. It necessarily became a central, if not always manifest, aim of expression. In fact, no figure in classical antiquity was more suited to reveal the ambiguity of blindness than that of Homer. Though his eyes do not see, he is the bard endowed with that rare divine gift of an inner vision that reaches into the depths of a future that regular human beings cannot know. This implicit tension in the numinous bard's image became a key feature in the cultural memory of antiquity, and it lived on through all later periods.

How much Homer was perceived as an embodiment of numinous blindness, containing all the components of this complex condition, can be seen in the vague intimations that some indistinct guilt stuck to him. Though nobody knew what the poet's fault was, it was sensed that he must have offended the gods and subsequently was punished by

blindness. In the *Phaedrus* Socrates says that there must be a purgation for the fault of offending the gods. Homer did not know what that purgation was, "for he never had the wit to discover why he was blind." Stesichorus, another poet who offended the gods, recanted, and "immediately his sight was returned to him."[72] However this observation was meant (and to whatever extent it may have been satirical), it discloses a belief, held by large or small parts of the audience, that in some earlier, though unknown, stage of his life Homer must have offended the gods; otherwise he would not have suffered blindness.

We now come back to our question and ask: How did artists in antiquity represent Homer's blindness in shaping only his head? The attributes that identify the blind in larger compositions with whole figures could not be used in a portrait bust. Other configurations had to be created to convey the poet's blindness and to suggest what it implies. Let us look at a single example, limiting our attention to the question of how the blindness was expressed.

Our example is a famous Homer image, a head now in Munich (fig. 8).[73] What we now have is a Roman copy, done at the time of the early emperors, of a Greek bronze statue created at the middle of the fifth century B.C. Recently the interesting observation was made that the eyes are not completely closed, or "empty." There is a distance between the two eyelids, but it is very narrow, forming a kind of slot. This, it is suggested, is a "natural" representation of a blind person's eyes.[74] This explanation is supported by another observation. Originally the head in Munich was part of a full-length standing statue. It has been argued convincingly that in mid-fifth-century Greek art the closed eyes of a standing figure could only have been understood as an indication of blindness.[75] We may, then, safely conclude that the head in Munich represents the blind Homer.

Another feature indicating blindness is the posture, the specific position of the head. It is slightly raised, as if directing the blind eyes toward the sky or to some light above the head. In the head in Munich this position is not too strongly pronounced, but it can be perceived. It is found in almost all renderings of blind figures in antiquity, and it can be seen in many works of painting and sculpture done in later ages.

The blind person raising his or her head was probably also noticed in Greek literature. To give an example, we shall again refer to Euripides. In the *Alcestis* he juxtaposes the blind person's body slumping down as an indication of the end of life, and the lifting up of the head as a particular sign of the blind's inner life.[76] In another of Euripides's plays, *Hecuba*, Talthybius says to Hecuba, the embodiment of greatest sorrow and severest degradation, words that evoke the image of the blind:

> Rise,
> lady. Lift your head to the light;
> Raise
> that body blanched with age.[77]

The combination of closed eyes and lifted head, however vaguely suggested, alludes to a conflict between darkness, closing of the eyes, and affinity to death on the one hand, and a drive toward light, vision, and desire for life on the other. A similar motif is already found in Egyptian images (fig. 9). It is a conflict that is profoundly characteristic for the image of the blind in antiquity.

Did the ancient artists representing the numinous blind find a formula for visually expressing the combination of an inner illumination and guilt? To be sure, no definite indication of guilt can be discerned in the dignified, awe-inspiring images of Homer and Teiresias. Perhaps the very fact of their blindness, a condition understood as resulting from some guilt, conveyed to the antique spectator something of that ambivalence. Here we may well have reached a limit of what classical visual imagery could achieve.

A Concluding Note

Antiquity, even if seen as restricted to the Greek and Roman worlds, is a long and complex period. In the centuries from Homeric religion to the beliefs in late antique mystery cults, from archaic vase painting to the wall decorations of Christian catacombs, there are many and far-reaching changes. Can this period be treated as one whole, even with many diversities and shifts of emphasis? When limiting our concern to

the subject of the blind, some general conclusions can be suggested.

First, in spite of all variations and contradicting tendencies, some basic themes—blindness as a testimony to guilt, the blind singer-seer—persist. These themes give an intrinsic unity to what classical culture had to say about blindness.

Second, the insight into the ambiguity or ambivalence of blindness remains the dominant motif in understanding the blind and in shaping attitudes toward them. The merging of pity and awe remains the complex emotion in the perception of the blind. This is also true for metaphors and personifications of blindness. It is because of their double nature that such seemingly different conditions as blindness and madness can be linked.

A third conclusion is more hesitantly reached. It is concerned with how different media imaged the blind and expressed the attitude toward them. Here some differences between literary and visual formulations can be seen. Sculptors and painters perhaps did not find appropriate formulae to visualize the ambivalence of blindness to the degree that writers and actors on the stage achieved.

Can a change in religious beliefs bring about a profound transformation both in attitudes to the blind and in the conceptual, literary, and artistic treatment of blindness? This question imposes itself when we attempt to trace the history of our subject through late antiquity and the early Christian world. It is a question particularly difficult to answer. We know that emerging Christianity, as well as other religious movements of late antiquity, were not able to form their own spiritual world without taking over (and transforming) elements and patterns from ancient culture. This heritage was a powerful force, even in new religions.

2

The Blind in the Early Christian World

Among the many elements that early Christianity inherited from previous ages were concepts of the nature and origin of blindness, as well as attitudes to the blind. It was part of those beliefs, common also among early Christians, that blindness is a punishment for sin. Sometimes this punishment could be effected by miraculous means, as in the Acts of the Apostles (13:8–11). While Paul was preaching, Elymas the magician sought "to turn away the deputy from the faith," so Paul "set his eyes on him" and said "behold, the hand of the Lord is upon thee, and thou shalt be blind, not seeing the sun for a season. And immediately there fell on him a mist and a darkness; and he went about seeking some to lead him by the hand."

Because blindness was somehow, even if only vaguely, connected with guilt, it could also be seen as joined to emotional states that were sins and vices. The coupling of blindness and vice often appears in the writings of the Fathers of the Early Church, and one cannot always say whether it is meant as a metaphor or taken more literally. St. Ambrose, the fourth-century bishop of Milan, for example,

understands blindness as a manifestation of passion.[1] Another late-fourth-century Father of the Early Church, Jerome, equates blindness with *arrogantia*.[2] At about the same time, still another Father of the Latin Church, Arnobius, linked blindness with insanity (*furor*), reviving the ancient affinity of losing one's eyesight to losing one's mind in a Christian version of the Greek concept of *ate*. He also perceives a connection between blindness and *dementia*.[3] In the early fifth century, when the period we call early Christian was drawing to an end, Augustine speaks of "blindness" as of a more or less metaphorical synonym of *furor* and *dementia*.[4] All these views, it would seem, accord well with the inheritance from classical culture.

The modern student, familiar with these notions and their link to ancient beliefs, hesitates to speak of "new beginnings" or of dramatic changes, whether spiritual or artistic, brought about by early Christianity. Is it not frivolous, one asks oneself, in such conditions to speak of marked shifts or transformations in the history of the attitude even to a specific subject?

In spite of these hesitations I shall argue that in the early Christian world we may discern a distinct modification in the understanding of blindness, and in the context in which the blind are seen. This also implies a shift, at least in some respects, in the emotional attitude toward blindness and the blind. I concentrate on these new elements in the present chapter. I should make it clear at the beginning that I do not intend to suggest that these elements were the dominant, let alone the only, factors that determined the early Christian approach to blindness. I am concerned with the new motifs precisely because they deviate from the then traditional, inherited orientations.

Broad changes in the understanding of a natural condition and the emotional attitude toward it are notoriously difficult to measure. The incessant transformations that are the very essence of history do not offer a stable foothold for precise calculation. The student of mental history, even more than the historian of any other aspect, is aware of the danger of reading the conclusions he wants to arrive at into the material he is exploring. Even within a subject seemingly so well-defined as blindness it may be difficult to pinpoint changes or to

determine with precision when and where they began. We may therefore find it helpful to focus on some limited and seemingly minor themes, for they at some times offer insights into broad, comprehensive subjects. In the present chapter I shall be concerned with some special and limited subjects that form part of the early Christian view of blindness. These themes may afford us a better insight into the broader process by which the new religion achieved stable, clearly outlined forms. I shall concentrate on two matters: the miracle of healing the blind and the phenomenon of temporary blindness and its specific contexts, particularly conversion and rapture.

The Healing of the Blind

The student of early Christian imagery, as recorded in the literary and scholarly media (legends, sermons, commentaries) as well as in the visual arts, will pay careful attention to the scene of the Healing of the Blind. It is well known that the range of themes that appear in early Christian imagery is rather restricted, particularly as compared to contemporary pagan imagery in late antiquity. The very selection of a subject for literary description or pictorial depiction is therefore of significance. This can best be observed in the painted or carved images, perhaps because the subject matter is so narrowly limited. The theme of almost every early Christian image reflects a profound belief or a basic emotional need that was central to, and dominated the spiritual world of, the new religion. The fact that in the repertory of the earliest Christian images the Healing of the Blind is important therefore deserves careful attention. While there are only a few paintings in early Christian catacombs, a catacomb such as that of Domitilla may have several representations of the Healing of the Blind. The location on the catacomb wall or on the front panel of a Christian sarcophagus where the Healing of the Blind is represented is also significant. It is the site that ensures better visibility in an environment where decorations are not easily perceived. But the location in itself indicates that the scene has a central symbolic meaning. Obviously the Healing of the Blind had a particular appeal for early Christian audiences.

In the original Hebrew Bible, or the Old Testament in Christian terminology, the restoring of sight to the blind is perceived as the ultimate miracle, an event that goes beyond what is thinkable in the terrestrial world and in our present life. So utterly utopian appeared the healing of the blind that it was understood as a distinctive mark of the messianic age. "And in that day," says Isaiah, "shall the deaf hear the words of the book, and the eyes of the blind shall see out of obscurity, and out of darkness" (Isaiah 29:18). Later, when the prophet describes that utopian state of bliss, he says: "Then the eyes of the blind shall be opened" (35:5). The transplantation of healing the blind into the messianic age may perhaps help us understand that the returning of sight to those who have lost it plays only a minor role in the Old Testament narratives.

As in the Hebrew Bible, in the culture of the late stages of the Hellenistic age, especially in Near Eastern countries, the healing of the blind remained an utterly miraculous act, even though it was perhaps more common in the imagination of the time. Eloquent testimony to this development of beliefs may be found in the Book of Tobit, a charming piece of religious fiction. In this apocryphal story, composed as early as the second century B.C., the whole narrative is framed by the action undertaken in order to return eyesight to a blind old man. As we know, in Tobit the miraculous healing is achieved by seemingly "natural" means, by sprinkling a medication made of the gall and liver of a fish on Tobit's eyes. The natural components of the medication, however, do not diminish the mysterious, miraculous nature of the event. The knowledge that these particular substances will have a healing effect is revealed to Tobit's son by an angel. Whatever else the story of Tobit may attest to, it shows that by the time it was composed the healing of the blind was no longer perceived as so utterly utopian that even as a miracle it could not be imagined as taking place.

No other apocryphal text presents the healing of a blind person in such explicit, narrative way as the Book of Tobit. But implicit evocations of the same miracle are also found in other apocryphal writings, though sometimes put in a negative form. Thus in what is known as the "Letter of Jeremiah," now a part of the apocryphal Book of Baruch,[5] it is said of the idols against whom the prophet preaches that

"They cannot save a man from death, nor rescue the weak from the strong. They cannot restore a blind man's sight, they cannot deliver a man who is in distress" (6:35–36). Such statements show, even if they do not explicitly state, that the restoring of sight to a blind man, though it remains miraculous, was considered feasible within the reality of our present world. The healing of the blind does not have to be postponed till the Messianic age.

In the pagan traditions of antiquity, especially in the later stages of the period, the idea of healing the blind arises in various forms. Thus it is explicitly told of Isis, one of the divine figures endowed with healing powers, that she restored sight to the blind. Many sick people came to her shrine to seek relief, and among them, Diodorus Siculus relates, those "who have been despaired of by their physicians because of the difficult nature of their malady [and] are restored to health by her [Isis], while numbers who have altogether lost the use of their eyes or of some other parts of their body, whenever they turn for help to this goddess are restored to their previous condition."[6]

The belief in the supernatural healing powers with which some elect people are endowed, however vaguely this endowing may be defined, also includes the restoration of sight to those who have lost it. The ruler in whom a god has invested his powers can perform the miracle of healing the blind. Tacitus tells that Vespasian, in the presence of a crowd, healed the eyes of a blind man by moistening them with his spittle.[7]

Less miraculous ways of restoring sight to the blind were also sought. To adduce a single example I shall mention the belief that the serpent, as a symbolic image of sharp sight, can provide a medication for the restoring of sight. Since the serpent was believed to be able to rejuvenate its sharp eyes, and therefore symbolized the sun,[8] the substance of its body is also endowed with particular healing power.[9]

What matters in our context are not the specific details of these stories, but the very fact that the possibility of healing the blind, however slight, was perceived as something thinkable within our reality. In the New Testament the stories of the miraculous healing of the blind play a central part in manifesting Christ's supernatural powers. The methods by which he restored sight to the blind vary. Sometimes the miracle

is performed by word of mouth alone, as when Christ says to the blind man: "Go thy way; thy faith hath made thee whole" (Mark 10:46ff.). On another occasion, a bodily contact is imagined in the healing of two blind men: Christ touches their eyes, and by this touch sight is restored to them (Matt. 9:27–30). Finally, an even more material contact is reported: this time a medicine is applied to the eyes of the blind man, a mixture of spittle and clay, prepared by Christ himself (John 9:6–7). We are not concerned here with the healing methods reported. Whatever the variations, the same basic concept underlies all these stories. In our present context it is of crucial consequence that the Healing of the Blind can take place in our terrestrial world, the world of the present, not of a coming utopian age. Christ's ability to perform the miracle may carry some connotation of the Messianic age to come, but his acts of healing take place in a pre-Messianic reality.

In the visual imagery of early Christianity, as recorded in paintings and sculptures, the theme of healing the blind acquired major significance and became one of the central subjects. What the painted and carved images of the Healing of the Blind suggest does not contradict, or radically diverge from, the ideas of such miraculous healing as related in the New Testament stories. But the images emphasize one particular aspect of the motif, an aspect that is less prominent in the texts. This is the conceptual context of the miracle as well as the specific, material object on which the Healing of the Blind is represented, that endow the individual scene of restoring the sight with its specific meaning.

In early Christian art, pictorial representations of the Healing of the Blind are found in places and on objects that are highly charged, in emotion as well as in dogmatic beliefs. With a rare exception, these places and objects have an immediate connection with the service for

Christian catacomb is not a neutral space, its walls are not the unobtrusive background provided by the walls of a museum. The catacomb not only is a space highly charged with emotion, but it also provides a distinct conceptual, religious context for whatever can be seen within it. The images and objects perceived here are endowed with an articulate meaning and carry connotations that point in one direction. This emotional and religious context is the craving for salvation, or, in the formulation of Charles Rufus Morey, the "deliverance from death (*vivas in Domino*), deliverance from sin and the misery thereof (*in pace*)."[11] In a catacomb, the Healing of the Blind is not a medical action; it is not even simply a miracle. Here it necessarily acquires the connotation of salvation. The blind person to whom sight is restored is an image of the transition from bondage to salvation. In particular, the healing becomes an image of the transition from death to eternal life.

The earliest catacomb paintings representing the Healing of the Blind are found in Rome, in the Catacomb of Domitilla (fig. 10). The painting is lost, but we know it from a line drawing made by a scholar who saw it. Another representation is found in the Catacomb of Peter and Marcellinus. The paintings in both catacombs were done in the late third century.[12] These images give us an idea how the Healing of the Blind was seen in early Christian imaginings, and what connotations were evoked by the scene. In both paintings, the healing Christ physically touches the eyes of the blind man. In the Catacomb of Domitilla he does so with the index finger of his right hand; in the Catacomb of Peter and Marcellinus, with his whole hand. In both paintings the blind man kneels before Christ. It is worth mentioning that in the text of the Gospels it is not suggested that the blind whom Christ healed knelt before him.[13] In the mental imagery of late antiquity however kneeling carried a definite meaning of submission to

and they played an important part in the mental and depicted images of early Christianity. Here the Orant figures had the particular connotation of afterlife. We can thus easily reconstitute in our mind how third- and fourth-century audiences visiting Christian catacombs understood the scene of the Healing of the Blind.

To grasp an early Christian spectator's understanding of a representation of the Healing of the Blind we should also recall that throughout antiquity the hand was known as a healing agent; it alleviated pain. Probably the best formulation of this belief was the "mellow hand" that reduced the pains of childbirth.[14] But in general the hand, particularly the touching hand, was considered throughout antiquity as healing severe illness and distress. One recalls the lines in Aeschylus's *Prometheus Bound* spoken to Io, who suffers madness (846–50):

> There is a city, furthest in the world,
>> Canobos, near the mouth and issuing point
>> of the Nile: there Zeus shall make you
>>> sound of mind
>> touching you with a hand that brings no
>>>> fear
>> and through that touch alone shall come
>>>>> your healing.

The miracle-working power of the healing hand is not restricted to Zeus. It is best known of Asclepius. Where a mortal physician depends on surgery, Asclepius heals by the mere movement of his hand. Such beliefs are specifically attested for the blind. Thus a blind man dreamt that Asclepius appeared to him and with his fingers opened his eyes. The next morning he got up, having his eyesight fully restored.[15] This kind of miracle penetrated into Christian imagination. St. Eligius healed a blind woman by the mere movement of his hand.[16] Gregory of Tours tells of a girl punished by being blinded who regained her eyesight in a similar way.[17]

In representing the bodily contact between the healer and the healed, focused in the gesture of Christ touching the eyes of the blind, artists also created a powerful pictorial device that guides the specta-

tor's attention to the central point. It is both the eye of the blind and the point where the divine and the human meet.

This compositional pattern—Christ touching the eye of the blind—was retained for centuries and was employed in both static, emblematic images and dynamic, narrative representations. A good example of the first category is an early-fourth-century sarcophagus, produced in Rome ca. 315. Here Christ healing the blind is placed between two symbolic scenes that have no narrative connection with the miracle portrayed: the Adoration of the Magi to the left and Daniel in the Lions' Den to the right. The blind person being healed is a small figure (fig. 11). Christ touches his eye, and this action is the center of the narrative. It is hard to say, though, whether he does so with his index finger only or with two fingers.[18] If two fingers are shown stretched out, the artist may have combined two actions—the pointing or touching as well as the blessing. In the representation of Christ healing the blind in a mosaic in S. Apollinare Nuovo, the blind man is as tall as Christ himself, he stands upright, holding in his hand the staff that identifies him as blind. That he wears a priest's garment may perhaps indicate that the healing is an opening of the blind one's eyes to the "true belief" that is Christianity.[19]

As an example of the narrative tradition we may look at an early-sixth-century Syrian manuscript illumination representing Christ healing two blind men.[20] The dynamic liveliness of the movement in this illumination is rarely matched in the art of the time. Two groups—Christ and his followers on the one side, the two blind men on the other—move toward each other energetically. They meet where Christ's hand, index finger outstretched, touches the eye of one of the blind men. Similar in movement, but with a great many narrative details, is the representation of the same scene in the famous Codex of Rossano, of the late sixth century.[21] Here, too, Christ touches the eye of the man born blind (or perhaps covers it with the medication he has prepared, according to John 9:6–7).

A discussion of the history and the typological ramification of the Healing of the Blind in early Christian art would go beyond the scope of the present study. We are here concerned with a different question.

It is obvious that the Healing of the Blind was one of the central scenes in early Christian art, and the original audiences, the early Christian believers, may have understood this intuitively. The modern student, however, must ask what the reasons were for the forceful emergence of the scene, and what made it one of the core mental images of Christianity in the early period of its crystallization. A change in the central imagery of a great religious movement cannot be an isolated phenomenon. It necessarily grows from profound, if hidden, roots of the new belief, and sometimes it reflects the character of the new religion more sharply than both patrons and artists consciously intended, or even were aware of. What, then, was it that produced, and was reflected in, the theme of the blind miraculously healed by the redeemer?

Some aspects both of the religions of salvation, that is, religions that make salvation of the individual soul and of mankind the centerpiece of their message,[22] and of the connotations of blindness should here be recalled, even if only in broad outline. First, it is a characteristic feature of all religions of salvation that they are fascinated with sudden change, with an unprepared (or seemingly unprepared) radical inversion. Such changes play a central part in their spiritual world. Moreover, these abrupt changes are usually polar inversions, an instant move from the condition of deepest distress to that of highest bliss. In these religions, we should keep in mind, salvation was never imagined as a continuous process, a gradual liberation from the suffering from which one longed to be redeemed. On the contrary, redemption has always been viewed as a sudden event, unprepared and precisely for this reason also miraculous. In Christianity this particular character of salvation becomes markedly manifest. The most radical inversion imaginable, the revival of the dead, became a central dogma in Christian belief, and for centuries it also remained a central theme in Christian art. In its sheer improbability, the miracle of healing the blind, of giving back sight to those who have lost it, has a certain affinity to the ultimate miracle of the revival of the dead. Because of this polar inversion, one understands how Christianity, totally oriented toward redemption, was mentally and emotionally prepared to make the healing of the blind a central image.

The other aspect that should be considered here has something to

do with the symbolic nature of blindness and seeing. In the writings of the Fathers of the Early Church, both Greek and Latin, the state of a person (whether Jewish or gentile) before his or her conversion is described as a condition of blindness and darkness; the state after the conversion is one of seeing and light. A single witness to this use of the terms will suffice. An important thinker of the early Latin Church, Tertullian, opens his short treatise *On Baptism* with a sentence about the "happy sacrament" of baptism, and says that its water washes away from us "the faults of the former blindness" and makes us free for the eternal life.[23]

In the language of metaphors that prevailed in the early Christian world the terms "blindness" and "darkness" (and often also "ignorance") are frequently considered as synonyms and are used interchangeably. These metaphors describe the nature of a believer's life before his conversion. Conversion is an illumination. Already in the New Testament, the act of conversion to Christianity is described as an enlightening (Heb. 6:4), and from this it naturally follows that our life preceding conversion was spent in ignorance, darkness, and blindness. The sins committed before our conversion, that is, before the moment of true "illumination," while we still lived in "darkness" and "blindness," are more easily forgiven than those committed after our minds have been illumined. These metaphors, making blindness a hallmark of false beliefs, were widely known and applied; they were also common in the thought and language of the various regions and trends of Christianity in late antiquity. Christian audiences in both the eastern and western part of the Roman Empire were familiar with these mental pictures and with the connotations they evoked.

These connotations, of course, also shaped the meaning of the Healing of the Blind and the way Christian audiences understood representations of the scene and reacted to them. The Healing of the Blind is not only an image of salvation from darkness to light; it is also specifically the message that conversion to Christianity, the religion of salvation, assures redemption, bliss, and eternal life. It is these connotations that explain the emergence and significance of the scene in early Christian imagery.

Blindness and Revelation: The Story of Paul

The other specific theme within the scope of our subject that arose in the early Christian mind, achieved particular significance in the religious imagination of the period, and had a long and rich afterlife is the temporary blindness of a mortal human being who has experienced a divine revelation. To be sure, in the canonic history of the early Christian religion, temporary blindness is not a common theme. In fact, it is a unique event, an occurrence that happened only once in the spiritual life of a single figure. This figure, however, was Paul, and in the New Testament his temporary blindness is presented as a crucial turning point in his life story and the history of the early Christian world. Echoes of what is told about this singular event in the New Testament reverberate throughout the history of the Christian church. In the following comments we shall consider the story of Paul's temporary blindness as the manifestation of a different, rare yet essential, interpretation of what blindness could mean. We shall ask two questions. First, what was the nature and meaning of Paul's temporary blindness, as it emerges from the New Testament? Second, how was the original story of Paul's temporary blindness received in the early Christian world, and how did it shape the image of blindness in this and the later stages of our history? We shall first briefly review what the sources relate about this crucial and miraculous event.

The canonical record of Paul's conversion, including the episode of his blindness, is found in The Acts of the Apostles. In The Acts themselves the event is reported in three different versions. The first version (Acts 9:1–9) is related by the author of The Acts, traditionally identified as Luke the Evangelist; the second version is found in Paul's address to the court by which he was tried (Acts 22:6–11); the third is contained in Paul's address to King Agrippa (Acts 26:13–18). In considering these versions we shall disregard the problems of exegesis raised by ancient and modern theological commentators. While these exegeses are often of great interest, they contribute little to our understanding of what blindness meant, and how the blind were imagined, in the mind and world of late antiquity and the early Christian religion.

As we remember, Paul's (then still Saul) conversion occurred while he was traveling to Damascus. He was "breathing out threatenings and slaughter against the disciples of the Lord" (9:1), i.e., the people who joined the new Christian faith. He was going to Damascus intending to further persecute the Christians. "And as he journeyed, he came near Damascus: and suddenly there shined round about him a light from heaven: and he fell to the earth, and heard a voice saying unto him, Saul, Saul, why persecutest thou me?" (9:3–4). It was Christ's voice, and it caused the conversion of Paul.

In all the versions the divine appearance is not understood as a subjective, purely personal, experience, a vision or a hallucination of Paul alone. Already in the first version Paul's companions on the journey also experience the event.[24] "And the men which journeyed with him stood speechless, hearing a voice, but seeing no man" (9:7). Since all the travelers, not only Paul, witness the appearance, the event is not merely "psychological." It is interesting, however, that while they heard the voice and wondered that they did not see a speaker, they apparently did not see the light. Yet for Paul the light had a distinctive, physically tangible effect; it struck him to the ground: "and suddenly there shined round about him a light from heaven: And he fell to the earth" (9:3–4). After arising from the ground, he is blind. "And Saul arose from the earth; and when his eyes were opened, he could not see: but they led him by the hand, and brought him into Damascus. And he was three days without sight, and neither did eat nor drink" (9:8–9).[25]

In the second version the traveling companions also see the light, but they do not hear the voice (Acts 22:9). In seeing the light there is a subtle but important difference between Paul and the other travelers. The light must have appeared to them in different intensities. The companions also see the light, but they are not blinded. It is only Paul who remains "without sight."

In the third version, finally, the light is further emphasized. Though it is midday, the light is shining "round about" Paul. In this version, both Paul and the other traveling companions fall to the ground (26:13–14). In all three versions Paul is blind for only three days after

witnessing the divine appearance. After these days of blindness, he is baptized in Damascus by Ananias and becomes the great defender of the new faith.

Restricting our attention to the apostle's blindness, two unusual features stand out and demand explanation: first, the fact that the blindness is temporary, and second, the somewhat unclear, perhaps even puzzling, relationship between the light that suddenly shone and the blindness that followed the experience.

The fact that Paul's blindness is temporary, that it lasts for only three days, bears witness to its particular nature and indicates the context in which it should be understood. This is altogether different from the context of blindness in antiquity. In contrast to what was taken for granted in antiquity, Paul's three-day blindness is not perceived as a punishment. Some modern interpreters of Scripture have noted this characteristic.[26] This is particularly significant since until the revelation of Christ, and the blindness caused by it, Paul persecuted Christian believers, and in the revelation the invisible Christ reprimands him for precisely this. Yet the three-day blindness was obviously not understood as a punishment for these sins. What, then, did Paul's blindness tell the early Christian world, and how was it seen in the following centuries?

We shall concentrate on two specific moments in the attempt to revive in our minds how early Christian audiences understood Paul's blindness. One of these moments is the specific place that the three days of blindness occupy in the spiritual development of the apostle; the other is the character—perhaps one can speak of an internal structure—of the blindness itself.

The significance of the place occupied by the temporary blindness in the narration of Paul's inner biography is evident. It clearly marks the sharp break between the two stages of his life. The earlier stage, the years devoted to the persecution of Christians, is abruptly set off from the later stage, devoted to the apostle's preaching and defending of the new faith, and finally his martyrdom.[27] In following the story of the conversion we note that the revelation of Christ remains without response from Paul before the three days of blindness have passed.

What the apostle's reaction to the theophany of Christ was we learn only when the narrator takes up his story after the pause of blindness. Immediately after the three days, when Paul regains the sight of his eyes—so we understand from the text—he converts to Christianity and begins the second half of his life. The spell of blindness, then, is the short stretch of time which separates the two parts of his life, and in this stretch the conversion actually takes place.

Blindness as the manifestation of the radical break in Paul's life carries several connotations. First, blindness is here perceived as a complete detachment from reality, both that surrounding the apostle and that of his own former life. The lack of sight can so manifestly show the break between the two periods in the apostle's life because in itself it is experienced as a pause. Nothing is intimated of what happened to Paul in those three days of blindness. There is no suggestion of pain, of remorse, or of any other emotional state or movement. Blindness is here the realization of nothingness, and therefore is fitting to stand for the total break.

Another aspect of Paul's blindness is perhaps even more important. Though it is elusive, difficult to grasp and hold, it had a lasting influence on the spiritual life of Europe. Placing it in a new context, it infuses blindness with a new meaning. In the cultures of antiquity, we recall, blindness was conceived as a stable, even a definitive, condition. The shift from blindness to seeing, from darkness to light, did not play a significant part in the imagery of Greece and Rome, if it was at all considered. Moreover, it was explicitly said that blindness cannot be changed. The blinding cannot be undone, said the goddess Athena to the mother of Teiresias. It is because blindness is so definitive that it could be seen as an embodiment of fate. All this is upset in the story of Paul's temporary blindness. Here a different reading of the condition emerges. The definitive nature of blindness is radically transformed in the story of what happened in Paul's conversion.

The total darkness that enveloped Paul for three days is, if I am not mistaken, among the earliest expressions of perceiving blindness as a condition capable of radical inversion. What appeared to classical culture of an earlier age as the epitome of static permanence is here

experienced as a moment of intrinsic tension, or rather of extreme reversal. Before his conversion, Paul has full command of his bodily eyesight, but he does not see the spiritual light. The spell of blindness brings about a dramatic inversion. The loss of his physical eyesight, even if only temporary, "opened his eyes" to the ineffable vision of divine revelation.

This chiastic, paradoxical nature of revelatory blindness, as it may be called, has a profound affinity with the interdependence of light and darkness, a theme that haunted medieval thought and imagery. We may here invoke a later thinker, who however continues the line of thought we have seen in Paul. He is John Scottus Eriugena, one of the most profound and daring writers of the early Middle Ages. Because God is an "ineffable light ever present to the intellectual eyes of all and known to no intellect as to what it is," John speaks of a "supernatural sunset" into the "darkness of incomprehensible and inaccessible light in which the causes of all things are hidden."[28]

The metaphysical interpretation of light is not our concern here. I should only emphasize the tendency to sudden inversions, to polar reversals, that are a characteristic feature of the theological tradition that developed this interpretation. These conceptual attitudes, for example those typical of the "negative theology,"[29] also gave blindness a new meaning.

In The Acts it is not explicitly said that the light seen by Paul was the cause of his blindness, though the sequence of the sentences—one speaking of the light, the next of his blindness—strongly suggests such a causal relation. In the imagination of the period, however, the fantasy of a dazzling light bringing about temporary blindness was common. I shall mention an example from the *Corpus Hermeticum.* Here Hermes Trismegistus is made to say: "You have filled us with a vision, father, which is good and very beautiful, and my mind's eye is almost (blinded) in such a vision." And a few sentences later: "We are not yet strong enough to open our mind's eyes and look at the incorruptible, incomprehensible beauty of that good."[30] This is very close to Paul's famous saying: "For now we see through a glass, darkly; but then face to face" (1 Cor. 13:12). The dazzling light that causes blindness, or our

seeing through a dark glass before the day of salvation, is part of the mental imagery linking blindness to redemption.

Where can we experience such dazzling light that causes temporary blindness? To the public in late antiquity the paradoxical metaphor of light and darkness, of seeing and blindness, may not have sounded so strange as it does to modern ears. In the spiritual climate of the period, both in its intellectual and emotional dimensions, such inversions were not unknown. It will be enough here to mention Philo's concept of "sober drunkenness."[31] Such chiastic inversions are found in states of rapture and ecstatic experiences. In suggesting these states Paul's language is full of striking contrasts, of astounding oppositions. It is in such a context that he employs the paradoxical metaphors of seeing and blindness. These images of sensory experience must have evoked intense reactions. Rapture was perceived, first of all, as a state in which connections with the outside world are cut off. The ecstatic is "outside himself." He does not experience the world surrounding him, and he is detached from his own regular self. The ecstatic's isolation could assume various forms, one of them being madness. Among the best-known motifs of ecstatic imagery is the God-inspired prophet who is considered "mad" because he is beyond or outside contact with his environment and his self. Blindness has something of this nature. It is a striking manifestation of being cut off from one's regular world. In being an embodiment of nothingness it is also a negation of one's self.

Paul himself suggests the connection between ecstatic experience and vision of the ineffable: "It is not expedient for me doubtless to glory. I will come to visions and revelations of the Lord. I knew a man in Christ . . . (whether in the body, I cannot tell; or whether out of the body, I cannot tell: God knoweth;) such an one caught up to the third heaven. . . . How that he was caught up into paradise, and heard unspeakable words, which it is not lawful for a man to utter" (2 Cor. 12:1–4).

In his descriptions of the visions perceived in an ecstatic state Paul also employs metaphors derived from, or referring to, visual experience. Here we also find such inversions from light to darkness and from blindness to vision. Again a single quotation will suffice. "While

we look not at the things which are seen, but at the things which are not seen: for the things which are seen are temporal; but the things which are not seen are eternal" (2 Cor. 4:18). To suggest the profound difference between our experience of God at the present age and in the Messianic age, he uses the bold visual metaphor we have already quoted: "For now we see through a glass, darkly; but then face to face" (1 Cor. 13:12).

Keeping in mind what we have tried to sketch in broad outline, we may assume that an early Christian reader would understand Paul's temporary blindness on the road to Damascus as part of an ecstatic experience.

Do works of the visual arts tell us more about how people in late antiquity and in the early Middle Ages imagined what happened during Paul's blindness? In looking for an answer, one notes, first, how rare the pictorial representations of Paul's conversion are in early Christian art. To be sure, Paul's image is not missing in early Christian iconography. In fact, he is quite often depicted, both as a "portrait" and in the visual narration of certain scenes in his life. By the mid- or late fourth century, Paul's physiognomic type, with his characteristic bald skull and long beard, was fully articulated and was handed down as a firmly established image. Look, for instance, at the bronze medals in the Museo Sacro in the Vatican, with the distinct profiles of Peter and Paul carved without hesitation.[32]

Already in A.D. 359 we find the same type of Paul in one of the most famous works of early Christian art, the sarcophagus of Junius Bassus in the Vatican. Here a narrative scene, the stage in the apostle's martyrdom known as the Judgment of Paul, is represented. It is one of the early narrative renderings of Paul's life. It is characteristic, however, that this is the scene of judgment, the stage before the execution of martyrdom, and not the conversion. The "judgment"—the trial before a Roman judge—is actually told of almost every Christian martyr, and is thus a very common image. It calls for reflection that the conversion, the event unique to Paul and one that must have stood out in legends and stories, is not shown. But neither is it in the other early narrative depictions of the apostle's life. One wonders whether this early reti-

cence to show the episode of his blindness is not derived from the same hesitation to show "the ineffable" that prevented writers from conjuring up in their minds what the apostle saw during his ecstasis.

By the sixth century, however, a multifigure, perhaps a multiscene, representation of Paul's conversion may already have existed. The original, probably an illuminated manuscript, is now lost, but we have reflections of it in other illuminated manuscripts, primarily of the *Christian Topography* of Cosmas Indicopleustes. This work, composed in mid-sixth century, probably in Egypt, is a strange combination of legendary geography, cosmological theology, and a travel book.[33] Two early copies, one in the Vatican Library and the other in St. Catherine's Monastery on Mount Sinai, contain representations of St. Paul's conversion. The two manuscripts are relatively late—the Vatican manuscript is of the ninth century, the Sinai manuscript of the twelfth—but the illustrations, especially of our scene, largely agree, and probably go back to a common source. Though the text does not mention the story of Paul's conversion, the artists who made the illuminations showed a detailed narrative of the event.[34] It has therefore been assumed that this Cosmas miniature is a copy from a (lost) illuminated manuscript of The Acts of the Apostles.[35]

In both manuscripts the image is composed of several scenes. From left to right they are: (1) Paul receives from the priests in Jerusalem a letter of introduction to the synagogue of Damascus; (2) Paul is struck by the light; (3) Paul is fallen to the ground; and (4) the blind Paul is led by a companion to Damascus. What do these detailed images tell us about how the apostle's blindness was imagined when this series of illuminations was created?

Carefully looking at the images in the *Christian Topography* with our question in mind, we arrive at some interesting assumptions. These inferences, even if not conclusive, should be taken into account. First, it becomes manifest that early Christian art did not have a distinct and articulate formula for depicting Paul's blindness. In the representation of our scene, even in the sixth century, artists still completely relied on the models and patterns inherited from classical antiquity. The figure of the apostle fallen to the ground is cast in the well-known formula of

proskynesis, the posture of adoration that originated, and was mainly employed, in the political iconography of late antiquity and of the Byzantine era. The other scene, the blind apostle led by a companion to Damascus, repeats the antique formula of the blind man led by one with unharmed eyesight. Instead of a young boy leading Teiresias, as we saw in the preceding chapter, it is here the traveling companions who lead the blind apostle into the city. These borrowings show that even by the sixth century, that is by the end of the early Christian world, artists had not shaped an original formula for the depiction of blindness, and particularly of Paul's temporary loss of sight.

Another tentative conclusion is that Paul's conversion, and especially his blindness, were completely reinterpreted, at least by the sixth century and among those who made, and inspired, the original cycle from which the miniatures of the *Christian Topography* are derived. In the moment of blindness the apostle is shown as a figure in the posture of *proskynesis*. This posture, as just noted, originated in the domain of political imagery, and it had a fully distinct meaning. What it conveyed was submission, unconditional acceptance of the emperor's or king's rule.[36] This meaning of the posture was so profoundly ingrained in the consciousness of many centuries that no artist, patron, or audience could disregard it. Both at the time the original (lost) cycle of illuminations was created and when it was copied in the manuscripts of the *Christian Topography*, everybody must have been aware of what the posture conveyed. Representing the blinded apostle in this particular posture became a new interpretation of the scene: Paul's blindness was no longer an image of his rapture; it became a visual proclamation of his acknowledging the supremacy and rule of Christ.

A Concluding Observation

In our brief discussion of the two specific themes, the Healing of the Blind and Paul's temporary blindness, we have been concerned only with what can be learned from them about the early Christian attitude to blindness. We can conclude that, while the inherited view of blindness as punishment did not disappear, some new elements of

understanding the condition emerged. Both by making blindness a temporary condition, that is, one from which one can be redeemed, and by making it a feature in the experience of rapture, of a supernatural vision, a new context of interpretation was established. Was this a lasting context? Did the new interpretation become a permanent feature of religious and artistic culture? As we shall see in the next chapter, in the Middle Ages much of the new interpretation was replaced by other views.

In the centuries of early Christianity, we used to believe, the fundamental suppositions of the spiritual world of the Western Middle Ages were formulated, and the basic attitudes that were to prevail for a long time were firmly established. What is characteristic of the intellectual developments of the Middle Ages themselves, we were often tempted to think, was largely the unfolding of what was already there, even if in a concise shape, in the early Christian mind. The historian of ideas and imagery, however, soon discovers that medieval culture often profoundly deviated from the attitudes that informed the first cen-

3
The Middle Ages

turies of the Christian era, and that it created altogether new shapes and images for which no model is found in the early Christian world. Few issues allow us to see this so sharply as the medieval attitude toward the blind, the explanation of blindness, and mainly the distinction between different types of blind figures. Next I shall argue that the differentiation of blind figures into a few distinct, hierarchically arranged types was the original contribution of medieval culture. Previous ages, it seems, did not bequeath to the Middle Ages any models for either the typology or/and the division into upper and lower classes. These were the outcome of the specific intellectual and emotional conditions that crystallized in the course of that period.

In the endeavors that ultimately led to the articulation of the types and their classification on levels of value, mythical images and the immediate experience of the physical and social environment coexisted, and partly merged with each other. For a long time the mythical and symbolic models dominated in the mental and artistic imagery of the Middle Ages. In the earlier stages of this period, even immediately

perceived reality had to be adjusted to conceptual patterns. It was only in the latter part of the Middle Ages that everyday reality came into its own as an important mental and artistic subject. We shall therefore begin the present chapter by discussing some central mythical figures that are, in a more or less immediate way, pertinent to the subject of blindness. Only after outlining some such figures shall we come to the way medieval culture perceived, and shaped in the mind, the actual blind person, as he or she could be seen as part of the physical and social world.[1]

The Antichrist

The first mythical figure we shall consider is that of the Antichrist. Though the Antichrist was never imagined as totally blind, his personage sheds light on what blindness meant to the medieval mind. In the following comments I will focus only on those aspects of the Antichrist that have an immediate bearing on blindness.

In the world of ideas of the period here considered the Antichrist was the embodiment of ultimate, apocalyptic evil. In the course of many centuries, the Antichrist has been interpreted in different ways. Some of the great teachers of theology have argued for certain specific explanations of this fearful figure. Some have seen him as human, others as the demon incarnate, as the "Son of perdition," or as a fallen angel. We need not go into these discussions, interesting as they may be. For our present purpose it will be sufficient to say that, whatever specific interpretation of the Antichrist myth was offered, in the Middle Ages he was basically perceived as the incarnation of radical evil. Some particular aspects of evil, however, are of special concern for us. As we shall shortly see, they have a unique significance in the forming of the Antichrist image, whether only in the mind or in actual description and depiction. A few words about the legend and image of the Antichrist in general may be useful.[2]

The origins of the Antichrist legend, modern scholars have shown, are found already in the Old Testament. Some students would assume that in the Song of the Sea (Exod. 15:1–18), one of the very early lay-

ers in the original Bible, motifs of mythical combat are to be found, which later contributed to the formation of the Antichrist legend.[3] In the Psalms and Isaiah other elements are found.[4] In the late parts of the Old Testament, mainly in Job and Daniel, the outlines of this satanic figure's character are more clearly articulated, and some of his acts described. The aspects prominent in these texts are Satan's contempt of God and his rebellion against the divine rule.

Christianity, both early and medieval, added new dimensions to the Antichrist image. While the Old Testament texts stress mainly blasphemy and rebellion against God as characteristic of the great enemy's character and actions, other layers are introduced in the early Christian sources. There was not only one, a single type of Antichrist; the great antagonist of God was imagined in various figurations. At the time, these various types were not neatly separated from each other, but looking back from a present-day vantage point we can make out clearly that emphasis was placed on different aspects of the figure, on different components of his nature. The Antichrist's properties most commonly emphasized in early Christian times are violence and cruelty. He is the evil tyrant, the wild beast, the bloodthirsty persecutor. However, there are also versions of the Antichrist legend in which other character traits were emphasized, primarily deceptiveness and hypocrisy. It is the hypocritical and deceptive type of Antichrist with which we are here concerned.

These specific characteristics are already adumbrated in the earliest stages of the Christian imagination. The New Testament as well as some other early Christian sources stress that the Antichrist, the great adversary of God, is a *subversive* enemy. The properties of his character and behavior emphasized in the earliest texts are secrecy and deception. The crucial formulation of this view is found in 2 Thess. 2:1–12. I shall quote some of the phrases that indicate this particular characteristic:

> Let no man deceive you by any means: for that day shall not come, except there come a falling away first, and that man of sin be revealed, the son of perdition;

Who opposeth and exalteth himself above all that is called
God, . . . sitteth in the temple of God, shewing himself that he is
God. . . .

For the mystery of iniquity doth already work: only he who now
letteth will let, until he be taken out of the way.

And then shall that Wicked be revealed, whom the Lord shall
consume with the spirit of his mouth, and shall destroy with the
brightness of his coming:

Even him, whose coming is after the working of Satan with all
power and signs and lying wonders,

And with all deceivableness of unrighteousness in them that
perish; . . .

And for this cause God shall send them strong delusion, that
they should believe a lie.

Note the cluster of descriptive phrases: the "mystery (*mysterion*) of
wickedness" that is secretly already at work; the "deceivableness of
unrighteousness," the "strong delusion," and the ability to make one
believe in "a lie"—all these characterizations point in one direction.
They combine to form a frightening image of a subversive power in
this world.

The emphasis on this particular aspect of the Antichrist's nature, on
his secret wickedness and his ability to deceive, had a strong lease on
life. It was echoed in Christian writings for centuries. The Antichrist
biography found in the text of the "Sybilla Tiburtina," compiled in the
fourth century, emphasizes the double nature of that great enemy as
political ruler and deceptive miracle healer. Using magic, he performs
miracles by which he deludes and misleads believers.[5] Deception is not
the only vicious feature of the Antichrist. He is also described as cruel

Church, was probably the first to dwell on the subject of the Antichrist. In his discussion of the "false prophets," he speaks of, and against, the "human Antichrist." How is it, he wonders, that the Antichrist behaves as if he were an ardent follower of Christ?[6] It is the Antichrist's deceptive nature that alarms him. In another treatise, dealing with heresies of different kinds, he conjures up the fear inspired by the double nature of the Antichrist; he even speaks of Antichrists, in the plural. Beneath the sheepskin there hide predatory wolves.[7] Hypocrisy and false, misleading appearance, then, are the dominant qualities of the great enemy.

Few thinkers had such a profound influence on western thinking about the Antichrist as Gregory the Great. Writing in a period of great crisis and confusion (he lived through the final stage of the Roman Empire's collapse, at least in the West), the Antichrist was a matter of great significance to him. His views on the subject are to be found mainly in his massive *summa* of Christian spirituality, the *Moral Interpretations on Job* (*Moralia in Job*). Offering a typological interpretation of Christ, he juxtaposes the Redeemer to the Antichrist. The type of Christ, Job, signifies the patient and humble suffering that leads us to God. What is characteristic of the Antichrist is his deceitful appearance. He is "the head of all hypocrites . . . who feign holiness to lead us to sinfulness."[8] It is evident that hypocrisy and deception, even more than cruelty and ruthless brutality, are characteristic qualities of the Antichrist's nature, and of his appearance and actions in the world. Gregory continues the line of thought, already formulated by Origen,[9] that what the true Christ will do upon his return is to destroy "the Lie" that is the Antichrist.

Here we reach a question that is close to our specific concern. How was one to visually imagine the Antichrist's false nature? One intu-

inner nature. How, then, can the Antichrist as hypocrite and deceiver be envisaged? It is because of this question that we come to consider the Antichrist in a study of images of blindness.

The danger of being deceived and misled by the Antichrist was a grave and real threat to Christian believers. The first manual of church discipline, the so called *Didache*, composed early in the second century, speaks of Antichrist as of the "seducer of the world," who appears as the Son of God and, by using magic, performs miracles.[10] Expressions of the apprehension of being deluded by the Christ-like appearance of the Antichrist continue to appear in the early centuries of our era. How can a true believer be certain that the redeemer who appears to him is Christ, and not his counterfeit? The question must often have arisen in the mind of Christians, and must have disturbed them.

To give an example I shall quote the text known as the *Apocalypse of Elijah*, written in the late third century. "The Lawless One," we here read, "will do the things which the Christ did," except for raising the dead. But how can you know, in regular conditions, that he is not the real Christ? Here is what this Apocalypse says:

> He [the Antichrist] is a small pelec [a word of uncertain meaning], thin legged, tall, with a tuft of gray hair on his forehead, which is bald, while his eyebrows reach to his ears, and there is a leprous spot on the front of his hands. He will transform himself in the presence of those who see him: at one time he will be a young boy but at another time he will be an old man. He will transform himself in every sign, but the sign of his head he will not be able to change.[11]

It was for reasons of safety that people looked for distinct, permanent, and reliable signs on which they could depend. The most certain, an altogether indelible, sign, they believed, was a physiognomic mark, branded into the very structure of the Antichrist's body or face. They therefore looked for signs, perhaps small in themselves, that could not be changed, and would thus give away the Antichrist's true identity. No wonder, then, that in the medieval centuries there was a lively interest in the Antichrist's face. It is here that we have to pay attention to what is said about his eyes.

A textual tradition, carried on for many centuries and recorded in some apocryphal writings, described the irregularities and asymmetries of the Antichrist's face and body. These asymmetries culminate in the shape and appearance of his eyes, as a few examples will show. We begin with the Syriac *Testament of the Lord*. In its present form this text dates to the fifth century, but its apocalyptic section is based on a third century Greek original.[12] After describing the signs of the end, the author tells his readers what the Antichrist looks like: "And these are the signs of him: his head is a fiery flame: his right eye shot with blood, his left eye blue-black and he has two pupils. His eyelashes are white; and his lower lip is large; but his right thigh slender; his feet broad, his great toe [or finger?] is bruised and flat. This is the sickle of desolation."[13]

This description is not altogether new; certain elements of it are found in earlier, mainly Roman texts. None other than Pliny knew of people with two pupils in each eye. It is worth keeping in mind that in Pliny's view (or according to what his informants believed) these people are of a threatening and uncanny nature. They "have the power of fascination with the eyes, and can even kill those on whom they fix their gaze for any length of time, more especially if their look denotes anger."[14] In Scythia some people have a double pupil in one eye, and in the other the figure of a horse.

The tradition of the Antichrist's irregular eyes lived on in the Middle Ages. At the end of the nineteenth century Bousset pointed out a similar motif in a Jewish source. In the Midrash va-Yosha, possibly of the tenth century, it is said of the Antimessia that "He shall be bald-headed, with a small and a large eye . . . on his brow shall be a scab, his right ear stopped, but the other open."[15] An early Irish Apocalypse of roughly the same time (late tenth century) describes the body and face of the Antichrist. Among other features it is here suggested that "He will have black hair pulled up like an iron chain. In his forehead he will have one eye shining like the dawn."[16] Though nothing is said about the other eye, one feels that it lacks the qualities of the shining one.

The image of the Antichrist with asymmetrical eyes was obviously widely distributed. But what did it say to medieval readers, listeners, and spectators? We should distinguish, I believe, between two elements

in the descriptions: one is the general asymmetry and irregularity of the Antichrist's body and face, the other is the specific irregularity of his two eyes. We do not have any direct explication, composed in the Middle Ages, of this strange image. Nevertheless, we can at least surmise how medieval audiences perceived it.

The overall asymmetry and deformation of the Antichrist's figure were obviously understood as the bodily manifestation of his evil character. It is the general physiognomic approach. But we also see here a new and specific version of the old attitude to the crippled and maimed as impure.

What is important for our present subject is the other striking asymmetry, the irregularity of the two eyes. The difference between the two eyes suggests, first of all, the deceptiveness in the Antichrist's appearance. Though the shining eye may be attractive, in fact the Antichrist's gaze is not altogether radiant. If he turns his head, you will see a small dark eye, and the agreeable appearance will be belied. Now, does the small, dark eye convey an additional message? So far as I know, no medieval text explicitly states that the Antichrist's small, dark eye is blind. Yet its reduced size and dark color may suggest blindness, especially when compared to the other, the large and radiant, eye. This, in any case, is how visual artists understood the mental image of the Antichrist's eyes. We now turn to the testimony presented by works of art. Once again, I shall discuss only a few examples. But these, I believe, document an attitude and a mental image that had a powerful hold on medieval imagination.

By the end of the eighth century, in northwestern Christian Spain, in the province of Asturia that was still threatened by Muslim invasion, the monk Beatus of Liebana, for many years teacher of the queen, composed his comprehensive commentary on Revelation. Feeling that the end of the world was drawing near, he described the cosmic events and the figures taking part in them, including the Antichrist. His commentary, widespread and often illuminated, contains the earliest images of the Antichrist in the visual arts.

Probably the first shape in which the Antichrist was imagined was that of a king. It was the archenemy's magic power, his seemingly

unlimited rule, that was feared, and this may have led to imagining him in the guise of a king.[17] Perhaps the earliest illuminated Beatus manuscript that has come down to us is the manuscript in the Pierpont Morgan Library, Ms. 644, in New York, that was done around the middle of the tenth century. Here the Antichrist is represented as a king, seated on a throne and wearing the royal insignia. In this illumination his face is badly damaged, and therefore we cannot say anything definite about the size and expression of the eyes. Another Beatus manuscript, however, now in the Escorial,[18] done shortly after the first one (at the end of the tenth century), does show the irregularity in the shape and proportions of the Antichrist's eyes. Wilhelm Neuss, the scholar who gave us many insights into the image of the Antichrist, wrote: "It is remarkable in the Antichrist's image that his right eye— only this one can be seen—is moved forward and is unwieldily large." He explains this irregular shape by the "widely held" belief in the asymmetrical eyes of the Antichrist.[19] Neuss makes a mistake in describing the large eye as the Antichrist's "right" one; in fact, it is the left.[20] The error, however, does not affect the basic observation that here the Antichrist has two dissimilar eyes.

In addition to Apocalypse manuscripts, the Antichrist was also portrayed in Psalters. In an initial in a Carolingian manuscript, the Corbie Psalter of about A.D. 800,[21] the letter Q, of Psalm 51 (Psalm 52 in the Vulgata) contains a depiction of the enthroned Antichrist (fig. 12). The Q is made of two entwined beasts, probably Behemoth and Leviathan. Interesting in the present context is the figure's posture. The Antichrist's large head is abruptly turned backward, and is seen in a sharp profile position. Only one of his eyes is visible, oversized, and strongly accentuated in color and shape. It convincingly suggests that the Antichrist is one-eyed.

Throughout late antiquity and the Middle Ages a missing limb was frequently considered a characteristic of demons. The *Testament of Solomon,* a Greek text of the gnostic period, describes a demon that has only one wing; in late antique magical literature, a devil is known who has only one breast.[22] In late antiquity the belief in a demon without a head was widespread.[23] All these different suggestions reach a climax in

the image of the one-eyed demon. In some areas and at some times it was even believed that all demons have only one eye.[24] Having only one eye, then, clearly carried demonic connotations; it evoked the sense of a satanic character. This connotation, one intuitively grasps, was appropriate to the image of the Antichrist.

One-eyedness also evokes some associations of blindness, even if only partly. One-eyed persons, who have a "bad eye," are afraid of losing their sight altogether. Such people may be endowed with magic powers. The "bad eye" may become what is known as an evil eye.[25] Showing only one eye, that is, appearing as seeing while in fact being half blind, may also be a material indication of the Antichrist's deceptive nature.

Looking at the medieval painted images we notice that in many of them the Antichrist is shown in sharp profile. Frequently the head is turned sharply backward, a stance that makes it possible to show the face in strict profile. Yet as a rule, the movement leading to this posture is not motivated by the story illustrated, nor is it required by the composition. Thus in the Corbie Psalter illumination, the seated figure of the Antichrist is seen as a whole in three-quarter view, oriented to the right, as is the throne on which he is seated (see again fig. 12). The head, however, is dramatically turned backward, and the face is displayed in profile. In this position only one eye can be seen. There is no narrative motivation for the turning of the head. To be sure, this movement lends the image great expressive power, but we must look in a different area for the motive that led to this contorted posture. In view of supporting examples, it is not exaggerated to assume that the artist chose this twisted posture to display the Antichrist's face in such a way that only one eye is visible.

Some later representations show that the model of the one-eyed Antichrist shown in profile persisted. Several images of the Antichrist occur in the Anglo-French illuminated Apocalypse manuscripts of the thirteenth century. Concentrating on the face we note mainly two types. One of them is a three-headed human tyrant, possibly a visual model to express the Antichrist's claim to be God, that is, the Trinity.[26] The other type is a regular human figure, though often the whole figure, and especially the head, are of more than normal size, perhaps an

indication that specific attention was paid to the Antichrist's head. Surveying these images one notes the tendency to avoid showing both eyes. When the second eye has to be shown, care is taken not to present the two in any symmetric arrangement.

As a final example I shall mention the fresco in the Church of Santa Maria in Porto Fuori, just outside Ravenna, representing the Last Judgment and the history of Antichrist. Painted about 1330, the fresco is now destroyed, and we know it only from old photographs. In the middle of the arch, just over the altar, the figure of Christ, the true judge, was seen seated on a throne. On Christ's right hand there was a scene of the Antichrist as tyrant, ordering the execution of the two witnesses. On Christ's left, the archangel Michael was seen slaying the enthroned Antichrist with his sword.[27] In our context it is interesting to note that, while Christ is shown frontally, displaying his full face and hence both eyes, the figures of the Antichrist, both to the right and to the left, are seen in profile, and hence show only one eye. The tradition that the Antichrist has only one eye must still have been alive in the workshops of fourteenth-century artists and in the minds of the audiences who came to church and saw the images on the walls.

The above observations, though to some extent tentative, make it possible to draw some first conclusions. For the subject of the present study, two points should be stressed. First, the notion that the Antichrist has only one eye—in other words, that he is partly blind—revives and reformulates the old belief in the intrinsic connection between blindness and evil. Second, the Antichrist, though evil and vicious, is never shown as totally blind, as is the beggar in the street. The reason for this suggestion and yet concealment of his blindness may be the fact that he is a ruler, of demons and of the demonic age. Figures of an elevated status, I shall argue, are never shown as totally blind, even if they are the embodiment of evil.

Allegorical Blindness

The Antichrist, even if he cannot be counted among the most central figures of the medieval imagination, suggests some of the original creativity

that is characteristic of the Middle Ages. The idea embodied in the figure and appearance of the Antichrist was not new. The close connection between the bodily ugly, the deformed, on the one hand, and the morally evil, on the other (the reverse of the connection between the beautiful and the good) was, of course, widespread and vigorous in antiquity. It was, however, in the Middle Ages that this link became personified, as it were, in the figure of the half-blind Antichrist. The manifest articulation of the demonic dimension of blindness, as it is shown in the Antichrist, is an original departure from traditional models, and it is a novel contribution to the subject. As we shall see, it is only one of the novel distinctions and original figurations of blindness in medieval culture and art.

A striking innovation of the Middle Ages in the understanding and representation of blindness, and in the attitude toward it, is the distinction between the blind belonging to two levels of value and dignity. The blindness of noble and heroic figures, all of them allegorical, was sharply separated from the real, normally low-class, blind person who could be seen in actual life. The divergence between these two types developed in the course of a long period, but it was mainly in the High Middle Ages that allegorical figures of an elevated status, such as the Blind Synagogue or Blind Death, grew strikingly apart from the figure of the blind beggar asking for alms in the marketplace or at a street corner. This divergence between the two types affected both the intellectual interpretation of blindness and the emotional attitude toward it. It is reflected in the specific forms in which the blind were conjured up in the mind and in the modes of describing them in literature and depicting them in art.

Next I attempt an analysis of some aspects of the medieval imagery of noble figures endowed with terrifying power and great intrinsic dignity. I begin with a specific, well-defined motif. Among the most famous themes of literature and art in the Western Middle Ages—an image rightly considered typical of medieval culture as a whole—is the juxtaposition of two allegorical figures, Ecclesia and the Synagoga. Treatises of theological thought and works of literature were devoted to it, and, perhaps in a somewhat different form, it exerted a profound

and lasting influence on the emergence of the theater play in the Middle Ages.[28] In the visual arts the subject was common for many centuries. We find it on pages of illuminated manuscripts, in the carvings of tiny ivories, on large-size stained glass windows, and, as carved monumental figures, flanking the entrance of some of the great cathedrals of the Gothic age.[29] It need hardly be said that the theme held an important place in the imagination of large audiences in the High and late Middle Ages, and continued to be a well-known topos in later periods.

Here we are concerned only with one limited aspect, actually a mere detail, of this juxtaposition, as it was imagined, described, and represented in the Middle Ages. One of the figures, that of the Synagogue, is blindfolded, while the other, the Ecclesia, has her eyes open, directing her glance either to the spectator or to her blindfold adversary. This feature is, of course, well known, and has been noted by medievalists in many fields of study. So far as I am aware, however, they have not asked what the feature may tell us about the attitude to blindness in general.

To understand what the blindfold Synagogue meant within the broad scale of blind figures, the connotations she carried in the Middle Ages should be recalled. In the medieval view of the salvation of mankind by Christ, the attitude to the Old Law was many-sided, and hence the Synagogue representing the Old Law was a complex figure. Crucial for us is that she preserved her dignity. Even when blindfold, she was not perceived as a blind, helpless creature, hesitatingly fumbling her way, and therefore evoking pity and compassion. While the Old Law did not see (was "blind to") that Christ is the light of true redemption, the Synagogue was not imagined as a mean villainous creature, crushed by her virtuous counterpart and punished by blindness. In the medieval imagination the blindfold Synagogue is a dignified, noble figure, a queen. A queen she remains even when she is seen as defeated, her rule broken, and her domain taken away from her. Rejection of the Old Law and awe before its divine origin merge in imagining the figure of its representative, the Synagogue. It is the dual, ambivalent attitude of medieval Christianity to biblical Judaism that comes to be manifest in the figure of the Synagogue. It is this complex

attitude, I shall argue, that ultimately accounts for the altogether unusual attribute of the Synagogue's blindness, the blindfold.

This attitude is clearly conveyed in the group of two juxtaposed carved figures, Ecclesia and Synagoga, that are familiar to every visitor to the great Gothic cathedrals. This pair of allegorical figures has impressed itself upon the cultural memory of the Western world. The statues may be considered the final form reached after a long history of visual juxtaposition. The Synagogue is here a standing figure, of the same size and character as the Ecclesia. Like her counterpart, the Church, she is dressed in regal garb, though her garment is sometimes less neatly ordered than that of the Ecclesia. In some rare cases it is even rent. Like the Church, the Synagogue holds in her hand a lance deco-rated with a flag, yet another symbol of rulership and dominance. Her lance, however, is broken, thus indicating that her counterpart, Eccle-sia, was victorious in their encounter. Most suggestive is the difference in posture. While the Church is fully erect, the Synagogue is bent (even if only slightly); while the head of Ecclesia is raised, that of Synagoga is inclined. In some representations both figures are imagined as crowned. But while the Church, holding her head upright, wears the crown securely, the crown is sliding down from the inclined head of the Synagogue, and has fallen to the ground.[30] However, the most striking attribute of the Synagogue figures in their "classical" (that is thirteenth-century) formulations is the blindfold that they wear over their eyes. The blindfold covering the Synagogue's eyes is a concise and yet clearly distinguishable symbol of the prevention of seeing, of blindness. In the High Middle Ages it became conventional not only for the Synagogue.

The Synagogue represents the Old Law and Judaism in general. For our purpose it is of importance to see how differently the allegorical fig-ure of the Synagogue and the figures of ordinary, living Jews were perceived. Occasionally, even in the thirteenth century, people were tempted to identify the two figures. In some medieval plays it was required that the Synagogue wear a yellow dress, the color of the Jews.[31] In some late medieval illuminated manuscripts she wears the pointed hat of the Jews,[32] or the hat is seen without her actually wearing it.[33]

In the High Middle Ages the real Jew and the allegorical figure of

the Synagogue are represented in two altogether different modes. The Jew who was the contemporary of the artists who produced the great statues was usually shown as an example of ugliness, of base character, and even of physical deformation. He could be shown pressing his mouth to the udder of a sow (as on a well known capital in the Church of Magdeburg).[34] At the same time, even in the same building, the allegorical figure of the Synagogue is presented in majestic dignity, even if defeated, and her vision obstructed by a veil or a blindfold. A striking example of this difference, in expressive mode as well as in explicit iconography, is found in the portal of the Cathedral of Bamberg of circa 1240. Here the double attitude is clearly shown. The Old Testament is the foundation of the New. This is shown by making the New Testament apostles stand on the shoulders of the Old Testament prophets. At the end of the row of figures, the Synagogue is represented as a benighted enemy, wearing the blindfold. She surmounts a group in which a devil puts out the eyes of a (contemporary) Jew (fig. 13). Both the devil and the Jew are much smaller than the Synagogue. Their movements are twisted and contorted, while those of the blindfold Synagogue, about twice the size of the figures beneath her, are restrained and harmonious. This juxtaposition of the Synagogue and the living Jew shows not only the different levels on which a figure could be perceived, but also the different modes of representing blindness. While the little Jew's eyes are cruelly scratched out, those of the Synagogue are covered with a light blindfold.

Several motifs, each with a venerable and complex history of its own, merged in the juxtaposition of the Ecclesia and the Synagogue, as we know it from thirteenth-century art. For our present discussion it will be useful to distinguish three of them: first, the very confrontation of the two personifications; second, the characterization of the Synagogue as blind; and third, the specific means of the blindfold as a form of showing the blindness.

The confrontation of the Old and the New Testaments, of Judaism and Christianity, is of course a central subject of Christian thought from its beginnings. At a rather early stage this confrontation was cast in the shape of a rhetorical dispute, carried out by personifications of

the two religions. In the medium of literature, both narrative and theological, the juxtaposition reached a fully articulate formulation in these disputes. At the beginning of this confrontation in literary form we find a text, *De altercatione Ecclesiae et Synagogae dialogus*, traditionally, though clearly wrongly, attributed to Augustine. For reasons of style and language, also because of its disregard of the rules of grammar, scholars now date this text in the period of the mass migration that marks the very end of the ancient world.[35] The text is a dispute between two women who quarrel about the right to inherit the rule over the world. The older woman, the rich widow Synagoga, clad in purple and holding a scepter in her hand, claims world dominance for herself. Her adversary, Ecclesia, also wears purple and has a crown on her head. As the bride of the Lord, she too claims world dominance. After repeated oration and counteroration, following popular rhetorical models, Synagoga finally has no further answers and is dumb.

We need not trace here the history of such confrontations as a literary genre in the Middle Ages. I should only recall that it reached a climax, in popularity as well as in polished form, in the scholastic age. In the twelfth and thirteenth centuries, when the *disputatio*, the formalized pattern of debate between two adversaries, reached a peak, the pictorial personifications of the Church and the Synagogue also attained their final form. It is at this stage that we find the common image of the blindfold Synagogue.

The second motif of our subject—the characterization of Judaism, or of the Synagogue, as blind—is a standard formula already in the New Testament. Says the apostle Paul: "For I would not, brethren, that ye should be ignorant of this mystery, lest ye should be wise in your own conceits; that blindness in part is happened to Israel, until the fulness of the Gentiles be come in" (Rom. 11:25). Sometimes the description is more attentive to details, as in 2 Cor. 4:3–4: "But if our gospel be hid, it is hid to them that are lost: In whom the god of this world hath blinded the minds of them which believe not, lest the light of the glorious gospel of Christ, who is the image of God, should shine unto them." While Israel is not explicitly mentioned in this sentence, medieval readers had no doubts as to whom the apostle had in mind.

And the same is true of 1 John 2:11: "But he that hateth his brother is in darkness, and walketh in darkness, and knoweth not whither he goeth, because that darkness hath blinded his eyes."

In patristic literature, from Tertullian and to the very end of this classic genre, it was argued time and again that Judaism is "blind." While blindness is not the only reproach made against the people of the Old Testament, it is clearly the primary and central accusation against the Old Law and the people adhering to it. To understand what the metaphor of the Synagogue's blindness conveyed to medieval audiences, we have to keep two major themes in mind. Both are medieval versions of archetypal motifs. One is the obvious fact that blindness, a crippling handicap, was perceived as a disaster. Scripture confirmed that blindness is indissolubly linked with distress. Medieval audiences—listeners, readers, and spectators—would have found their feelings approved in the sentences of Lam. 5:16–17 (with which many of them were familiar): "The crown is fallen from our head: woe unto us, that we have sinned! For this our heart is faint; for these things our eyes are dim." Dimming of eyes, then, goes together with a faint heart.

The other theme, also going back to the very beginnings of Christianity but more emphasized in the advanced stages of patristic and medieval thought, is the intertwining of obduracy and blindness as the characteristic feature of Israel. Here blindness is both the outcome and the manifestation of a moral guilt. Israel is blind by its own fault; it does not want to see the light of redemption. A significant testimony to this thought is a text written at a relatively early stage in the history of our theme. It is Augustine's *Sermon Against the Jews*. How can the Jews see the light of redemption, Augustine asks, since it was said of them "Let their eyes be darkened, that they see not"?[36] Rhetorically turning to the Jews of his own time, Augustine exclaims: "So great is your blindness that you do not see, or so inconceivable your impudence that you do not want to admit" that the redeemer has already appeared on earth. Throughout this sermon, but also in other texts by Augustine, Israel's blindness is stressed, and it is explained by a failure of collective character. It is the collective nature that here becomes the guilt. Lack of eyesight is coupled with the qualities of evil nature, and

particularly with obstinacy and refusal to see and accept the redemption of mankind.

Without attempting to trace the history of the blind Synagogue's figure in the medieval imagination, we can quite safely say that this image was common in the Middle Ages. After the twelfth and thirteenth centuries, almost everybody visiting the churches (especially in towns) would be familiar with it. Seeing, while entering a church, the image of the blindfold Synagogue, almost everybody, whether educated or illiterate, would identify and understand the figure.

All these connotations, whether fully articulated or rather suggestively expressed, combined to make a statement about the nature of blindness in general. What was this statement? Blindness, this seems to be the main point, is not so much the wages of an individual fault or sin; it is rather the manifestation of a corruption of nature and character. It is not a specific evil deed that is stressed in explaining blindness, though individual sinful acts are of course mentioned. The main reference is to the basic and unchangeable character of a figure. The Synagogue is blind primarily not because of the sins Israel has committed, but because of the very nature that prevented it from seeing the light of redemption. Contrary to the Greek attitude it is not an evil act, let alone an unintentional event, that causes blindness, but a mental and moral structure. Israel's obdurate rejection of salvation is part and parcel of an evil nature.

We now come to our final motif. How was the Synagogue's blindness visually imagined in the Middle Ages? Medieval writers and artists were, of course, aware that the Synagogue's blindness was a metaphor. They were faced with the task of translating a metaphor into a real, visible, and, as it were, tangible object, without altogether losing its suggestive, expressive nature. Such an object, people in the Middle Ages must have felt, should in some way also suggest that the Synagogue, though its very nature prevented it from seeing and accepting the redemption by Christ, is yet a pillar of the Church, and hence of an elevated status. The result of these attempts was the blindfold.

The blindfold, the bandage covering the eyes, says Panofsky in his classic essay on Blind Cupid, is an invention of the Middle Ages.[37]

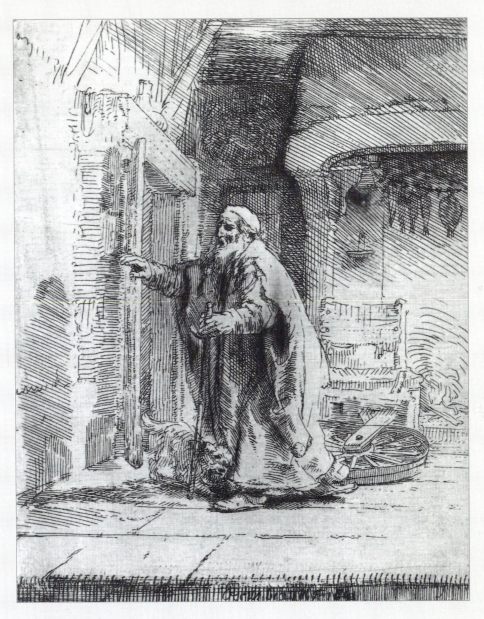

Fig. 1. Rembrandt,
Tobit Advancing to Welcome His Son,
1654, Etching

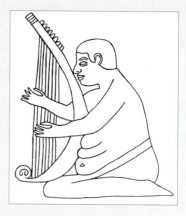

right
Fig. 2. Neferhotep,
a Blind Harpist,
Stela, Middle Kingdom,
Museum van Oudheden,
Leiden

below
Fig. 3. Greek Amphora,
the Blinding of Polyphemus,
Eleusia

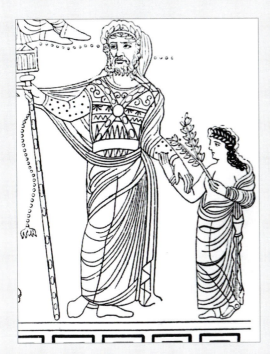

top
Fig. 4. Etruscan Urn,
the Blinding of Oedipus,
Florence

left
Fig. 5. Teiresias, Drawing after
a Lost Crater (detail)

above right
Fig. 6. Late Antique Ivory,
Scenes from Medea and
Oedipus, Hermitage,
St. Petersburg (author's sketch)

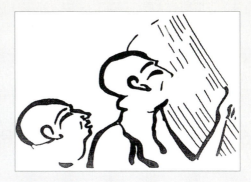

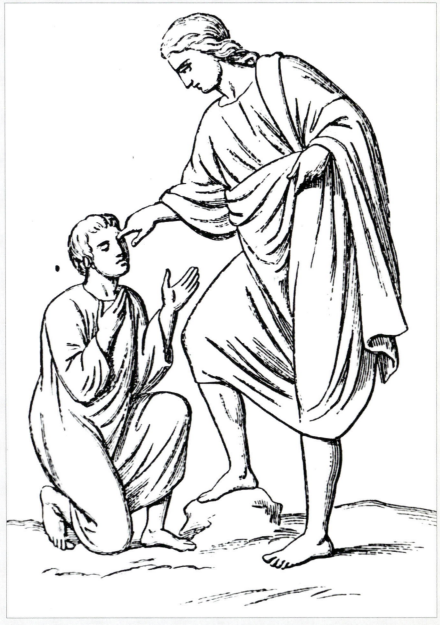

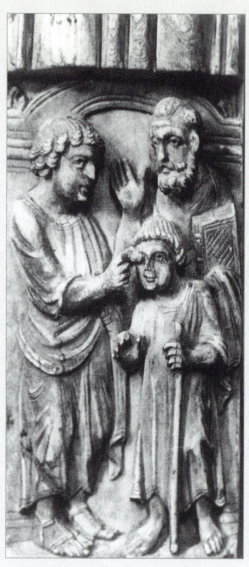

left
Fig. 13. Bamberg Cathedral,
Synagogue and Jew Blinded
by Devil (author's sketch)

above
Fig. 14. Ecclesia and
Synagogue, Sketchbook of
Petris de Funes, Bibliothèque
Municipale, Amiens
(author's sketch)

above left
Fig. 15. Blindfold Death,
Notre Dame Cathedral, Paris
(author's sketch)

above right
Fig. 16. Blind Led by Dog,
Flemish Manuscript,
Walters Art Museum, Baltimore

right
Fig. 17. Blind, Illustration from
Georg Philipp Harsdörffer,
Der Geschichtspiegel,
Nuremberg, 1654

above
Fig. 18. Pieter Brueghel, *The Parable of the Blind*,
Museo Capo di Monte, Naples

below
Fig. 19. The Pilgrim, Illustration from *Het Boek van der Pelgrim*,
Haarlem, 1496

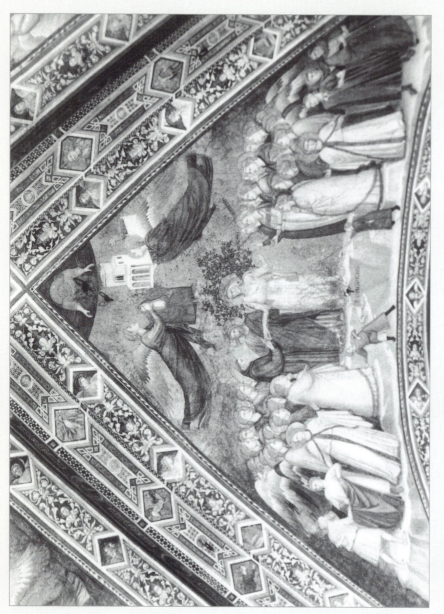

Fig. 20. *The Marriage of St. Francis with Poverty,* Lower Church, St. Francis, Assisi

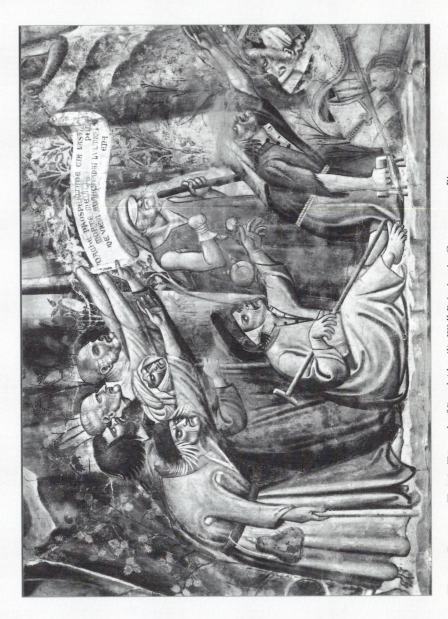

Fig. 21. Francesco Traini, *Triumph of Death* (detail), Wall Painting in Camposanto, Pisa

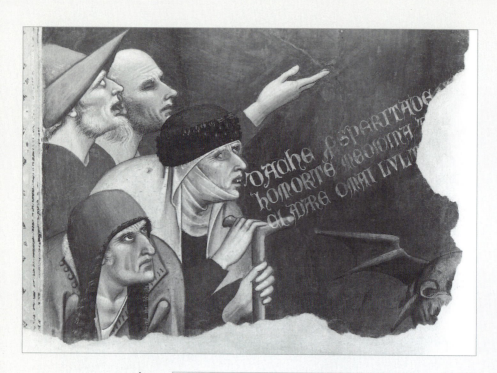

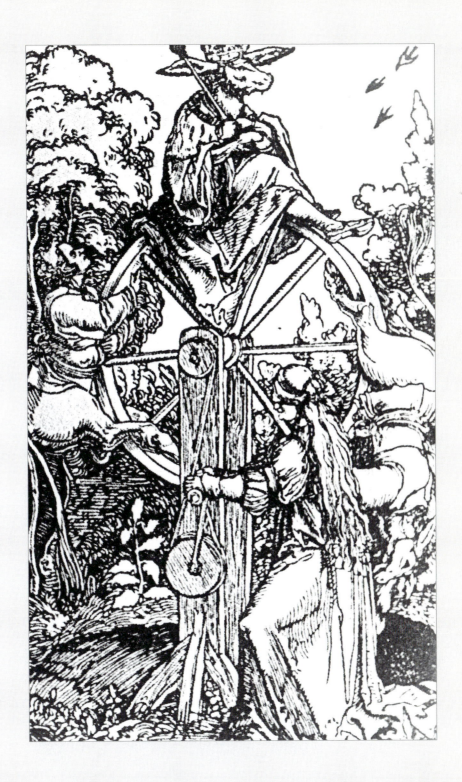

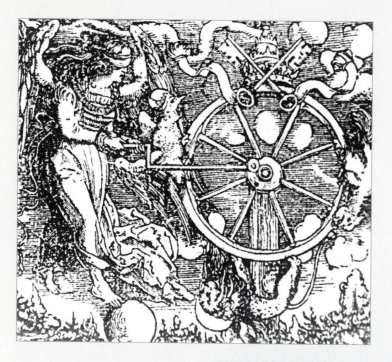

Fig. 27. Raphael, *Parnassus*, Vatican

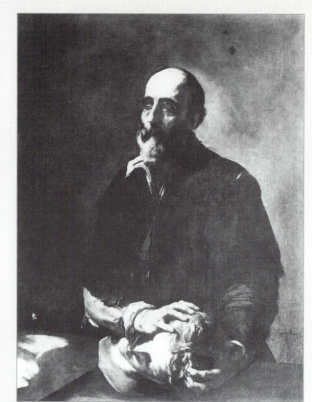

right
Fig. 28. Ribera, *Sense of Touch*, Pasadena, California

below
Fig. 29. Ribera, *The Blind Beggar and His Boy*, Oberlin College, Ohio

While this is certainly true, the blindfold as such has a long and venerable history, and for the understanding of our present subject, the different levels of the blind, it is well worth our while to look briefly into the connotations this object carried in earlier times. Some of them may have entered the image of the Blind Synagogue.

In antiquity and the Middle Ages the covering of the eyes or of a ritual object carried different, though not altogether unrelated, connotations. On the one hand, it conveyed a sense of the sacred; on the other, it was a means of obstructing vision. The precise location of the covering object—a veil, a curtain, or something similar—could also change, in the imagination as well as in actual reality. Sometimes it is placed over what should not be seen, more often over the eyes of the spectator. No clear rule can be established as to when the veil or curtain should be placed at one spot or another.

The variations in the veil's placing were supported by the authority of Scripture. A medieval reader would remember the different ways and means by which the children of Israel were prevented from seeing the divine or the sacred. Moses saw only the "back parts" of God, but not his face (Exod. 33:23); God descended in a "cloudy pillar" and thus could not be seen (Exod. 33:9); and Moses put a veil over his own radiant face (Exod. 34:33). Elaborate veils and curtains played an important role in the tabernacle (Exodus 26). Were they primarily meant to divide the empty inner expanse and to create more open or more closed spaces, or was their main purpose to hide the sacred spaces (and whatever may have been in them) and remove them from the uninitiate's sight? It is often difficult to give a clear answer.

In the New Testament the veil is explicitly transformed into a metaphorical expression of blindness. In using the image of the veil over the face of Moses, Paul altogether inverts its meaning. Putting forward an important element of his theology, he says, "And not as Moses, which put a veil over his face, that the children of Israel could not steadfastly look to the end of that which is abolished: but their minds were blinded: for until this day remaineth the same veil untaken away in the reading of the old testament; which veil is done away in Christ" (2 Cor. 3:13–14).

The inversion of the function the veil is meant to fulfill—to protect the children of Israel in the case of Moses's shining face, to prevent the obdurant sinner from seeing the truth of redemption, in the formulation of Paul—is a small, yet significant, facet of the great historical turn that marks the end of the classical world. Throughout the Middle Ages raising the veil or the curtain, or removing them altogether, becomes an expression of revelation. On the other hand, letting the veil hang down, or the curtain remain closed, expresses staying in darkness, not accepting the revelation. The very act of raising the veil or opening the curtain becomes therefore a highly charged, ritual performance.[38]

It is not surprising that this inversion of the veil's function is echoed in the two personifications, the Church and the Synagogue. Throughout the Middle Ages the Synagogue was imagined with eyes covered. This not only was a living tradition of the workshops of sculptors, illuminators, and painters, but it is also amply documented by literary texts. Yet for many centuries the precise nature and shape of the cover was not firmly established, and hence its image frequently changed. Only in the thirteenth century do we come across a more or less precise description of the object covering the Synagogue's eyes. It is the blindfold. This early description is by Albert the Great. He was obviously familiar with a representation of the Crucifixion in which allegorical figures, especially the Church and the Synagogue, were also represented.[39] It is interesting to note what precisely is clearly defined in this description and what still remains somewhat vague. Albert knows that the Church is placed on Christ's right, the Synagogue to his left. The face of the Church is beautiful and she wears a crown ("pulchra facie et coronata"); the face of the Synagogue is sad, her head is inclined (so that the crown she once wore fell off), and her eyes are bound with a piece of cloth or rag ("oculis panno ligatis, tristi facie, inclinans caput, et corona decidente"). There may be some difficulty in describing the expression of her face as sad when her eyes are covered with a piece of cloth. However that may be, the statement that the Synagogue is blindfold is obvious and unmistakable. It may nevertheless be of some significance that Albert does not yet employ the technical term for "bandage," *ligamen*.

In the medieval imagination the blindfold itself carried contradictory, conflicting connotations. On the one hand, it was a sign of profound humiliation; on the other, it was understood as a means of salvation, of protection from ruin and destruction. The meaning of humiliation could be derived from Scripture. In the story of Christ's derision Mark (14:65) tells that "some began to spit on him, and to cover his face, and to buffet him." The covering of Christ's face, then, was not imagined as placing a veil over the whole face, but rather as a covering of his eyes. Already in the mid-twelfth century Richard of St. Victor, referring to Mark, speaks of "veiling the eyes" ("velamen oculorum") of Christ.[40] In medieval Passion plays Christ was represented as blindfold in the scene of the derision. In the late Middle Ages we also find pictorial representations of the Derision of Christ, mainly in illuminated manuscripts, showing Jesus with a blindfold over his eyes or two figures of scoffers holding a blindfold over them.[41]

In the spiritual world of the Middle Ages, however, covering the eyes could also be understood as a means of protection and salvation. Though this interpretation was not common, some of the great thinkers of the age suggested it. Mechthild of Magdeburg, the twelfth-century woman mystic, saw in her imagination that when the time of the Antichrist comes, the children of God will be blindfold. The blindfolds will protect the just and the true believers from the temptations of the Antichrist.[42] Bernard of Clairvaux is quoted as saying that virtue covers the eyes of men in order to save them from annoyance and temptation.[43]

Without going into the further ramifications of this ambiguity, it should be stressed that in both contexts and meanings the blindfold suggests that the figure wearing it has great dignity. Whether humiliated or saved, or both at the same time, it is not the blind beggar known from the street corner or from the entry to the church who is imagined as blindfold. This shows again that, whether or not the audience was fully aware of it, the Middle Ages knew two types of the blind, one of sublime dignity, the other a poor cripple. This distinction becomes tangible in the specific means of showing blindness visually.

How did the blindfold emerge as such a charged object? We can best

follow the stages of imagining the blindfold over the Synagogue's eyes, and also over the eyes of some other figures, by studying its representation in works of the visual arts. Turning to the blindfold Synagogue in painting and sculpture, I shall briefly discuss a few select examples that may illustrate our point.

In examining the history of the blindfold Synagogue one notes first a striking discrepancy between text and painted images. As we have seen, the blindness of the Old Law or of the Synagogue was already an established topos in theological literature during the early centuries. Augustine made the "darkened eyes" of Israel a firmly crystallized formula that lived on in literature. It took centuries, however, before that topos acquired articulate form in the visual arts. Personifications of the Old and the New Testaments in the shape of two female figures are well known since late antiquity and the early Middle Ages. Some of the best-known examples are the painting in the apse of S. Pudenziana and the mosaic on the portal of S. Sabina, both in Rome. In both works the allegorical figure of the Old Testament anticipates in shape and mode the Synagogue of the medieval images. Yet, though both works were done at the period when Augustine wrote about the blindness of Israel, or even later, the images do not in any way depict the Old Testament as blind or blindfold.

It is only in the ninth century that we find some indications of the blindness of the Synagogue (in the Drogo Sacramentary).[44] The specific pattern of the blindfolding, however, seems to have appeared even later, by the end of the tenth century. It is not the Synagogue that here wears the blindfold but a representation of Night; this personification is a woman whose eyes are covered with a bandage.[45] In transferring the blindfold to the Synagogue, artists (and patrons?) seem to have hesitated. In the Uta Gospel manuscript, produced in the early eleventh century, the Synagogue, placed within the space of an initial, is not blindfold, but that she is blind in a metaphorical sense is indicated in an original manner: her eyes are covered by the frame of the letter.[46]

Some interesting motifs emerged out of these hesitations. Of a particularly demonic character is the figure in a colored drawing from the sketchbook of an artist whose name, Petris de Funes, is recorded. The

drawing, now in the Bibliotheque Municipale in Amiens, was done in 1197. Both Church and Synagogue are here seated, both holding banners in their hands. The flag of the Church is straight and erect, that of the Synagogue broken (fig. 14). The Church looks openly at her adversary; the Synagogue inclines her head. To indicate the Synagogue's obduracy and sinfulness, a big, dark serpent winds around her eyes and covers them.[47] As a rule, however, by this period it is the veil or blindfold that covers her eyes. In some examples only one eye is covered. This version seems to have been employed around A.D. 1100 and in the first decades of the twelfth century. This occurs mainly in representations of Christ between the Church and the Synagogue. In the Missel of Tours a semitransparent veil falls down over parts of the Synagogue's face. One half of the face, that turning toward Christ, is uncovered, the eye looking at the blessing Christ in the center. The other half of the face, covered by the veil, can be made out only vaguely, and the eye is suggested, though a fold of the veil, similar in shape to a strand of hair, partly hides it.[48]

Another example of half-covered eyes is found in representations of Christ placing the crown on the head of the Church and pulling away the veil from the Synagogue's face. A good illustration may be seen on the carved baptismal font from the church of Selincourt, now in the Museum of Amiens. Pulling the veil away from the Synagogue, Christ unveils half of her face. One eye is fully visible, while the other is completely covered.[49]

In looking at these works of art, one cannot help thinking of the one-eyed Antichrist. The motif of the Antichrist with one seeing and one blind eye became popular precisely at the same time, and in the same cultural area, as the motif of the Synagogue whose one eye is still covered. Could this similarity have gone unnoticed by the artists and spectators of the time? Or is the motif perhaps intended to express the Synagogue's ambiguous nature? We cannot give a positive answer. We should note, however, that this intrinsic polarity is characteristic of broad iconographic contexts, and that, in one way or another, it bears testimony to the meaning of blindness in general.

The Synagogue is the best-known motif of a blindfold personification in

medieval art, but it is not the only one. Several other personifications were imagined, in a more or less discontinued, ephemeral form, as blindfold. Like the Synagogue, these allegorical figures are evil and sinful, but at the same time also have irresistible powers, and thus inspire awe. Thus in the late Middle Ages, Lust is imagined as a "nude woman, with blindfolded eyes."[50] Another famous figure that emerged at the very end of the Middle Ages and continued through the baroque era but has its roots in the culture of earlier periods is Fortuna. She is the most famous image of a naked woman with eyes covered by a blindfold. Man, it was felt, is exposed without mercy to Lust and Fortuna. Again, both figures are evil, but both have an intrinsic greatness that lifts them above regular, mortal human beings.

The central one of the sinister forces over which man has no power is surely Death. And in fact, Death was often somehow endowed, directly or indirectly, with a blindfold. In the late twelfth or early thirteenth centuries blindfold Death was represented in the apocalyptic cycles that can be seen on the west facades of the great Gothic cathedrals, such as those of Amiens, Reims, and Paris. In these cycles blindfold Death is a female figure, presented in the act of disemboweling her victim (fig. 15).[51] So deeply connected were Death and the blindfold in the imagination of the late Middle Ages that even when Mors came to be depicted as a skeleton, it still carried the blindfold.[52]

In descriptions of Death in late medieval and Renaissance literature the blindfold appears repeatedly. A somewhat strange version is found in a famous poem, *Der Ackermann aus Böhmen*, composed in 1401, that abounds in poetic images and enables us to familiarize ourselves with late medieval fantasy. Of particular interest is the passage where the author, Johannes von Tepl, makes the allegory of Death describe his own image as it is painted on the wall of a sanctuary in Rome. As far as I know, a Roman wall painting precisely corresponding to this description has not been found, but nevertheless the text of the *Ackermann* is of great interest to the student of medieval imagery. Death here says that in the wall painting he is portrayed as sitting on an ox whose eyes are covered by a blindfold; the rider holds an ax in his right

hand, a shovel in his left.[53] Whether or not the scene is an allegory of the blindness and randomness of the "drive of death," the description shows that in the culture of the time the link between death and blindfold was accepted as a common feature.

While in the *Ackermann* it is not Death himself who wears the blindfold, Shakespeare has the full image of blindfold Death. In *Richard II* (1.3.221–24), John of Gaunt laments the forced exile of his son and says,

> My oil-dried lamp and time-bewasted light
> Shall be extinct with age and endless night;
> My inch of taper will be burnt and done,
> And blindfold Death not let me see my son.

Obviously, Shakespeare assumed that the audience was familiar with the figure of blindfold Death, and would accept the expression as an intelligible metaphor that needed no further explanation.

In attempting to draw some conclusions from our brief observations about the Synagogue as well as other allegorical figures that wear a blindfold, three main points should be stressed. First, in the Middle Ages the blind, and blindness in general, were imagined on two levels: the noble and the common. The first type was limited to allegorical figures. Second, the allegorical figures imagined as blind are of an intrinsically ambivalent nature. The Synagogue, Lust, Death, and similar personifications all belong to the dark side of the medieval cosmos; they are all rejected and considered sinful and disastrous. At the same time, however, all these figures are endowed with majestic dignity and are believed to hold an irresistible power over man. Their blindness is imagined differently than that of common people. Third, the visible mark distinguishing between the high and the low types is the blindfold. Blindfolds are employed only in imagining noble, elevated personifications. In fact, unknown to former stages of the European imagination, the blindfold emerged in the Middle Ages, became a widely known figuration only toward the end of the period, and was one of the motifs that medieval culture bequeathed to later periods.

The Blind Beggar

So far we have briefly considered the major religious connotations, both demonic and majestic, of blindness in the Middle Ages. Yet we should remember that the blind person was not to be seen only in religious contexts, whether theological, exegetical, or the imaginative creation of popular piety. After all, he was also a very real figure, a live individual encountered fumbling his way in the streets or begging for alms where crowds congregated. What was the medieval attitude to the blind in the everyday world? And how did the simple, familiar blind person appear in the imagination of the period? Was there in high and late medieval culture only one predominant image of the everyday blind? In attempting to outline the image of secular blindness in the Middle Ages we must remind ourselves that our concern is less with the actual conditions (social, economic, institutional) in which it occurred than with its image in the culture and art of the time.

Clearly, no simple answer can be offered to our questions. It may, therefore, be best to start with a piece of literature that may well reflect some of the ideas about the blind that were current during the High Middle Ages. In a thirteenth-century text, *Miracles de Notre Dame de Chartres* by Jean le Marchant, the blind is made to meet the dumb. It was the predominant tendency of the time to cast clear-cut types, especially in works addressed to a large, and necessarily not highly sophisticated, audience. These types are sharply distinguished from each other. In the *Miracles de Notre Dame de Chartres* the blind person (he is actually one-eyed) is presented as an expert minstrel, corrupt ("lecheor"), scandal mongering ("mauparlier"), jeering ("acharnissant"), full of falseness and guile ("plain de boidie, de barat et de faussete"), a drinker who is always seduced by good wines. The dumb one is an altogether different type. He is simple and pious. The blind suggests to the dumb that they make a pilgrimage together to Chartres, to pray there to the Holy Virgin and plead for the healing of their crippling deformations. When they arrive at Chartres, the dumb one hastens to the church, prays with great devotion to the Virgin, and is actually healed. The blind one behaves differently: first he goes to the

tavern, and thus begins his stay in Chartres by drinking wine. When he eventually comes to the church to pray to the Virgin that she restore his eyesight, the tears he sheds are tears of wine. He stays blind.[54]

This comparison between different kinds of invalids is not unique in the High and late Middle Ages. In the more common of these comparisons, the juxtaposition of the blind and the lame, the latter invariably represents the pious while the former is always seen in a negative light. There is a good illustration in a complex allegorical interpretation of an imagined feast, found in the writings of the late medieval German author Hermann of Fritzlar: the blind stands for the rich man who is "blind" to spiritual values, while the lame represents the pious soul who, though devoid of any wealth, fervently longs for, and has always present in his mind, the final redemption.[55] The demonization of the blind that is indicated here had a long life, and it reaches well into the Renaissance. It would be interesting to investigate whether the famous view by Leonardo da Vinci to the effect that blindness is the worst of evils that can befall man does not owe something to this medieval tradition that conceived of the blind person as a figure deprived morally as well as physically.

The impact of the religious tradition on secular figures, especially on that of the blind, emerges from many sources and is evident in many forms. In legends, transmitted from generation to generation in the Christian world, the blind are a symbol of pagans whom the devil deprived of eyesight, or of adherence to the pagan gods. The *Legenda aurea*, that late-thirteenth-century collection of tales of the lives and deeds of the saints that were told for centuries, offers many examples. The healing of the blind pagan becomes concomitant to conversion to Christianity.[56] For attempting to make a Christian sacrifice to the pagan gods one is punished by being instantly struck with blindness.[57]

Some of the causes by which blindness was explained suggest that the condition was linked to sin. A frequently mentioned reason for the loss of sight is drunkenness.[58] Blindness may be derived from a revolting misdeed. In the *Pratum spirituale* three blind men tell their story: one lost his eyesight because of a disease; the other, a glassblower, was blinded by fire; the third lost his sight because of the grave sins he had

committed. He was looting corpses, and one of the dead punished him by striking him with blindness.[59] It was usually by insinuation rather than by explicit statement that some of the most cruel crimes and terrible disasters were linked to the blind. That insinuation was enough to explain a disaster by the participation, or the mere presence, of blind people, shows how deeply seated and widespread was the suspicion of them. A single example will suffice. During the summer months of 1390 the story of a poisoning of wells caused a great deal of turmoil in Chartres. The reports about this event, or rumor, shed light both on accepted beliefs and the way they fascinated and came to dominate popular imagination. Vagabond beggars were believed to be the culprits. One day in June of 1390, so the story goes, the beggars, "in the company of a blind man," settled on the road to the city.[60] The conclusion of the story, which emerges clearly even if it is not spelled out, is that the demonic figure of the blind man is the origin of the criminal act of poisoning the wells. Another story tells that blind beggars carried off children and pulled out their eyes in order to evoke popular pity and thus to collect alms.[61]

The demonization of the blind reached into distant corners of institutionalized secular life as well as of legend. In the chess manuals of the period, for example, the blind figure is the embodiment of cunning.[62] In legend it is taken as a matter of course that a blind person cannot perform an important role in society. A king who went blind, a medieval story goes, transferred the jurisdiction over his people to his son. The son erred, however, and the old king had once again to take up the judging of his people. Since his rulings were just and without blemish, his blindness was miraculously healed.[63] This king, however, is an exception. In narrating both that after becoming blind he renounced his function as judge and that he was miraculously healed, the legend attests to the widespread belief that a blind man, even if he is a king, is not permitted to fulfill the responsible function of a judge.

It was, however, not only in legend but also in real life that the belief that the blind person is a sinner, that he carries a grave, even if unknown, moral fault, a belief that was obviously derived from the religious heritage, had tangible effects in social and administrative real-

ity. Perhaps based on Lev. 21:16–24, a passage we have discussed in chapter 1, medieval society established rules that prohibited the blind from serving as judges and city councilors, or in any other social function of importance.[64]

After indicating, however briefly and fragmentarily, some of the social and psychological conditions of the blind in medieval society, we come to our specific question: What was the image of the blind in the mind, the literature, and the art of that period? Did they have some distinct shapes, and were some expressive modes considered appropriate for depicting them?

We should begin with a simple observation. The social group to which medieval culture assigned the secular blind was mainly the beggar, particularly the itinerant beggar. Works of medieval literature, especially in the High and late Middle Ages, bear ample evidence to the association of the blind and the beggar. It will be sufficient to mention one of the earliest poems in which the blind person is the central theme, *Les trois aveugles de Compiegne.* Another poem, to which we shall shortly revert, *Le garçon et l'aveugle,* opens with a monologue by the blind man, a soliloquy he recites while he is begging for alms. The itinerant blind beggar appears so frequently in medieval literature that one necessarily concludes that for many generations such a figure must have been a permanent and prominent social feature. Poets telling about the itinerant blind beggar obviously presupposed that their readers, or perhaps rather listeners, were familiar with the figure from their real life experience. To be sure, in the literature produced between the thirteenth and fifteenth centuries the story of the secular blind person, or even the blind beggar, is sometimes transformed into the story of a miraculous healing. In such stories the blind one may turn out to be some kind of saint. Yet in spite of the inclination to transform a secular story into the report of a miracle, we still have enough texts about the regular person in everyday life and society to be able to discern the outlines of the figure in popular imagination.

With increasing urbanization and the other far-reaching changes that began with the twelfth century, mendicancy, and with it the blind beggar, must have increased considerably, a process that reached a climax in

the fifteenth and sixteenth centuries, particularly in Northern Europe.[65] Throughout the ages, beggars and begging were situated on one of the lowest rungs of the social ladder. Before the upheavals that introduced a new age in Western Europe, pity and compassion prevailed in the attitude to the beggar, particularly the blind one. Conversion and miraculous healing are frequent in early medieval stories about the blind. A twelfth-century text, *La Conversion de Saint Denis*, consisting of a dialogue between St. Paul and a blind man (who may be assumed to be a beggar), is a good illustration.[66] The tone pervading the text is one of compassion; the blind man himself is presented as a pious Christian, a "pure soul." Beginning with the thirteenth century a certain change may be discerned in the attitude toward the blind beggar. Though it goes without saying that no precise date can be given in such a historical process, the attentive reader of the texts composed after the beginning of the social transformations cannot help perceiving new tones and motifs in the description of the blind. Derision, suspicion, and to a certain degree even gloating now become conspicuous. It is these attitudes, often difficult to pinpoint in detail, that were crucial in shaping the image of the blind.

While naturally "blind" is not fully identical with "beggar" (not all the blind begged for alms, and surely most beggars were not blind), following the fate and image of the beggar may help us to understand the story of the blind in the Middle Ages. Begging, especially by itinerants, was clearly perceived as a threat to the public order. "The beggar ceased to be simply a poor person; he/she became a social deviant."[67] Crucial was the distinction between the poor invalid, struck low by nature, and the beggar, who was perceived as a strange and suspicious social actor. The attitude to the former, at least in principle, was one of compassion; to the latter, that of increasing suspicion and rejection. The difference between a poor man and a beggar, it is said, was that as between a true man and a thief.[68] Since in our sources the blind appear primarily as beggars, asking for alms because blindness does not enable them to choose any other occupation, the latter attitude becomes increasingly dominant in what is told about them.

What is characteristic of the blind beggar's behavior, as the High

and the late Middle Ages saw it? In many of the literary texts composed in that period the blind beggar's character and behavior range from deviousness to outright fraudulence.[69] Already in the thirteenth century distrust and suspicion toward the blind beggar is attested. In *Les trois aveugles de Compiegne* the cleric who is to help the three blind itinerants first wants to make sure that they are really blind.[70] Obviously, the belief was widespread that many of the beggars who appeared as blind had, in fact, unimpaired vision. Itinerant poets and storytellers took it for granted that their audiences were familiar with the suspicion that the beggar's blindness was, in fact, a fraud, a "false blindness." This suspicion attained increasing significance in the literature of the next two centuries. Take for instance the interesting *Farce joyeuse à trois personnages, c'est à scavoir un Aveugle et son Varlet et une Tripière*, composed in the middle of the fifteenth century. Close to the beginning of the poem, the trash seller ("tripière") doubts that the blind beggar she encounters is really blind. In literature this suspicion that the blind beggar is not really blind had a long life. It is not difficult to see that it emerged, and was most likely supported, by suspicions current in the social and mental realities of those times.

In an emotional climate in which compassion for the blind was largely (though never completely) replaced by suspicion of fraud, or even outright rejection of the attempt at begging, the mode in which they were imagined changed. Motifs of ridicule and derision now appear. Audiences were obviously pleased with the presentation of the comic situations that may result from the blind person's handicap. In a play, *Farce de l'aveugle et de son varlet tort*, staged in 1512 but going back in plot to an earlier medieval tradition, a burlesque interlude focuses on the blind's vanity. A mischievous servant mocks a blind man's conceit and his inability to know how he really looks. After feigning a cosmetic operation on the blind man, the servant makes him believe that he is now beautiful, and asks him if he wants a mirror to enjoy his new looks. The vain man agrees, but instead of a mirror the servant shows him his buttocks.[71] The very fact that such a scene was staged shows how profoundly the attitude to the blind had changed. Large audiences must have enjoyed this crude parody of the handicap.

How was the intricate, antagonistic attitude to the blind expressed in visible shape and appearance? In the course of the late Middle Ages, and even later in Northern Europe, the interest in bodily deformations increased. Distortions in nature were a riddle; one tried to understand them, their reason and meaning. Hence they were interpreted in different ways and placed in different contexts. Close attention was paid to invalids and cripples of different kinds. The dwarf, the hunchback, the clubfooted, the retarded—they all occupied the mind and formed the subject matter of literature and art.[72] Bodily deformations of a grotesque appearance fascinated not only popular audiences but also scholars. Grotesque body imagery became an important subject in literature.[73] The deformed in body were represented as distinct types. Both in literary descriptions and in depictions in the visual arts the external shapes of the deformations were sharply articulated and were distinguishable at a first glance. How, then, was the blind one's external shape and appearance imagined and represented?

In most types of bodily deformation nature herself guided the artist's hand. As most of these deformations are instantly visible, they impose themselves upon both the spectator and the artist. Famous examples are found among the masterpieces of European art. Velasquez's representations of the court jesters, Ribera's *Club-Footed Boy*, Dürer's drawing *Portrait of an Idiot*, to mention only some of the most famous works, amply attest to the fact that the artists started with, and developed, what they could see in nature.[74] But how were the artists to handle blindness? Here particular difficulties prevail. The bodily deformation of the blind is limited to the eye, and often the eye, a small area, is hardly visible. In the discussion of the grotesque body image, Bakhtin indeed wrote that "the eyes have no part in these comic images" of the face. The shape of the grotesque figure focuses only on what protrudes from the body.[75] But protrusion is not part of the blind person's bodily characteristics. These natural data may be the reason for the difficulties in visually imagining blindness and for the different ways of conjuring up, in the mind and in a work of art, the blind one as a figure that is instantly distinguishable.

As we have seen, for the representation of allegorical figures of great

power or dignity the problem was solved by the blindfold, the bandage covering the eyes, or the end of a mantle shielding them from view. It was this object that designated the figures as blind. But, as already noted, the blindfold was reserved for figures that, even if representing evil forces, imposed a sense of awe on the spectator. The secular blind man, the beggar near the portal of the church, could not evoke awe in the spectator, and he was never depicted as blindfold. The presence or absence of the blindfold is the most striking sign of distinction between the "high" and the "low" blind. We are now dealing with the latter. How, then, was the figure of the blind in everyday society imagined?

There were mainly two ways in which the medieval imagination conjured up the image of the "low" blind, and it is these two ways that formed the basis for representation in works of visual art. Both approaches, it should be kept in mind, are not mere strategies of representation, that is, means invented by artists in order to characterize a figure as blind without blindfolding the eyes. In both models an essential dimension of blindness is revealed. In one of them the figure is characterized as blind by its place in a story, its function in the unfolding of an event; I shall call this the "narrative" approach. The other characterizes a figure as blind by stance and movement; I shall call this the "gestural" type of representation. The two models cannot be fully separated. A figure's acting in the course of an event cannot be carried out without movement and gesture; on the other hand, a figure's gestures and movements necessarily bear some relation to what is going on around it, to the situation in which it is seen. In the history of imagery, however, these two types, while never fully separated, do indeed differ from each other and have impressed their particular character on imagery of the Middle Ages and of later periods.

In the visual imagination the narrative approach to representing the blind person is basically to show his relationship to other figures or to objects in the world surrounding him. Classical art and literature were fully aware of this approach. The blind seer led by a boy, or Oedipus supported and led by his daughters,[76] are parts of narratives; they suggest an event that unfolds in time and by the interaction between figures moving in space. They also show blindness by the particular

interaction between the sightless and another figure. Literary and artistic imagination in Northern Europe, from the High Middle Ages to the sixteenth century, rarely employed the classical model of the blind led by a seeing figure (though this also occurs), but it showed great inventiveness and originality in what we have called the "narrative" method. The climax of this development is Pieter Brueghel's great painting *The Blind Leading the Blind*, now in Naples, to which we shall revert in the next section. Here we should only emphasize that in the course of centuries high and late medieval art showed many variations on the theme of the blind being led by another figure, and some of these variations, I believe, were new and original.

Among the variations that, so far as I know, are innovative is the image of the blind led by a dog. It appears in literature as well as in the visual arts. A king without understanding, says the late medieval German poet Heinrich von Mügeln, resembles a blind man who is led by a dog, or by a child, or by the staff of the blind.[77] In describing the nature of a dog for the blind it is stressed that if such a dog sees a bone somewhere, it will pull its owner deep into the mud.[78] By the beginning of the modern era, then, a dog leading a blind man must have been a common sight; the authors using this image obviously believed that their readers would instantly understand it.

The image of a blind man led by a dog was also known in late medieval art, though here it does not seem to have been very common. Characteristically it is found in the *droleries*, those images fusing sharp and merciless observations of the outside world with twisted and distorted products of the imagination. The margins of Gothic manuscripts are an almost inexhaustible treasure-house of *droleries*. A good example of such a figure, forming part of a *bas-de-page*, is found in a Flemish manuscript of the early fourteenth century, now in the Walters Art Museum in Baltimore (fig. 16).[79] The blind man seen here holds a stick in one hand, in the other a cord with which he follows his dog. The dog rushes forward and jumps upward (following the ingenious shape of the frame around the text), holding a bowl in its teeth. In this bowl, one imagines, alms are meant to be placed. The blind man holding the rope is obviously making a great effort to follow the

jumping dog without falling. His legs are spread wide, his back is sharply bent, his head stretched forward—all these are dramatic movements, but they are not devoid of a slightly comic note. The whole image, evoking both tragic and slightly ridiculous associations, illustrates the unfortunate, strenuous, and fragile condition of the blind beggar's existence.

In visual representation one could also suggest that a figure was blind without having him led by the hand by another figure, or following a dog. A classic form is to make the blind man stumble over an inanimate object that a person with normal eyesight would naturally avoid. Like the blind person led by a child or a dog, the stumbling one shows the complex, intrinsically clashing relationship between the blind man and the surrounding physical reality, the world of objects that he cannot see. On the one hand, one will explain the stumbling by the fact that the blind man is isolated from the objects around him. On the other hand, however, the very fact that he stumbles shows that he is not completely detached from the encircling world. The objects he cannot see make an immediate and physically tangible impact on him.

A classic formulation of this stumbling, at least in the tradition of the European Middle Ages and early modern times, is found in the Book of Tobit. There, as we remember, it is told that blind Tobit, hearing that his son Tobias was returned from distant lands, "came out of the door, and stumbled" (11:11). Throughout the centuries the Book of Tobit was interpreted and the events and figures described in it were represented in art.[80] Sometimes old Tobit is imagined groping with his outstretched right arm for the door, and just missing it. The stumbling of the blind father was a theme on which many variations were formed. In a famous etching (see again fig. 1), Rembrandt illustrates Tobit's blindness by combining the two features: he gropes for the door with outstretched arm and fumbling hand, but misses it; at the same time he stumbles over objects he cannot see—a wheel placed on the ground and a dog rubbing against his leg.[81]

In concluding these few observations on imagining and representing the blind by means of narrative, we should stress two points. First, neither the Synagogue nor Mors, nor any of the other allegorical figures

wearing a blindfold, ever fumbles or stumbles. The figure of Mors on the portal of the Notre Dame in Paris, though blindfold, is unhesitating and precise in the movements of disemboweling the victim. Clearly, the display of the shortcomings of blindness was thought appropriate for simple, low-class, secular figures, but not for the noble, even if controversial, figures of allegorical imagery.

The second conclusion, difficult to prove yet perceptible, is the employ of a certain slightly comic expression, a mode of slight derision. A comparison of the noble, if defeated, blindfold Synagogue with Tobias missing the doorframe, or the heroic, if terrifying, blindfold Death with the blind man pulled by the dog, immediately shows the difference in the modes of representation. Such a comparison, however, not only shows that the difference in level of the figures extends to their expressive character but also specifically shows that the "lower" blind, secular figures of everyday life, may tend to arouse the spectator's smile. The misfortune of blindness also produces slightly comic effects, and in the Middle Ages and the Renaissance of Northern Europe these are concentrated in the figures of the secular blind.

Representing the blind by means of narrative, that is, by placing them in an unfolding event, is only one way of suggesting their blindness. The other is to show blindness by means of the figure's gestures. The outstretched hand is the most characteristic gesture, and it became a shorthand emblem for blindness. Whoever lacks the sense of sight depends on the sense of touch (and of hearing). An old Latin proverb has it: "Si tibi lumen abest, manibus res tangere podest."

Already in the Bible we find a full articulation of the gesture of fumbling and touching as a characteristic feature of the blind. In the curses of Deuteronomy we read: "The Lord shall smite thee with madness, and blindness, and astonishment of heart: And thou shalt grope at noonday, as the blind gropeth in darkness" (28:28–29). The same image is further developed with great expressive power by the prophet Isaiah: "we wait for light, but behold obscurity; for brightness, but we walk in darkness. We grope for the wall like the blind, and we grope as if we had no eyes: we stumble at noonday as in the night" (59:9–10). Throughout the Middle Ages the groping, fumbling hand of the blind,

this obviously insufficient substitute for the eyes that do not function, are an image often employed in literature.

Does the blind one's groping hand indicate an expressive mood? Sometimes even this characteristic gesture may convey, however slightly, a comic effect. The blind man carefully and hesitatingly probing the wall in which there is no opening or anything else worthy of our attention evokes, in the very lack of suitability, laughter, or a smile of derision. Like the Latin proverb of the "blind hunter" (*cecus venator*), frequently used in medieval literature, the gesture demonstrates the utter impossibility of the action (hunting blindly), and hence the lack of meaning in trying to carry it out. Even where it does not have the slightly comic meaning, it is an illustration of the fragility of man's existence in the world.

In the visual arts the blind person's groping and fumbling seem to have appeared only in the late Middle Ages and in the Renaissance. Thus an illustration in Georg Philipp Harsdörffer's *Der Geschichtspiegel*, a work that originally appeared in Nuremberg in 1654, shows the blind figure as half nude, probing the ground with his stick (though not actually reaching it) and stretching out his other arm to touch his surroundings. Yet in fact there is nothing to touch; he moves in an empty space (fig. 17).[82] In these representations there is not a trace of the elevated nobility of the blindfolded figures of the Synagogue or of Death.

The Blind and His Guide

The figure of the blind man, particularly of the blind beggar, we have seen, entered the imagery of the High and late Middle Ages under complex circumstances. The ancient belief in a link between blindness and guilt (fully inherited even if not always fully spelled out) was combined with a new distinction between the "high" and the "low" blind. A new mode, both literary and pictorial, of representing the low-class, secular blind person, the blind beggar, emerged in that period. In this mode, compassion for the predicament of the blind merges with the laughter, sometimes coarse, brought about by some of the situations in

which the blind easily find themselves. From these complex social conditions and emotional attitudes several specific motifs emerged in the imagination and arts of the time. In the present section we shall concentrate on one motif, the blind man and his guide, and try to analyze the changes it underwent in the period here discussed.

The blind man and his guide—this is a nodal point at which major characteristics of blind existence interrelate in reality and are made manifest in presentation. The inability to find his way on his own in the surrounding world, the utter dependence on the assistance offered, are fully revealed in the blind man's having to rely on a guide whom he cannot see. The group of the blind man and his guide is also a dramatic and focused juxtaposition of seeing and blindness. It is not surprising, therefore, that this motif, based on what could easily be observed in everyday life, impressed itself upon writers, artists, and audiences, and became a significant motif in the various representations of the blind. The theme, as goes without saying, is known in almost every age, and often it gives us an insight into what was thought about blindness and what the cultural attitude toward it was. In spite of its venerable history—or perhaps precisely because of it—the motif of the blind guided by a seeing person underwent profound transformations. It is specifically the relationship between the two, the blind man and his guide, that changed in the course of ages. These changes were particularly far-reaching in the the late Middle Ages.

At this point it will be useful to recall the mode in which the motif was presented in antiquity. The comparison with ancient presentations may help us to discern more sharply and clearly what is characteristic and new in this theme in the late Middle Ages. In antiquity, as we saw in chapter 1, the helping guide is a well-known, perhaps even an essential, component of depicting the sightless. What the comparison of this theme in the two periods immediately shows is that in antiquity it is not a distinctive mark of the beggar, or of the low-class blind person in general, to be led by a guide, even by a young boy. We remember that the blind seer Teiresias, an awe-inspiring figure of great inherent dignity, was led by a young boy. In literature as well as in vase paintings (see again fig. 5) the old seer's hand rests in that of the boy who will

guide his steps. Even Oedipus the king, after blinding himself, is led away by his children (see again fig. 6). Having a person to guide the blind is, then, not a class mark, let alone the indication of inferior rank.

A second observation concerns the character and expressive nature of the guiding figure, both in literature and in the visual arts. As a rule, the blind one's guide lacks any distinctive features or any marked characterization. In stance, movement, and body structure, the guide is an altogether passive figure, an "attribute" of the blind rather than the image of a human being in its own right. That it is normally a child, mainly a boy, bears testimony to the tragedy of the blind; even a child can lead the steps of an adult, even an old and venerable man. In the few literary references to the guide transmitted from antiquity, the figure lacks any specific features or characteristics. In ancient vase painting, where the motif occurs, the figure is also devoid of any characterization. As a rule, it is not even compassion with the blind man's sorry condition that the figure expresses, or is intended to evoke.

The third observation follows from what has been said: between the blind man and his guide, as they are described and depicted in antiquity, there is no real interaction. The guide defines the blind person, as it were, but the latter does not address him. In the Oedipus ivory (see again fig. 6) the king supports himself on his daughters who lead him away, but he does not turn to them, and they do not in any way interact with him. In the other great image of a blind man and his guide, Teiresias and the boy waiting to lead him (see again fig. 5), not even a propping up is suggested. The boy is simply there, but no real, live relationship develops between the two.

In all these respects the motif radically changes in the imagery of the High and late Middle Ages. In both literature and the visual arts the motif of the blind led, or helped in any way, by a person with unimpaired eyesight is frequently dealt with, especially after the twelfth or thirteenth century. But the guide is now profoundly different from what he was in antiquity; he has a distinct appearance, a physical and moral character of his own. That character is not always compassionate, and hence we can say that, in an important sense, blind and guide are juxtaposed to each other. From this it follows that there is a lively,

sometimes even dramatic, interaction between them. We shall see that sometimes the plot of a story or play, or the composition of a pictorial rendering, are based on interaction between the pair of figures. Next I shall discuss two prominent examples of this particular motif between the thirteenth and sixteenth centuries. One of these is literary, but we shall also look at its artistic formulations; the other is a painting, but we shall try to show its literary sources. It should be stressed that these analyses are made with only one question in mind: how was blindness understood, and how were the blind evaluated in the late Middle Ages?

Le garçon et l'aveugle

Shortly after the middle of the thirteenth century the citizens of the town of Tournai, and the people who came to the fair that was held there, could witness the performance of a play that we now know as *The Boy and the Blind Man* (*Le garçon et l'aveugle*).[83] This play was what was then called a "comedy."[84] In the thirteenth century, as Edmond Faral suggests in his classic study on jugglers ("jongleurs") in medieval France, comedies were usually performed by two, but no more than three, actors. We cannot discuss here what in the High and late Middle Ages was considered a "comic performance." In the present context we shall only briefly point out some characteristics—an inclination to select a certain kind of subject matter and a particular mode of presenting these themes to the audience.

Among the best-known features of the medieval comic plays, or "farces," is that they often exposed the failings and defects, physical as well as moral, of man. These presentations of human weaknesses and defects were often of a cruel nature, making fun of the "comic" misfortune of one's fellow. People maimed or specifically deformed, by nature or by fate, were therefore an ample source of inspiration to the authors and actors of such plays. In some of them, the unfortunate fate of the dwarf, the hunchback, or the retarded is displayed before the audience, mocked, and scoffed at. The audience must have laughed at the creatures shown. *Le garçon et l'aveugle* shows that already in the mid-thirteenth century the blind joined other handicapped as the cause of laughter.

In stories, but particularly in plays, the reaction of the audience was evoked by various means, but of specific importance was the display of typical situations resulting from a specific physical defect. The infirmity was presented as a plot, or an event, rather than being indicated by an attribute, or embodied in a single, static figure. *Le garçon et l'aveugle* opens with such a typical situation: the desperate blind man pleads for the boy's help, because the boy had warned him not to walk in a certain direction, so as "not to fall into this ditch." But in fact, as every spectator in the audience could see for himself, there was no ditch at all. It was the crass contrast between the blind man's anxiety and the obvious fact that there was no reason for it that gave rise to laughter. Employing such a typical situation is not only a means of artistic presentation; it is also a statement about the prevailing attitude toward the blind. The blind man is a ridiculous figure. Blindness, or at least a typical result of it, becomes the subject of public mockery.

Mockery of the blind person's shortcomings, transforming his disability into a laughingstock, is a characteristic feature that continues throughout the play. The boy, by speaking in an intentionally changed voice, makes the blind man believe that he is addressed from heaven (verses 147–49). After that the boy, speaking with his natural voice, pretends not to have heard anything. Making crude use of the other's inability to see is both a means of presentation and a characteristic feature of the boy's behavior. It even enables him to hit the blind man without any fear of retaliation.

Making the blind man a laughingstock only sets the stage, as it were, for showing his character. The statement about the blind beggar's character and the nature of his activity in the streets of a thirteenth-century town is far more radical than mere mockery. The whole plot leads the spectator to cast doubts on the blind man's honesty. When the boy agrees to help him, the blind man suggests that they both walk the streets of Tournai. You, he says to the boy, will beg for alms, and I will sing, and thus we shall both earn much money and bread (verses 31–32).

Presenting the blind man as a beggar is probably a faithful reflection of the actual social reality; many blind men, one safely assumes, were

indeed beggars. By identifying the blind with begging, one placed the former within a social group to which urban medieval society was becoming increasingly antagonistic. Whether at the time beggars did in fact become a "terrible plague," as Huizinga maintains,[85] the urban population intensely disliked them and viewed them with growing suspicion.[86] Beggars crowded the churches, disturbing the service with their songs and the noises they made. This condition is suggested in *Le garçon et l'aveugle*. At a somewhat later stage people tried, though in vain, to push them out to the doors of the church, as happened in Notre Dame of Paris. Among them there were many *validi mendicantes*, ecclesiastical authorities said. Later on, some political speakers got carried away by their rhetoric and said that beggars should be hanged and burned.[87] But already in the thirteenth-century play with which we are here concerned one perceives a hostile attitude toward beggars, and it is not difficult to imagine that this attitude prevailed in the early urban centers. First by insinuation and later by open declaration it was claimed that beggars deceived the population in order to extract alms.

In *Le garçon et l'aveugle* suspicion of the blind is explicitly expressed. The boy suspects that the blind man who walks the streets begging for a coin is, in fact, a rich man. What is suggested is that the blind beggar's call for compassion, the request to give him alms, is an excuse, a means of deceiving the public.

Modern students have noticed that in *Le garçon et l'aveugle* the style and language of the blind man's part in the dialogue change as he is gradually unmasked.[88] While at the beginning of the play he appears as an altogether pious person, and invokes the Virgin, he gradually discloses his true, and more terrestrial, concerns: his girlfriend Margot, his love for drinking, his gluttony, and his sensuality. As the play proceeds, his language becomes coarse, cynical, and sometimes obscene. The blind man, it turns out at the end, is a hypocrite; he pretends to be pious while in reality he is not. These properties of character go well together with what we know at the end of his social condition: he begs for alms, while in fact he is rich. In sum, the blind beggar is a tiresome, cunning character; he flatters his guide in order to win his confidence, but wants to take advantage of him.

Le garçon et l'aveugle not only makes a statement about the character of the blind beggar, but also creates an image of the boy who guides him and of the relationship that develops between the two. To properly understand the image of the blind in late medieval culture it may be useful to briefly point out some aspects of the guiding boy's figure.

To begin with the obvious, the guiding boy, Jeannot, is not a one-dimensional, almost abstract figure, as was the child that led the blind seer Teiresias in antiquity. Jeannot is not only a person with an individual name (as opposed to the anonymous "child" in the antique tradition), he also turns out to have a distinct, and rather intriguing, character. Several times in the text of the play, Jeannot suggests that the image the people, and especially the blind beggar, have of him does not truly reflect his real personality. It is my own fault, he says, that the blind man believes me to be lacking in everything (verses 236–37). In fact, it has been noted, in the course of the play the spectator can observe for himself that the humble servant, as Jeannot appears at the beginning, becomes a self-assured person, certain of his superiority over his blind "master" who depends on him. It is the garçon who chooses the time and place of begging (55–56) and who directs the blind beggar to sing his song (81–82). The blind man's dependence on the guide is not limited to avoiding "falling into the ditch;" it is a more comprehensive and complicated combination of reliance and fears.

Here one may well ask what the function of the boy in *Le garçon et l'aveugle* actually is. While this question cannot arise with regard to the young boy leading Teiresias, it imposes itself upon the reader of the thirteenth-century text. Is Jeannot's major function to lead the blind beggar where and when the latter wishes, or is it rather to tear off his mask, fully uncover his character, and show his true nature? The very fact that this question occupies the reader's mind, and must have arisen in the minds of late medieval spectators, shows how far the medieval formulation of the motif of the boy leading the blind is from what it was in antiquity. But it also shows that the interaction of the two figures, of the blind beggar and the boy who guides him, is a live, complicated dialogue, in which both figures are defined by their counterpart, and by the way their images are reflected in the minds of each

other. The medieval version, then, is not simply a revival of the ancient one; it is a new and different creation, necessarily arising from a new social and mental reality.

Brueghel's *The Parable of the Blind*

What can we learn from the visual arts about our specific motif? I shall conclude these brief observations on the image of the guided blind by looking at Pieter Brueghel's famous painting *The Parable of the Blind*, now in the Museo Capo di Monte, Naples (fig. 18). This painting was done in 1568, and it may seem odd to conclude a discussion of the blind in the Middle Ages by looking at a painting of as late as the second half of the sixteenth century. Moreover, Brueghel was aware of, and influenced by, Renaissance trends, largely by those that originated in High Renaissance Italy. Yet so many medieval traditions permeate this painting, and it sheds such revealing light on some elements of medieval culture and thought that one feels justified to link it with the imagery of the Middle Ages. In my brief comments I do not intend to discuss this painting as fully as a masterpiece of this rank demands. I shall here consider it only for what it discloses, openly and implicitly, about the understanding of blindness in late medieval culture.

Even when seen from such a restricted point of view, *The Parable of the Blind* is an unusually rich, multilayered work. It fuses—one is tempted to say, in an almost unique manner—a kind of imaginative "realism" (of a particular type that goes beyond what can actually be seen in reality) with several dimensions of symbolic connotation. In the same, almost unique, way the painting reformulates the motif of guiding the blind.

Scholars who have studied Brueghel's painting saw it as a representation of the famous New Testament parable. Matthew records a saying of Jesus: "Let them alone: they be blind leaders of the blind. And if the blind lead the blind, both shall fall into the ditch" (15:14). To some art historians the link between the sacred texts and the painting seemed so close that they spoke of "illustration." While, in fact, the parable of the blind, famous and often quoted throughout the ages, is indeed the subject matter of this highly unusual scene, the painting carries additional

connotations. Even if they are only implicit, they contribute both to the breadth of the painting's meaning and to the dense complexity of its subject.

In the painting the connotation of sinfulness, or at least foolishness, is not as crude as in *Le garçon et l'aveugle*. Nevertheless, it cannot be overlooked. This connotation emerges, of course, from the original text. Christ's words are spoken in the context of a dispute with the "scribes and Pharisees," and the parable of the blind is adduced to show their hardness of heart. In Brueghel's painting the sinfulness of the figures is expressed by visual means. The anatomical deformations of the beggars, to which I shall shortly return, is a formula of showing the burden of sin distorting the human frame.

Like other motifs of this kind, the theme of the blind guide leading other blind men, falling into a ditch, and pulling them with him has a venerable and multisided history. Without attempting to trace this history, we can safely say that the paradoxical scene is, or was, understood as a concise, condensed statement of the world turned topsy-turvy. In the High and late Middle Ages, the sense of the established order breaking down and the whole world turning upside down was often expressed in a series of images of what seemed impossible. Among them is also the image of the blind leading the blind, all of them falling into an abyss. Thus in a poem of the *Carmina Burana*, among the evocations of such impossibilities as dancing oxen and donkeys playing the flute, the image of the blind leading the blind, and all of them plunging together into a ditch or abyss, is also formulated.[89]

Sinfulness, regardless of how it is expressed, is not the only context in which the *The Parable of the Blind* should be seen. Two clusters of meanings are evoked with particular force by that unusual image of the wandering blind beggars. One of these themes is the pilgrimage, or rather the wandering, through life. The mental image of roaming played a central part in the world of late medieval imagination, and it often carried symbolic meanings. Probably the most distinctly crystallized version of the motif at this time is the comparison of man's life to a pilgrimage. It is, however, not a pilgrimage in the sense that you know in advance what the stages and directions of the road you walk

will be. It is rather an image in which roaming in a wide and unknown territory is combined with the sharp sense of ignorance as to where precisely the road is leading. In this sense the theme played a crucial part in late medieval imagination. A single illustration of this feeling will here be enough. In his poem *Le pelerinage de la vie humaine* (completed in 1332) the French Cictercensian monk Guillaume de Daguilville gave a classic formulation to the subject of man wandering "blindly" through life, that is, without advance knowledge where the road leads and what difficulties and pitfalls he will encounter in walking it. This poem, supposedly recording the dream of a sinful monk, was soon translated into all languages spoken in Western Europe; it was frequently copied, emulated in similar texts, illustrated, and later also printed. It soon became one of the most popular texts of the late Middle Ages. In 1486 a Dutch translation appeared and was soon reprinted and illustrated. A rather simple woodcut illustration in a somewhat later Dutch edition, that of 1496, has a general similarity to Brueghel's painting.[90] The "pilgrim," probing the ground with the long staff in one hand, stretches out the other (fig. 19). That other hand, to be sure, is meant as speaking rather than groping, but in the overall character of the movement, and its compositional form on the printed page, it is close to the gesture of a blind man. Though in a simple, matter-of-fact sense the wanderer is not blind, the formal affinity of the illustration to Brueghel's work may suggest how the great master's painting was understood at the time. At least in mood, it conjures up the idea of wandering in the dark.

In the latter part of the sixteenth century fusing the themes of the itinerant blind beggar and the allegorical wanderer through life was not new in the visual arts. In a lost painting by Jerome Bosch, probably representing a similar theme as Brueghel's, the blind man carries the pilgrim's long staff, and even wears on his headgear the pilgrim's emblem, the conch. In pictorial renderings of the parable of the blind in the period between Bosch and Brueghel the number of the itinerant blind gradually increases. In Brueghel's *The Parable of the Blind* the sightless beggars have become a train of figures. In the rising and

descending line, the group clearly suggests a moving procession. It could thus be understood as an emblem of the pilgrimage of human life.

The connotation of wandering, of groping and hesitatingly walking through life, to some extent limits the meaning of guilt and sin. To be a wanderer through life in this world, not knowing precisely where the next step will lead us, was obviously perceived as the universal destiny of man, the fate no human being can escape. Therefore, the wanderer is not singled out as a sinner and as guilty; as one whose infirmity testifies to his wrongdoings in the past. But in addition to wandering and roaming, another connotation, evoked by the literature on the blind and fully embodied in Brueghel's painting, removes the blind even further from the context of sin. That other connotation is evoked by the external appearance of the blind beggars.

The itinerant blind beggar, collecting alms wherever people congregate, is clad in rags. This was not only a matter-of-course social reality, with which everybody in town was obviously familiar, but was also a distinct and characteristic feature of the mental image of the blind. Already in the early performances of *Le garçon et l'aveugle*, whenever the blind beggar appeared onstage, he was instantly identified by his worn and torn dress.[91] His costume indicated extreme poverty, as groping gestures manifested blindness. The combination of a hesitant step, a raised but eyeless head, and poor, torn dress is also characteristic of the blind in Brueghel's painting.

It is true, however, that important trends in the spiritual life of the late medieval world brought about, at least within certain domains, a complete reversal in the attitude toward the dress of poverty. In the Franciscan movement, Sancta Paupertas was an ideal figure, and Franciscan preachers, writers, and artists were concerned with her appearance, including the dress she wears. In Giotto's famous fresco in the Lower Church of St. Francis in Assisi, *The Marriage of St. Francis with Poverty*, the rags in which she is dressed are emphasized, and they serve as an identification mark of the ideal figure (fig. 20).[92]

Even more powerful and explicit than the Franciscan Sancta Paupertas in Italy is a comparable figure, fully crystallized in Germany and in other countries of Northern Europe. It is the figure of Virtuous Dame

Poverty (*Tugentreich fraw Armut*). In popular moralistic literature, in sermons, and in that so widespread late-fifteenth-century work *The Ship of Fools*, the equation of virtue and poverty is increasingly suggested.[93] What emerges from these sources, texts, and illustrations alike is that the personification of poverty wears a torn dress; her garment is old and worn. But she is also a personification of virtue, and thus her dilapidated appearance is approached with awe. In this climate, prevailing in the late medieval imagination, especially in Northern Europe, the rags worn by the poor could not be completely separated from the appearance of Virtuous Dame Poverty, and thus an additional emotional and symbolic character is infused in the beggars' rags.

Clearly then, at the end of the Middle Ages the blind beggar, smitten by God and placed on the lowest rung of the social ladder, largely because of his poverty, is now related not only to sin and moral failure, but also to virtue. Ambiguity of meaning, in spite of clear identification of external appearance, becomes a central character trait of the secular blind.

Scholarly disputes as to whether or not there was a period which we call the Renaissance have been going on for quite some time. Nobody would deny, I think, that in the fourteenth and fifteenth centuries some significant new beginnings were made in Italy and gradually spread over large parts of Europe. On the other hand, no serious student will doubt that a great deal of continuity from medieval culture and views colored what was believed, said, and shaped in the Renaissance. Whether one stresses the new or the old in the period, the original or the traditional, depends to

4

The Renaissance and Its Sequel

a large extent on what particular aspect or subject we are discussing.

Blindness is not a central theme in Renaissance imagery. Neither in literature nor in the visual arts is much attention paid to the sightless person. To the student of Renaissance culture, particularly in Italy during the fifteenth and sixteenth centuries, this seeming lack of interest in the blind, and their world shaped by this defect, remains a puzzle. We hardly know of a period in which vision was so highly valued as in the Renaissance. Intact eyesight was not only a crucial good in human life (so it was considered at all times), but was also thought to be "a genuine and indispensable organ for the understanding of reality."[1] Leonardo's praise of the eye is one of the classic expressions of the value of vision. "Who is there who would not wish to lose the senses of hearing, smell, and touch, before losing sight? For he who loses his sight is like one expelled from the world, when he does not see it any more, nor anything in it. And such a life is a sister to death."[2] But unimpaired vision is also a means of scientific cognition.[3]

In spite of the significance granted to vision, the persons deprived of

it are marginal, often nonexistent, figures in the Renaissance typology
of man. Yet the question of how the blind were imagined in Renais-
sance culture offers the attentive spectator interesting, sometimes even
surprising, vantage points for observing this period as a distinct unit of
historical development. It also enables us to observe how great cultural
trends are reflected even in a marginal subject. The Renaissance image
of blindness is not uniform; there is no established tradition of repre-
senting it. For the purpose of the present investigation I shall
distinguish between several trends in imagining the blind person in
Renaissance culture. They are recorded in the artistic and literary pro-
duction of the period.

The Blind Beggar

At the center of one trend is the figure of the secular blind person.
Only a few explicit attempts at depicting the fate and evoking the
image of such an individual are found in Renaissance art and literature;
however, the few works in which this is done are of great significance,
both for their aesthetic and cultural value and as eloquent documents
of the period's mental, and perhaps also social, life. While in portrayal
of the ordinary blind person, actually the blind beggar, it is only a few
paintings and texts that need be discussed, the Renaissance imagina-
tion greatly enriched the imagery of allegorical blindness. Both in the
allegorical personifications imagined as blind, and in the iconographic
attributes employed to show the blindness, the Renaissance continued,
and broadened and transformed, the medieval category of the elevated
blind figure. Here too, however, tradition and originality merge. The
Renaissance did not go on representing the specific allegorical figures
that the Middle Ages imagined as blind; it created new figures and
endowed them with traditional attributes. The distinction between
upper- and lower-class blind persons, inherited from the Middle Ages,
remained the basic structure of this whole group of images. The indi-
vidual personifications imagined as blind are however new, and, at least
in the form they were given, largely creations of the Renaissance. Some
of these figures would hardly have been intelligible to a medieval spec-

tator. To discuss the Renaissance images of the secular blind it will be best to begin with works of the visual arts.

Fourteenth-century Italian representations of beggars, including blind ones, have occasionally been termed "realistic." Without going into a discussion of the highly problematic concept of "realism," we should say that in the course of centuries it came to indicate two main meanings. One refers to style and lifelikeness, the other to the subject matter that shows a low-class social reality. Keeping in mind the latter meaning, the pictorial representation of scenes and figures of beggars and the blind may properly be called "realistic."

Two great works of wall painting, one from the Camposanto in Pisa, the other from the Church of Santa Croce in Florence, show us how the blind beggar was imagined at the beginning of the Renaissance. The monumental fresco representation of the Triumph of Death in the Pisan Camposanto was badly damaged in a fire in 1944, and, to be saved from total destruction, was transferred from the walls on which it was originally painted to panels now exhibited at the National Museum in Pisa. While much of the original impression is lost, the parts we can see are a powerful achievement of the art and an important document of the culture and imagery of the early Renaissance in Italy. The great allegorical fresco is composed of a series of semi-independent groups. One of these, painted by Francesco Traini, represents a pack of ugly and deformed cripples and beggars, one of the very few representations of cripples and beggars in the Italian Renaissance. Modern scholars are agreed on what this group was meant to convey within the general theme of the Triumph of Death. While the figures belonging to most of the other groups are trying to escape Death's sickle, the unfortunate, suffering beggars and cripples wait for him to come. They stretch out their hands to Death, imploring him to relieve them from their pain and suffering (fig. 21). We are concerned here with two specific aspects of this group: one is the general concept of the crippled beggar, as it emerges from the fresco; the other is the two or three figures that, in one way or another, represent blindness.

Let me begin by carefully looking at the beggars in the fresco. The expressive mode of the whole is best shown by the personage to the

extreme left, the only standing figure in the beggar group that is seen in its entirety. Sharply stooping, he stretches out his taut left arm, the hand with open palm slightly raised, in a rhetorical gesture of invocation. In the other hand he holds a club. This elongated piece of wood cannot be understood as a walking staff; it is both too short and too heavy for that purpose. A large dark purse hangs from his belt, the only representation of a purse in the whole fresco. The face is that of a malicious, angry sorcerer. Note particularly the hair: its pointed strands form a kind of devilish coiffure, recalling some representations of demons with flaming hair. The meaning of this figure is not clear. Most of the other beggars are marked by the bodily defects from which they suffer: the lame holds crutches, the beggar with amputated hands stretches forth his truncated arms, etc. The figure to the left manifests no obvious sign of a specific infirmity. The money bag hanging from the belt may indicate, however, a connotation of sin, suggesting either the beggar's avid collecting of money or (perhaps) the usurer who has to hide his wealth.[4] Whatever the specific meaning, the suggestion of sin prevails.

At the other end of the group stands a figure with one hand cut off; in the other he holds a tall staff; his eyes are covered by a piece of cloth that may be understood as part of his headgear. Is he blind? In fourteenth-century Florence, we know, some blind men covered their eyes with a piece of linen,[5] probably in order to spare the people around them the repulsive sight of their empty eye sockets. It seems likely, therefore, that this figure in Traini's fresco represents a beggar who is both crippled and blind. The physiognomic type of this beggar, as far as can be made out, is coarse and plebeian, but I can find no explicit suggestion of vice or sin in his figure. It is the blind beggar's low-class nature, his gross and vulgar character, that are emphasized.

At roughly the same time as the Pisa fresco, Andrea Orcagna made, in the Church of Santa Croce in neighboring Florence, a monumental wall painting representing the same theme, the Triumph of Death. This work, and two others that Orcagna painted in the same church, were destroyed. Only two fragments survive. One of the fragments (fig. 22), discovered behind an altar erected by Vasari (who was probably

responsible for the destruction of the paintings in order to give the venerable church a new look), represents a group of beggars who long for Death to come. Prominent among them is a blind man. He differs, in character as well as in manner of representation, from the blind beggar in the Traini fresco. The pale face and bald head have nothing of the pronounced vulgarity, the deformed shapes of Traini's blind figure. Orcagna's blind man has something noble and restrained. His sightless eyes are not hidden, but they are delicately represented. His outstretched hand, appealing to Death to come, also differs from the stiffly extended arms of Traini's beggars; it is raised in a gesture of supplication rather than in a movement of challenge and almost command. Yet although Orcagna's blind figure differs from that by Traini, both are placed in the group of low-class, everyday cripples.

It is not clear whether some of the other beggars in this group are also blind. One or perhaps two of them may be so, though this is not certain. Thus, the bearded beggar with the large hat, placed to the left of the pale one just described, has an unnaturally widely opened eye, and his glance is so rigid and motionless that he may well represent another version of blindness.

An interesting novelty should be observed in the Orcagna painting. It is the still hesitant attempt to indicate by means of stance and gesture that a figure is blind. In itself the motif is not new; one finds it already in Egyptian art.[6] However, it does not seem to have occurred in the artistic tradition of fourteenth-century Florence, nor could Orcagna have known the Egyptian representation. Whether or not he invented the posture, he employed it with great suggestive power. The main feature is the raised head and the uplifted face. It seems as if the blind man is turning to a light in the sky, which he cannot see. In the following centuries this stance became a hallmark of the image of the blind. In the fourteenth century, however, the gesture of raising the head with eyes that cannot see does not seem to have been generally accepted. The posture does not occur in the Traini fresco, though at least one of the beggars is blind.

Some of the features that appear in the paintings must have been known in actual reality, as we can learn from central literary texts of

this century. The clustering of the blind, particularly when begging, was a familiar image. Dante wrote in the *Purgatorio*:

> The impoverished blind who sit all in a row
>> During the Indulgences to beg their bread
>> Lean with their heads exactly so,
> The better to win the pity they beseech,
>> Not only with their cries, but with

their look

>> of fainting grief, which pleads as loud

as speech.[7]

Here Dante confirms, as a generation before him did Rutebeuf,[8] the late-thirteenth-century Parisian poet, that the blind clustered in groups, both for the purpose of begging and, in the evening, for eating and mutual social entertainment. But Dante goes further than recalling the blind beggars' inclination to congregate in groups; he also casts doubt on their honesty. To be sure, they are indeed blind, but they "lean with their heads exactly so," to enhance the impression of their "fainting grief." The half-light in which the blind were seen in the Middle Ages in Northern Europe can be found also in early-fourteenth-century Florence.

The image (or was it a reality?) of the congregating blind beggars lived on. In the second half of the fourteenth century, about the time when Traini and Orcagna painted their murals, we again find the motif of the clustering blind in literature. Franco Sacchetti, the author of *Il Libro delle Trecentonovelle*, tells how the blind congregate in the morning for begging and in the evening for common meals and sometimes heavy drinking. He describes them as drunkards ("inebriati").[9]

Sacchetti's stories are testimony to the belief that the blind are untrustworthy, and to the suspicion that they beg for alms though they are rich. This belief was still very much alive in Florence at the turn of the fourteenth and fifteenth centuries. In the evening the blind beggars count the day's yield, and noisy quarrels ensue when one of them has collected considerably more than the others. It is suggested that one of the blind men, having amassed a great amount of alms over the years,

is actually rich, yet he continues to beg, chants the blind beggars' chant, and for an appropriate reward sings the *intermerata*, a particularly long Latin oration addressed to the Virgin.[10] The old feeling, never fully articulated, that there is something diabolic about the blind (or at least some of them) also reappears in Sacchetti's stories. When the blind beggars quarrel and shout, a neighbor asks whether there are demons dwelling on the floor above.[11]

Many of the features described in these stories are, of course, traditional motifs and model stories inherited from medieval literature, and now repeated time and again with only slight modifications. But Sacchetti may also well offer some observations of actual life, as he directly experienced it. Thus he treats the fact that the blind are guided by dogs as a matter of course, and even tells an amusing story about a scuffle between the dogs of the different blind beggars, and its unfortunate and ridiculous consequences for those who depend on these dogs.[12]

In sum, the fusion of inherited models and actual observation of reality is manifested both in the frescoes of Traini and Orcagna and in the descriptions by Dante and Sacchetti. In a broader, more comprehensive, view we may conclude that in the rapidly growing Italian towns of the fourteenth century the blind beggar was obviously a common sight. He entered the urban culture of the time and is portrayed, in tones that are often coarse rather than compassionate, in literary compositions as well as in pictorial representations of the period. What was the further fate of the blind, or rather of their image, in the later stages of the Renaissance? What was their significance when Italian culture and art became increasingly shaped by the great "humanistic" movement?

Metaphorical Blindness

A student of history always feels awkward when he has to say that the subject that concerns him has declined or even altogether disappeared. Total disappearance can be contradicted by the discovery of even a single object (in this respect archaeology can teach us a valuable lesson), and the decline of a subject, in frequency and significance of treatment,

is notoriously difficult to measure. In spite of such hesitations, how-
ever, one feels confident in claiming that in Renaissance Italy the image
of ordinary blind person, especially the blind beggar, dramatically
declined in the fifteenth and sixteenth centuries. The subject of blind-
ness in general underwent profound changes during these centuries.
While the theme of the everyday blind man fades away, metaphorical
blindness becomes not only a prominent, but also a variegated subject,
more than ever before. It is mainly personifications of abstract concepts
that are represented, in verse and illustration, as blind. Both the mean-
ing of their blindness and the manner in which it is presented to the
eye move away from what we learn in Traini and Orcagna, as well as in
Dante and Sacchetti.

I shall begin our brief discussion of figures of blindness in the imag-
ination of the Italian Renaissance with a motif in which a (supposedly)
real blind person is meant. This motif, found only in the emblem liter-
ature of the sixteenth and seventeenth centuries, seems to have enjoyed
a very wide distribution. Let us first look at an example in Andrea
Alciati's *Emblemata*. An emblem, as we know, usually consist of three
parts: a concise verbal motto, an image (in the sixteenth century usu-
ally a woodcut), and an explanatory poem. The motto of our emblem
(fig. 23) reads "Mutuum auxilium" (mutual assistance). The woodcut
shows a blind man walking, reminding us in his external appearance of
an itinerant beggar, probing his way with a stick. On his shoulders he
carries another figure, a lame man whose wooden leg is prominently
displayed. The lame whose sight is not impaired tells the blind where
the road is and where it leads.[13]

The poem to this emblem is an interesting document of the pro-
found change in the context within which blindness was seen. Two
points should be stressed. First, the verse documents a new, and
somewhat abstract, way of seeing blindness. Here it is not perceived
as the ultimate disaster that can befall man, the darkness and utter
dependence from which there is no escape. But it should be kept in
mind that the blind man is also not presented as the cunning beggar,
the drunkard, and the dishonest character who takes advantage of his
tragic defect to move us emotionally, to force pity upon us, and thus
to compel us to give alms. The whole group, and the blind and the

lame individually, are presented in a religiously and emotionally detached tone. These disabled people are not shown as enduring punishment for some sin, but neither are they tragically suffering figures. In their interaction they offer a kind of didactic advice; they demonstrate how limitations can be overcome. It is worth noting that at least in the translation in one edition (Paris, 1542) the poem that forms part of this emblem concludes with a reference to God's command: God has ordered that we help each other.

It is this mode of detachment and a certain emotional distance, I believe, that leads to the most prominent use of blindness and the way of representing it in the Renaissance. The student of Renaissance imagery, in literature as well as in the visual arts, will note the personifications of ideas and abstract concepts that are imagined and represented as blind. Not only are these figures themselves of an abstract nature, but the blindness conceived as their attribute is, of course, also metaphorical. I shall briefly outline two of the personifications that were most significant in Renaissance imagery, which reveal the problems and the particular sources of this kind of blindness.

One of the best-known of these personifications is the figure of Fortuna. This goddess, or personification, of luck has a long history, and scholars have devoted much attention to it.[14] We need not deal here with its many and eventful aspects. What concerns us is that her vision is obstructed, that she appears as blindfold. We should note that it is only late in the life of Fortuna in European culture that we find her eyes covered. The idea expressed in the blindfold is, of course, that luck is fickle, that it is always changing and that no firm reasons can be given for this. The distribution of luck and disaster, it has always been felt, has no rational grounds; it is blind.

These ideas, however, were expressed mainly in symbols other than blindness. The proverbial Wheel of Fortune that she spins, and the globe on which she precariously balances, were Fortuna's primary attributes, suggested or shown in words and illustrations. Without attempting to discuss these attributes, we may keep in mind that the notion of blindness always seems to be present in the background of the Fortuna imagery.

When Augustine attacks the "pagan goddess" Fortuna, his main argument is that she distributes her gifts at random. This is a kind of blindness. "Why is she worshipped, who is thus blind, running at random on any one whatever, so that for the most part she passes by her worshippers, and cleaves to those who despise her?"[15] To Augustine Fortuna's blindness is altogether metaphorical. He does not allude to any particular form of that pagan goddess. He does mention an image of Fortuna,[16] obviously some kind of ritual statue, but even here he does not suggest any specific visible form, and no shape whatsoever that would indicate her blindness.

Augustine's assault on the pagan goddess did not uproot her from the memory and imagination of following generations. Not long after Augustine, another great writer, whose impact on the intellectual life of the Middle Ages was formative, dealt with her in some detail. This was Boethius, who, in the ups and downs of his life, in the dramatic changes of his fate, was well qualified to testify to her power. In *The Consolation of Philosophy*, the dialogue Boethius wrote while he was in prison waiting to be executed, Fortuna plays an important part. Let us listen to what Boethius says:

> What is it, mortal man, that has cast you down into grief and mourning? You have seen something unwonted, it would seem, something strange to you. But if you think that Fortune has changed toward you, you are wrong. These are ever her ways: this is her very nature. She has with you preserved her own constancy by her very change. She was ever changeable at the time when she smiled upon you, when she was mocking you with allurements of false good fortune. You have discovered both the different faces of the blind goddess.[17]

Boethius knows the image of the Wheel of Fortune. "Are you trying to stay the force of her turning wheel?" Philosophy asks the condemned man, to show him the futility of his attempts to escape the rule of Fortuna.[18] The image of this figure is, then, fairly clearly present before Boethius's eyes. But he, too, seems to perceive her blindness as a mere metaphor, a metaphor that does not take on any distinct visual

shape. However, Fortuna's constant changeability did eventually assume such a shape: the rotating wheel. It remained her stable and permanent attribute. The medieval Fortuna was the Fortuna with the wheel, while her blindness remained an abstract statement.

This does not mean that the blindness was forgotten. Medieval authors who evoked the image of Fortuna rarely omitted to mention it. I shall quote here only that remarkable protohumanist, Alan of Lille. In *Anticlaudianus*, written between 1181 and 1184, Alan describes Fortuna in his lively, chiastic style: "She is fickle, unreliable, changeable, uncertain, random, unstable, unsettled. When one thinks that she has taken a stand, she falls and with a counterfeit smile she feigns joy. She is rough in her gentleness, overcast in her light, rich and poor, tame and savage, sweet and bitter. She weeps as she smiles, roams around as she stands, is blind as she sees."[19] The whole text merits careful reading. It is a marvelous mirror of the medieval imagination, and Alan devotes specific attention to Fortuna. But though he is aware of Fortuna's blindness, her main attribute in his mind is the wheel.

Fortuna's wheel prevailed over all her other attributes, though it did not suppress them altogether. Dante bears important testimony to this development. He conjures up Fortuna several times, once or twice even referring to her appearance. On at least three occasions he either describes or intimates the wheel as her major attribute.[20] Dante also articulated a new attribute of Fortuna's fickleness, her never ceasing change, and of the instability that characterizes her. This innovation is a sphere on which she balances precariously.

> But she is blessed, and for that recks not:
>> Amidst the other primal beings glad
>> Rolls on her sphere, and in her bliss

exults.[21]

It adds to Fortuna's malicious nature that she derives pleasure from every movement of the rolling sphere, which, we remember, means the misfortune of many people. She, however, is indifferent to their suffering and enjoys the play of movement. In our context it should be noted specifically that her blindness recedes into the background.

We should keep in mind that, whatever the attributes and their changes in the course of centuries, the nature and status of Fortuna herself remained remarkably stable throughout the Middle Ages. She is perceived as thoroughly ambiguous, a combination of a supernatural spirit endowed with a miraculous, irresistible force, and a dark, demonic creature. In the whole period from antiquity to the Renaissance Fortuna's elevated status was never in doubt. It was taken as a matter of course that nobody, whether individual or nation, ruler or slave, could shake off her unlimited rule. In medieval parlance this was expressed by saying that none can stay the turn of Fortuna's wheel. It is this status and nature—dominating and demonic—that determine her shape in the imagination of the period after the Middle Ages.

The Renaissance did not forget the medieval images and attributes of Fortuna; the wheel she turns and the sphere on which she balances are firmly established motifs in the imagery of the period. In addition to them, however, in the Renaissance, and especially the sixteenth century, people were again paying attention to the blindness of the pagan goddess. A certain difference may perhaps be discerned between literature and the visual arts in the emphasis on her blindness, but on the whole we can say that both wished, in one way or another, to stress that aspect of the figure.

But how could the mind imagine the shape of that blindness? The blind being, Fortuna, is on the one hand demonic and devilish, on the other elevated above the level of regular mortals. Authors and artists must have felt that the empty eyes, the blind man's staff, the hesitant step, and the fumbling gesture, in short, all that designates the blind beggar, are not suitable to show the blindness of this redoubtable pagan goddess. What, then, is?

To answer the question I shall analyze one example, the description and depiction of the goddess Fortuna by the sixteenth-century mythographer Vincenzo Cartari. Mythography, a particular branch of what we might now call cultural studies, was one of the great and original creations of the Renaissance age. Mythographers were a fusion of antiquarians, literary scholars, and (what is not sufficiently emphasized) students of the imagination of a culture. What the original

mythographers asked was: How did the ancients imagine their gods? To be sure, they wished to reconstruct ancient monuments, both known and unknown ones, and for this purpose they made original, creative use of ancient texts. But their true aim was to see and understand the shape of the gods, whether or not they executed these shapes in marble or in color. In his *Imagini delli dei de gl'Antichi*, which first appeared in Venice in 1556, Vincenzo Cartari devotes a lengthy chapter to the shape of the goddess Fortuna.[22] How does she look? And how is her blindness represented?

He describes the pagan goddess as a beauty. She is a nude woman, with large wings ("con ali"), precariously balancing on a wheel (thus merging the Wheel of Fortune and the globe on which she stands in Dante). Cartari obviously had difficulties with Fortuna's blindness. How was that defect to be imagined? There is an interesting difference between what he says about Fortuna's blindness and what the images show. At one place in the text he says that Fortuna looks downward ("guardare al basso"), perhaps indicating that her eyes, cast down, cannot be seen. At another point he says that she has twisted eyes ("occhio torto"), that is, she is cross-eyed. The woodcut that illustrates Cartari's description tells an altogether different story. She neither looks downward nor is she cross-eyed. In fact, we don't see her eyes at all—they are covered with a large blindfold.

A spectator aware of historical contexts cannot help being surprised to see a blindfold covering Fortuna's eyes in the work of a humanistic mythographer of the sixteenth century. We have seen the blindfold in medieval personifications of the Synagogue and of Death, mainly in Northern Europe. In Italian art and imagination of the sixteenth century the Synagogue plays no significant role at all. I am not aware of any Italian image of that time that represents the Synagogue, or a personification of the Old Testament or of Judaism, as a blindfold female figure, let alone a nude one. Death, though more frequently represented, also does not appear as a naked blindfold figure. We cannot avoid asking two questions. First, where did the illustrator of Cartari's text find the unusual feature of the blindfold? Is it at all connected with the medieval blindfold, or is it an altogether new invention? Second is

the more important question of what the blindfold means here. What are the connotations of the blindfold, particularly in a period that, as we have seen, was well acquainted with the more or less realistic image of regular, everyday blind people?

We do not know what artist illustrated Cartari's text or, with any precision, what his sources were. But we do know that the blindfold on Fortuna's eyes had appeared before him, though in images bearing witness to a cultural mood altogether different from that of Cartari. An interesting pictorial source is the edition of a text by Petrarch published in 1532, about two decades before the first edition of Cartari's work.[23] Petrarch's text does not add any new indications of Fortuna's external appearance, but the illustration does. In the center of the woodcut (fig. 24) we see the almost unavoidable Wheel of Fortune, but this time it is planted on a mighty pole, and figures are moving on it, upward and downward. A woman standing to the right of the pole, wearing an ample dress, her eyes covered with a blindfold, spins the colossal wheel. The place that this Fortuna occupies at the foot of the pole, her long and flowing hair, and perhaps even something in her posture, are vaguely reminiscent of Mary Magdalene at the foot of the Cross. The resemblance may suggest that at the time the edition was published or the unknown artist prepared the illustration there was no traditional, broadly accepted model for Fortuna. In any case, in pictorial composition and expressive mode, the Fortuna of the 1532 woodcut is far removed from Cartari's naked pagan goddess balancing on a rotating wheel. But the specific motif of the blindfold is clearly articulated.

In a slightly earlier (1519) woodcut, made by Hans Weiditz, illustrating a text by Ulrich von Hutten, the German poet and political reformer of the early sixteenth century, we also see the Wheel of Fortune on which political symbols move up and down as it is spun by Fortuna. Here (fig. 25) the pagan goddess, to the left of the wheel, is a mighty winged female figure, fully clothed, treading with one foot on the clouds, with the other on the by now customary globe. But as she spins the wheel, her eyes are covered with a blindfold.[24]

The development of this motif—the blindfold Fortuna—reaches a

climax in figures such as that in the illustration to Cartari. Here she is a nude, thoroughly pagan mythical personage, wearing the blindfold that for centuries was indissolubly linked to the figure of the Synagogue, a figure created by, and existing only in, the Christian imagination. What, then, is the specific character of the blindfold here?

Before offering an answer to this question we should recall that Fortuna was not the only ancient, if you wish "pagan," figure that in Renaissance imagination was equipped with a blindfold. Another example, probably even more famous than Fortuna, is the blindfold Cupid. Cupid is one of the best-known figures bequeathed to us by antiquity, still used in different present-day media. The emergence, and the main turns in the development, of blindfold Cupid have been discussed by Panofsky.[25] This study shows that the nude and blindfold Cupid, presented later in the Renaissance as a more or less harmless figure, "had to extricate himself from a very strange-looking and, indeed, demoniacal image." It is an image where the nude boy Cupid is not only blindfold, but has talons like those known from images of the devil. About a generation before Traini and Orcagna created their realistic blind beggars in Pisa and Florence, a Cupid was painted in nearby Assisi, in the church of S. Francesco (fig. 26). He is "a boy of twelve or thirteen, with wings and a crown of roses. His eyes are bandaged and he is entirely nude, except for the string of his quiver, on which are threaded the hearts of his victims like scalps on the belt of an Indian. Instead of human feet he has griffons' claws."[26]

We can now attempt to draw some preliminary conclusions. In Renaissance understanding, the two figures we have discussed, Fortuna and Cupid, have certain important traits in common. They are both personifications. Humanistic scholars were well aware that these figures originated in the ancient mythological pantheon of gods and semigods, and that there they were endowed with a particular reality. In Renaissance culture, however, they are understood and rendered mainly as personifications of notions and ideas. Even more significant is that, as understood in Italian culture of the Renaissance, Fortuna and Cupid combined the supernatural and semidivine with some explicit demonic properties. To the spectator in fifteenth- and mainly sixteenth-century

Italy, saturated as he was with Christian beliefs, both these mythological figures carried the connotation of sin and guilt.

It is precisely this combination or fusion of supernatural power and sinfulness that is expressed in the blindfold. In both cases, blindness as such carries, even if only in a concealed way, the suggestion of culpability. Explicitly, the blindfold says that, in one case, luck is distributed at random, and, in the other, that there is no rational reason for the lover to be passionate about a specific beloved. Behind these obvious meanings, however, blindness carries the sense of guilt and is even a kind of hidden sign of a demonic nature.

Here we come back to the main point of the present theme: Blindness is expressed differently in the figure of the real-life beggar and in the semidemonic yet noble personification. The hierarchy of blindness and its signs, which as we have seen was so clearly articulated in the Middle Ages, continues during the Renaissance. To be sure, the identity of the "noble" blind has changed: instead of the Synagogue we have mythological figures. The thought model of hierarchy, however, remains.

The Revival of the Blind Seer

The images of the secular blind referred to so far, whether portraying real beings (blind beggars) or imaginary figures (blindfold personifications), carried more or less explicit connotations of sinfulness. But the Renaissance imagination, at least at the time when this culture reached a climax, knew still another image of secular, or at least non-Christian, blindness; it is the image of the blind Homer. Homer's figure belongs, of course, to an altogether different cultural context than the beggar or even the personification of blind luck; this is part and parcel of what we are generally used to describing as the revival of antiquity in the Renaissance period. The *rinascimento dell'antichità*, as has been shown in many important studies, often amounted to a radical reinterpretation of the models inherited from antiquity. This also holds true for the image of the blind Homer. For the Italian Renaissance antiquity was primarily Roman antiquity, and this may explain the fact, strange at first glance, that Homer was not frequently described or depicted as a

blind poet. Only a few images present blind Homer. One of these, however, is a central and typical monument of the period, and it has profoundly impressed itself on the cultural memory of the modern age. For our purpose it may be best to concentrate on this work of High Renaissance painting, a work that has become an icon of the culture we are here considering. It is Raphael's fresco in the Stanza della Segnatura representing the Parnassus.

The ensemble of Raphael's frescoes in the Stanza della Segnatura in the Vatican is generally considered a major monument of the classiciz-ing, "revivalist" trend in the High Renaissance. No other painting comes as close to the realization of the humanist utopia of a perfect *rinascimento dell'antichità* as the *Parnassus*. Here the "divine" Raphael conjured up a classical theme and cast it in what, at least in the first two decades of the sixteenth century, was believed to be a classical form. The striving to be "true" to models of antiquity dominated even the shape of the musical instruments depicted.[27] Within the system of images pre-sented in the Stanza, the *Parnassus* is of particular significance for our subject. It is a pictorial statement about blindness. In the fresco the mythological mountain of poetry and poetic inspiration is inhabited by Apollo, the god of poetry, and his assistants, the Muses. In addition to the mythical figures, a group of poets is depicted. The poets' figures are lifelike; some of them can be identified by their portrait-like features. They are those of the poets most famous and popular in the Renais-sance. Poetry is timeless, we learn from the painting; poets of different ages and languages are shown together. Around Homer cluster Virgil, Dante, and Petrarch. However, both in the place he occupies in the composition and even in the size of his figure, Homer, the first Greek poet, clearly forms the center of the group (fig. 27).[28] The painter took care to emphasize the centrality of Homer. He not only towers above all the others, but he is the only one in the group to be fully and frontally represented. No other figure overlaps, or at all obscures, the first of poets.[29] In the *Parnassus*, the undisturbed full view of Homer has only one parallel—Apollo himself.

In this image Homer is not only a central figure, but his distinct character, differing from that of all the others, is emphasized. Raphael

depicted him as a venerable, awe-inspiring sage, an old man who some-how conveys the sense of the aged possessing secret knowledge. He turns his divinely animated face upward, as if he were looking at some celestial revelation (which he could not see) or listening to a voice com-ing from heaven. The poet's blindness is so obviously made manifest that one cannot doubt that this was precisely the artist's intention—to convey to the spectator that the venerated Homer was blind. His sight-less eyes are not hidden from the spectator, they are also not deformed as we have seen in the images of blind beggars. Neither are they cov-ered with a blindfold as those of the Synagogue, Fortuna, and Cupid. Homer's blindness evidently should not be hidden. It is revealed as both awe-inspiring and beautiful.

The tradition of Homer's blindness goes back to the archaic stages of antiquity. The bard of the *Hymn to Apollo*, an early Greek poem long attributed to Homer, describes himself as a blind man.[30] The descrip-tion of another blind poet and singer, Demodocus, found in the *Odyssey*, was also read as a Homeric self-portrait.[31] In the present con-text we should keep in mind what is said in the *Odyssey* about this otherwise unknown bard. At a feast the king of the Phaeacians says: "And let our glorious bard, Demodocus, be summoned. For no other singer has his heavenly gift of delighting our ears whatever theme he chooses for his song."[32] The origin of Demodocus's gift and inspiration is divine. "No one on earth can help honoring and respecting the bards, for the Muse has taught them the art of song and she loves the minstrel fraternity."[33] The gift of sweet song given to the bard, we learn in the same text, is ambivalent: the singer's divine inspiration is linked to his blindness. Demodocus is introduced as the Phaeacians' "favorite bard, whom the Muse loved above all others, though she had mingled good and evil in her gifts, robbing him of his eyes but lending sweetness to his song."[34]

In ancient lore even Homer's blindness, though intimately linked with the divine gift of poetry, was not altogether divorced from con-notations of guilt. The poet's blindness was not only the price of his "sweet song" but was also understood as a punishment. For this view we have the important, if parodistic, testimony of none other than

Plato. Homer the poet, says Plato in the *Phaedrus*, "never had the wit to discover why he was blind," but "Stesichorus, who was a philosopher . . . knew the reason why." Homer, the philosopher says, "lost his eyes, for that was the penalty that was inflicted upon him for reviling the lovely Helen."[35]

The combination of receiving divine inspiration and being robbed of one's eyes by the same god suggested to many generations a link between blindness and supernatural vision. In fact, still in the ancient world, particularly in late antiquity, Homer's blindness was understood not merely as a natural misfortune, or even as an ambiguous gift of the gods. It became a metaphor for transcendent vision. In late antiquity Proclus is our best source for this interpretation.[36]

There is no continuity in the history of blind Homer. In the Middle Ages his figure seems to have faded from memory and imagination. I am not aware of any explicit medieval rendering, literary or pictorial, of the great poet as a blind sage. There were certainly several reasons for this suppression of what medieval readers had learned from antiquity. In addition to the general desire of a Christian culture to set itself off from the ancient heritage that was understood as pagan, there may have been the difficulty of resolving the striking contrast between blindness, on the one hand, and the mental image of a venerable wise man or a saint, on the other. For many ages blindness was too closely linked with guilt, it was too much conceived as the wages of sin, to be considered an appropriate appearance of a greatly revered sage. If this rather intuitive explanation is correct, we have to ask what happened in Italian culture around 1500 that made possible the revival of blind Homer's image. And how did the culture that reached such classic expression in Raphael's *Parnassus* understand Homer's blindness?

Without offering a simple answer to such an intricate question, we should remind ourselves of important trends in Renaissance culture— intellectual, emotional, artistic—that would have formed an appropriate background for the emergence of an image of the blind Homer reciting his epics, and might suggest how the audience understood it. A sixteenth- century image of Homer is, of course, part of a major cultural movement of the time, the revival of antiquity. An artist working in Rome shortly

after 1500 may have been acquainted with an ancient bust of Homer that could have suggested blindness. Raphael's Homer, however, is not a copy of an antique model. In spite of the fact that in the *Parnassus* Raphael drew from antiquity, both in subject matter and probably also in form, his Homer is an original, a "modern" creation.

Raphael's emphasis on Homer's blindness is stronger than in any ancient representation of the poet that could have been known in Renaissance Rome. The stance of the figure and the raised head, the sightless eyes shown to the spectator, all this makes the poet's blindness very prominent. When Marcantonio Raimondi made an engraving after the *Parnassus*, he stressed the features suggesting Homer's blindness even more strongly.[37] A significant movement in humanistic thought and reflection on art that began in Rome in the first two decades of the sixteenth century may explain, or make appear less strange, the emphasis on the poet's blindness. A characteristic tendency of this movement, or perhaps it should rather be described as a mood or kind of intellectual climate, was the shift of emphasis from the careful observation of the external world to introspection, to focusing on inward experience. In religion it was the sense of personal devotion, of an inward experience, an "illumination," as distinguished from ritual performance, that was steadily gaining in significance.

In the mental life of the sixteenth and seventeenth centuries, at least in some areas and trends, introspection, the looking inward into one's soul, was a condition one strove to achieve. In the intellectual atmosphere and imagination prevailing in these trends, blindness could have been considered as appropriate, or at least understandable, for a certain type of figure or condition, for the mystical seer, but also for the artist and the poet. In some of the most significant religious movements of the time metaphors that suggest the prevention of seeing (even up to the plucking out of the eyes "of the body") are the core images of central treatises. From the *Cloud of Unknowing* by an anonymous late-fourteenth-century author to the *Dark Night of the Soul* by St. John of the Cross, conditions obscuring vision—the night or the clouds—are perceived as a precondition for true contemplation. Contemplation is oriented to our inner soul; it leads the glance inward.[38]

Introspection, so appropriate for mystical experience, was also considered valid in understanding the poet's and artist's work. In theoretical reflection on the arts inspiration and inner vision played a part that is to some degree comparable to that of "illumination" in religion. Stressing the part played by the artist's inner vision in the creative process sometimes explicitly supplants the demand for a faithful rendering of the external world and a scientific knowledge of the objects described or depicted.[39] This emphasis leads to introspection, to looking into the depths of our soul. In the early decades of the sixteenth century forms of introspection were the core idea of powerful movement both in religion and in the arts. The creation of a work of art was seen as a projection of an image dwelling in the artist's mind. Moreover, Renaissance reflections on the various arts often suggest (metaphorical) blindness as a stage in the process of creation. Since artistic creativity was imagined as the artist's drawing from the depths of his own soul, metaphorical blindness could be taken as a sign of that inward-directed glance. This development in reflection on art, often by artists themselves, has been studied,[40] and we need not repeat the well known. I shall quote only one text, Raphael's letter written in 1516, only a few years after he completed the frescoes in the Stanze, to Baldassare Castiglione, the author of *The Courtier*. "In order to paint a beautiful woman," Raphael writes, "I should have to see many beautiful women, and this under the condition that you were to help me in making a choice; but since there are so few beautiful women and so few sound judges, I make use of a certain idea that comes into my head. . . . I try very hard just to have it [the idea]."[41]

The "idea" of a beautiful woman dwells in the artist's mind. The introspection needed to perceive this "idea" does not amount, of course, to blindness in a literal sense. But the turning into oneself, into one's own mind and soul, may well go together with the concept of a creative artist who cannot perceive the outside world.

Let us now come back to the question posed at the beginning of this section: What does the image of blind Homer suggest about views concerning the nature of blindness? As we have seen, blindness could

assume various meanings, ranging from punishment for guilt to prophetic understanding. The Renaissance inherited, and was aware of, these past meanings of blindness, but it also suggested a new interpretation. This new understanding is adumbrated in the image of the blind poet Homer. Blindness, the condition of looking inward, is the sign both of the divinely inspired sage who contemplates the secrets of the gods and of the poet and the artist who are immersed in the process of creation.

Two points should be emphasized in this Renaissance interpretation of blindness. First, in this context the ancient idea that guilt, whether known or unknown, is a cause and explanation of blindness seems to have altogether disappeared in the Renaissance interpretation of Homer's blindness. In antiquity, as we have seen, there were some beliefs that a former guilty act of the poet caused his blindness. The passage from Plato's *Phaedrus* we have quoted may not have been altogether isolated. In taking over the heritage of antiquity, the Renaissance, however, was selective. In sixteenth- and seventeenth-century literature and art the poet's guilt is nowhere even suggested.[42] Raphael's blind Homer does not suffer a penalty. He is a spiritual hero.

The second point, though not as prominent, was a formative power in Italian Renaissance culture. It is the idea of the inspired artist who creates by introspection. Raphael's blind Homer, then, is not only a spiritual hero but also, perhaps specifically, the model of the creative artist.

Early Secularizations of the Blind

When speaking of the Renaissance as a historical period, we often have in mind what is otherwise called the early modern age. In other words, we perceive some unity in a period longer than a specific movement, ending with the Reformation or Counter Reformation. This extended period, lasting from the beginnings of Humanism and leading up to the threshold of the Enlightenment, was a very complex age. Not only did it abound in currents and countercurrents that were essentially contemporaneous with each other, but it also experienced some dra-

matic transformations in successive stages. Great intellectual, religious, and emotional movements developed in opposed directions, often leading to clashes, some even violent. In many respects, however, the student of history does perceive a distinct break in the overall culture of this time, and this break divides the period into the stage before, say, the last third of the sixteenth century, and the epoch that came after this date. The break, or crack, is marked, especially for the countries that remained Catholic, by the great movement we know as the Counter Reformation. Beginning with the sixties and seventies of the sixteenth century, the Counter Reformation made a profound impression on European thought and imagination, and left its imprint on the centuries to come. It would be impossible to draw a sharp dividing line between the time before and after the beginning of the Counter Reformation. The continuity of ideas and images carried over from the sixteenth into the seventeenth century is an important component of the early modern period. In religious imagination, in literature and in the visual arts, new themes emerged at this critical stage, and traditional themes were often treated in a new way. Blindness, it should be said at the beginning, did not figure centrally in seventeenth-century imagery, as it did not in the sixteenth century. Nevertheless, in the seventeenth century the blind figure shows the marks of the broad transformations that were shaking European culture of the time. We are in the habit of referring to the age after the break as the baroque period. Without attempting any clarification of this much debated term, we shall stick to the accepted terminology.

Before asking how the blind person was understood in the seventeenth century, we should remind ourselves of baroque views concerning the nature of vision and visual experience. Vision was felt as intrinsically contradictory. On the one hand, visual experience played a central part in the culture of the time. The baroque has been described as a "culture of the sensible image,"[43] and vision was believed to assure an immediate experience of the sensible world. It is the power of vision that endows the so-called visual arts, painting and sculpture, with a crucial position in the period's intellectual world. The work of the visual arts was regarded both as a record of scientific exploration and as a means of,

mainly religious, propaganda. The foundation of these views was the belief in the superiority of the sense of sight over the other senses, especially over hearing. This means, of course, the superiority of the image over the word. The comparison between the senses originated in the art literature of the early sixteenth century, and it goes back to Hellenistic literature, but it reached a climax in systematic articulation and wide diffusion in the seventeenth-century baroque.

On the other hand, however, seventeenth-century scientists and thinkers questioned, to a degree unknown in former ages, the reliability of visual experience. What you so directly see—is it really there, and is your perception of what you see really correct? Can we fully depend on visual experience in our cognition of the world? More than in any earlier period, the baroque was aware that even full and immediate visual experience may be misleading. What we see may be a deception or a fraud (*inganno*), as some writers of the time put it.[44] It was a sign of the modern scientific spirit emerging in the seventeenth century that trust in visual experience, however direct and immediate, was shaken, leading to the belief that even what we directly witness with our eyes has to be analyzed and tested.

It is against this background that the baroque conception of the blind in religion, literature, and the visual arts should be seen. As we have just said, the blind person is a marginal figure in the imagination and iconography of the baroque period. Nevertheless, his image reflects the new trends and inclinations characteristic of seventeenth-century culture. Moreover, the figure is now considered in new contexts. In the following observations I shall briefly mention two figurations of the blind. It is not my intention to be in any way exhaustive, and for each of the aspects I shall adduce only one or two examples. I hope, however, that these examples will show how the emotional attitude toward the blind was changing. The two themes I shall briefly touch on are the use of the blind figure for didactic purposes and the expressive character of the blind in some works of art that reveal a new spirit, especially in the pictorial representation of the realistically observed blind beggar. In the seventeenth century the blind beggar could evoke, however vaguely, the connotation of the saint.

Sense of Touch

The problem of the senses, of what immediate sensual experience can, or cannot, provide, was one of the great themes of seventeenth-century thought. In its most striking form it is probably best known in Descartes's radical skepticism concerning sense impressions as a source of knowledge. In the intellectual world of the seventeenth century the problem appeared in a great variety of forms. One was the attempt to define the particular character and specific degree of "truth" of the experience derived from each of the senses. What is characteristic and unique of the sense of sight, of the senses of hearing and touch, and what do they tell us about the world surrounding us? Comparison of the senses was a kind of hobby subject in the seventeenth century, and it may be found in different fields of intellectual endeavor. The problem also appears in the arts and plays a part in literary reflection on the works of painters and sculptors. Let us begin with a pictorial example, Juseppe de Ribera's painting illustrating the sense of touch, now in Pasadena, California.

In *Sense of Touch* (fig. 28), painted circa 1615–1616, the young Ribera, a Spanish artist who spent most of his life in Naples, dramatized his subject.[45] A blind man, his eyes tightly shut, is unable to see the drawing (or painting?) of a man's head placed in the foreground. He turns away from the drawing which he cannot see. In his coarse left hand he holds the finely chiseled and smoothly polished head of a sculpture, probably an antique, and with his right he feels the shapes of the face. The blind man's hands, callous and horny, are in striking contrast to the glossy surface of the head he is touching. This juxtaposition of textures illustrates, I believe, one of the experiences, and a dimension of the world of material objects, which we can learn best by the sense of touch. That the blind man fingers the statue's eye, its shape and opening, may also not be accidental. Ribera presents us with a pictorial statement about what the sense of touch can teach us.[46]

In a later work, done almost two decades after the painting in Pasadena, Ribera came back to the subject. In *Sense of Touch* in Madrid, painted in 1632, the blind figure is of a different nature. His touching,

feeling hand is no longer so callous, his face, with a high, shining fore-head, does not represent a peasant or laborer. He rather suggests a wise old man. The sculpted head in his hands is now clearly an antique, and it may be characteristic that here the blind man does not touch its eyes; he only feels the wavy hair. But whatever the differences between the two pictures, both show that the comparison of the senses in general, and the exploration of the sense of touch in particular, was a concern of the artist, and, one presumes, it must have had an appeal to the audience.

The two paintings can, of course, be approached from different points of view, including their style, their models in the pictorial tradition, and many other aspects. Here I shall concentrate on a single question, namely: What do these paintings tell us about the seventeenth-century attitude to the blind? It will be enough to stress a few specific points.

My first point is obvious. To experience an object by touch requires, so it seems, that it not be experienced by sight. To demonstrate the total exclusion of visual experience, it is a blind man who is experiencing the carved head. The context of blindness is here simply the exclusion of vision. In other words, the blind person is here seen in a neutral or, to use a modern term, value-free, context.

My next point is less simple: it is the human type of the blind, and what may be inferred about his nature and social position. In the past, as we have seen, the figure of the blind oscillated between a low-class beggar, often associated with deception, sin, and guilt, and a mythical seer or singer, endowed with supernatural gifts. The blind man depicted by Ribera is neither of the two types. In the Pasadena painting he may be a peasant or a manual laborer (as the rendering of the hands perhaps suggests), but there is nothing derisive or grotesque about him; no suspicion or blame are intimated. The figure is not deformed, the face and hands are not distorted. His dress, too, does not indicate any grotesque deviation from accepted social norms. The later painting, the one now in the Prado in Madrid, even vaguely suggests a certain idealization of the blind man—an aura of wisdom and of noble intro-spection seems to surround the figure. On the other hand, however, he

is not a blind singer, no new version of Teiresias or Homer. A new type is slowly taking shape.

Of particular interest is how the blind man's face, and especially his sightless eyes, are represented. As we remember, two major models of showing blind eyes emerged and were followed for many centuries. One, probably the dominant tradition, is reluctant to show the eyes. To indicate blindness, other means are employed. We recall the blindfold— of the Synagogue, of Fortuna, and of similar figures—that was the most famous model to present blindness without actually showing the eyes. A more realistic way of covering the blind eyes is seen in Traini's *Triumph of Death* (see again fig. 21). Here the blind beggar's cap is pulled down over his eyes, thus removing them from the spectator's sight. The other great model of showing blindness is to depict the face and the grue-somely deformed and distorted eyes. A classic example of this tradition is found in Brueghel's *The Parable of the Blind* (see again fig. 18).

The seventeenth century opens up a new path in depicting blind eyes. Both paintings by Ribera are good illustrations of this new depar-ture. In the Pasadena painting the eyes are not hidden or distorted, they are simply closed. In the Madrid picture the eyes are somewhat overcast with shadows, but here, too, the shape of the eye and of the lid is clearly outlined. Perhaps more than anything else, this depiction of the blind man's eyes betrays the profound transformation that the understanding of blindness, and the emotional attitude toward the blind, were undergoing in the seventeenth century.

The Blind Beggar in the Seventeenth Century

It has often been said that one of the hallmarks of the baroque imagination—whether recorded in sermons, in works of literature, or in the visual arts—is the fusion of a terrestrial, sometimes crude, real-ism and a fervent religious sentiment. In the nineteenth century it became a matter of course to link realism with the profane world, a world in which there are no miracles and no angels. In the seventeenth century, it goes without saying, realism carried different connotations. As opposed to what we know from the nineteenth century, the realism of the baroque does not carry connotations of a profane, secular world

contrasted with the celestial one. Realism is mostly oriented toward sacred stories and holy figures, and brings these supernatural figures and events within the scope of human experience. No period excelled to such a degree as the baroque in depicting and describing martyrdom,[47] vividly conveying the real, physical pain suffered by the saints. The "verism" of baroque imagination and art does not contradict the profound emotional devotion to religious contents. It brings home to spectators and readers that human suffering can be a vessel for supreme religious experience. Does this sense of realism also apply to the image of the blind beggar? Did his image change in the seventeenth century?

Two conflicting attitudes to the blind beggar may be discerned in this period. One is the inherited disposition of suspicion: beggars, especially blind beggars, are deceivers, demonic figures, and rebels. Such attitudes die hard, and in the seventeenth century the accepted view remained dominant. Thus, to give but one example, in 1659 a high French judge asserted that these people, because of the sloth and idleness characteristic of their lives, are addicted to drinking, debauchery, passion for gambling, blasphemy, quarreling, and rebellion.[48] Itinerant beggars were sometimes believed to directly cause blindness, especially of young children. They were said to steal small children and to put out their eyes in order to make them arouse pity and thus be of value in begging.[49]

The traditional attitude to the blind also survived in the widespread belief that blindness is a punishment. In the seventeenth century many stories were told of people going blind because of the sins they committed, and these stories found credulous listeners.[50] Openly or implicitly, then, the blind were seen as sinners. The blind beggar was thus still doubly cursed: he suffered from his physical disability, and he carried the odium of guilt.

Next to this traditional attitude of suspicion, rejection, and condemnation, and overshadowed by it, another view of the blind, together with a changed disposition to them, was beginning to take shape. The slow and gradual emergence of the other attitude, a process that continued for many centuries, may perhaps best be described as the secularization of the blind. Its beginnings may be found in the late

Middle Ages, perhaps as far back as the thirteenth century. Yet it was only in the seventeenth century that this attitude reached some articulate expression, though even then it was still far from being dominant. Here the blind person is perceived as a suffering individual. It is not the dramatic pain of martyrdom, but the continuous burden of a grave and incurable impairment. Already in the thirteenth century, Louis IX established in Paris hospitals for two groups of invalids—the lepers and the blind.[51] These hospitals, it is not difficult to see, were set up both to take care of the people so fatefully afflicted and to have control over them. The social conditions of the two groups were, of course, altogether different. While for the lepers a strictly imposed isolation was the supreme rule, the blind had to be allowed contact with the crowds. They were itinerant beggars, and without reaching alms-giving people they could not subsist. In fact, they were allowed to move to public places, yet only in small groups, no more than three blind beggars together. Whatever the reasons for such social regulations, in some way they single out the blind, and pave the way for a special understanding of their condition.

Another indication of a gradual change in the attitude to the crippled, to the physically impaired in general, and possibly to the person deprived of sight in particular is that in the mental life of the seventeenth century the strict removal of the blind from ritual and from any contact with the implements of ritual was breaking up. We hear more of miraculous healings of the blind. Sight was restored not only by a sectarian's prayer, but more often by using holy oil.[52] We remember that in the religious heritage of the seventeenth century there was an explicit exclusion of the blind from any contact with ritual implements and a prohibition of their participation in any ritual act.[53] This ancient prohibition, which had become the conceptual framework of so many rejections of the blind, was now being undermined.

The process we have called the secularization or humanization of the blind found expression in the arts. Let me now return to Ribera, to the painting *The Blind Beggar and His Boy*, now at Oberlin College, Ohio (fig. 29). This picture, done probably in 1632, may serve as a pictorial testimony to the process here indicated. The blind man is depicted as

he raises his right hand with the alms cup, while placing his left on the shoulder of a youth. One of the oldest motifs of depicting, and visually identifying, the blind is revived in this work—the almost timeless composition of the blind old man led by a young boy. Already in the art of ancient Greece this motif reached classic formulation. It survived the Middle Ages, and the medieval impact was not lost, as we can see in the baroque versions. In classical Greek literature and art the blind old man led by a boy was Teiresias, a kind of prophet, a human being endowed by the gods with the ability of supernatural vision. It was medieval society and culture that cast the blind man in the role of the itinerant beggar, and this is how he appears in the seventeenth century. Another, more elevated, reference to the medieval heritage in Ribera's painting is the piece of paper attached to the cup in the blind man's hand. The inscription on the paper evokes a sentence from the Requiem Mass announcing the Last Judgment. It runs "Dies Illa, Dies Illa." In the requiem itself the sentence reads "Dies Irae, Dies Illa" (day of wrath, that day). The echo of the Last Judgement is, of course, intended to impress upon the spectator the role that charity will play in our favor on the day of final accounting. The new attitude to the blind takes shape within the mental framework of medieval concepts and visions.

Some critics have suggested that the subject of Ribera's painting is derived from the picaresque novel *Lazarillo de Tormes*, first published anonymously in the middle of the sixteenth century. The novel tells of a harsh and domineering blind beggar who cruelly oppresses the boy who leads him and assists him in begging. The boy, the story goes, is forced to outwit his master in order to obtain his share of food. In late-sixteenth- and seventeenth-century Europe this story, which continues a motif common in medieval literature (the affinity to *Le garçon et l'aveugle* is obvious), was famous. Does it shed light on Ribera's painting?

The popular story of the ill-treated boy casts the blind man in his traditional role of the immoral deceiver. But it does not account for what is essential in Ribera's painting: the expressive nature of the blind figure, and the spirit of sympathy in which the scene is represented. Raising his head in the gesture so familiar to every observer of the

blind, the beggar here shows a noble and animated face, sharply illu-mined as if by a spotlight. The eyes are not hidden—they are shown in full light—but they are also not distorted. Though tightly shut, they heighten the expression of spirituality radiating from the face. At first glance, this blind man could be taken as the image of a saint. It has been shown that Ribera did indeed use the same model for the depic-tion of a saint (*Saint Joseph and the Young Jesus,* now in the Prado). This expressive affinity between the images of a blind beggar and a saint cannot have escaped the painter and his audience.

Whatever Ribera's sources of inspiration, his image reflects the final stage of a process that was in the making for centuries: a radical trans-formation of the understanding of the blind. It is the process of secularization and of humanization of the blind figure, and particularly of the blind beggar.

In following the history of changing interpretations of blindness, and of changing attitudes toward the blind themselves, we have seen that two basic approaches coexisted in all periods. To be sure, they did not attain an equal degree of explicit articulation. In literature and art, one interpretation is frequently expressed and crystallized in various motifs; the other, one feels, is mostly passed over in silence. Nevertheless, there is little doubt that both have existed, side by side, throughout history. The one attitude that is not so predominant in literature and art would seem to us to be the natural reaction. The blind

5

The Disenchantment of Blindness:
Diderot's *Lettre sur les aveugles*

person is understood primarily as unfortunate, disabled, a human being deprived of what has always been considered the most precious gift man has received. Though not powerfully expressed, compassion for a suffering human being must always have existed. Even though poets and painters were not particularly concerned with it, people must always have felt pity for those who cannot see and cannot find their way without assistance. The simple fact that for many periods the blind lived on alms that individuals gave them shows clearly the continuous existence of compassion as a major factor determining the attitude to the sightless. The other approach conceived of the blind person as a human being who has some mysterious link with a supernatural reality. Most often this supernatural reality was felt as hostile and threatening; the blind, who are somehow linked with it, were therefore perceived as demonic. In rare cases the mysterious reality to which the blind were believed to have access was understood as divine; here the blind person was considered a prophet, one endowed with grace, sometimes with the gift of divination. Since the early modern

age, with the beginning of secularization, a third approach to the blind, and particularly to their spiritual world, began to take shape. In the mid-eighteenth century this new attitude reached a high point, and this moment in history was marked by an important document, Diderot's *Lettre sur les aveugles*. To understand the formation of the new approach, it will be best to concentrate on the text of the *Lettre*.

The *Lettre* was published (clandestinely) in the summer of 1749. It was one of the first independent efforts of a freethinking philosopher, Denis Diderot, who was to become a central figure in the French Enlightenment. Only a few weeks after it appeared, the author was imprisoned in the fortress of Vincennes, accused of distributing writings "contrary to religion, the state or morals." After some time in prison Diderot recanted, mentioning three publications in particular. One of them was the *Lettre sur les aveugles*. Today we may wonder what in the *Lettre* struck the authorities as "contrary to religion, the state or morals." While in Diderot's text we find nothing about any of these, the officers who arrested the author were not altogether mistaken in sensing something new, and potentially threatening, in the publication. In this treatise about the blind there were indeed elements of an intellectual revolution.

When asking what precisely the new elements in the *Lettre* are, we cannot help being perplexed. Most of the observations Diderot presents here are not radically new; they are adumbrated, in a more or less explicit and articulate form, in the literature of many centuries. Each of our author's opinions can be traced back to traditional sources, either in the literature of classical antiquity or in that composed since the beginning of the Renaissance. What is new in the *Lettre* is the general direction of thought. Diderot attempts to explore the inner world of the blind, and obviously the assumption underlying his treatise is that there *is* such a world. It is not the blind person's impairment that the thinker of the Enlightenment wants to understand, but the structure and the functioning of his world. This new intention was based on an overall intellectual upheaval.

The Enlightenment, the central intellectual movement of the eighteenth century, articulated new attitudes in many fields of study; a new

approach to blindness was one of them. Two major components in the spiritual life of the eighteenth century prepared the Enlightenment to formulate the conceptual foundations of this modern view of the blind. One was the well-known criticism and rejection of what was called superstition. It is no exaggeration to say that the Enlightenment rejected with particular zest those superstitions that singled out special groups of people. To be sure, we do not have any discussion by an Enlightenment writer telling us explicitly that the inherited beliefs concerning the particular nature of the blind were superstitious. Yet without going into the interesting problem of what precisely superstition meant to eighteenth-century authors, and according to what criteria an opinion was considered superstitious, we can safely assume that the *philosophes* judged the beliefs in the demonic or even immoral nature of the blind as superstitious prejudices.

The other major component developed without any direct link to the rejection of superstition. It was the Enlightenment's profound concern with sensual experience, and more specifically with the nature of sense perception, and the role they play in the life of the mind in general, and in the process of cognition in particular. The central importance assigned to sensual experience can be seen in many fields of study, but it is most clearly visible when we consider the ideals and procedures of the natural sciences. In the seventeenth century definition was considered the ultimate aim at which scientific endeavors are to be directed; in the eighteenth, description was believed to be the main end of scientific cognition. In seventeenth-century science the mathematical formulation of the structure of nature and its processes was the central method; in eighteenth, it was careful observation and description of natural phenomena that replaced mathematical formulation.[1] In the latter century the supreme aim of scientific endeavors and cognition was to grasp the breadth of nature and the diversity of its forms. This new orientation of thought and science necessarily included, and gave pride of place to, the experience of the senses.

The desire to understand the fullness of nature and to observe and describe the varieties of specific sensual experiences not only dominated general philosophical reflection, but also became a central theme

in the exploration of more limited phenomena. In eighteenth-century thought the so-called problem of Molyneux occupied a surprisingly central place. William Molyneux, a late-seventeenth-century Irish scientist, raised the question of whether experiences derived from one sense will enable us to grasp and understand what we perceive by a different sense. Can we, for example, move from the experience of touch to the experience of sight? Assume, he said, a person born blind who, by means of successful surgery (the secular version of miraculous healing), receives the sense of sight he never possessed. While still blind, he learned by touch the difference between a cube and a sphere. Will this person, now healed, recognize the cube and the sphere when he perceives them by sight only? This question, seemingly only a marginal and hypothetical case, fascinated many of the great thinkers of the time. It was discussed in detail by the English philosophers John Locke and George Berkeley and by the French philosopher and man of letters Condillac. This debate also forms the background of the *Lettre sur les aveugles*. Diderot explicitly refers to the problem in the text.

Before the middle of the eighteenth century Molyneux's problem was a purely theoretical concern, a subject of hypothetical speculation. This changed when, surprisingly, in 1749 the French scientist Reaumur removed by surgery the cataracts of a girl born blind, and thus gave her sight. It was, as has been said, the "experiment of the century."[2] Now a merely hypothetical case could actually be observed and be experimentally tested. Diderot was fascinated with this event, and it was decisive for his intellectual development. The analysis of what is involved in the transition from blindness to vision gave rise to what is considered his mature philosophy. It influenced his thought in many fields, and was also of consequence for the evolution of his aesthetics.[3]

Diderot's analysis of what the blind person who has recovered sight recognizes by the visual perception to which he is not accustomed sheds light on eighteenth-century philosophy, and it is of particular importance for the study of his thought. However, we shall not discuss the *Lettre sur les aveugles* with these broad questions in mind. We shall only ask what the *Lettre* tells us about Diderot's interpretation of blindness itself. Yet to grasp this point we shall have to make a brief

comment on the philosophical question that forms the core of the *Lettre sur les aveugles.*

Like so many eighteenth-century philosophers, Diderot sees it as a matter of course that all our cognition and ideas originate in the experience of the senses. Nothing is in the mind that was not before in the sense—this was the dogma of the empiristic philosophy of the period. The only thing the mind has to work with is the evidence conveyed to it by the senses. In his literary work, the adherence to what is experienced directly may also account, at least to some degree, for Diderot's fascination with the concrete, with the specific detail. Yet while he was in full accord with the views prevailing in his time concerning the overall significance of sense experience, his exploration of the world of the blind is radically different from the way most philosophers of his era saw it. With respect to the blind, even the aim of his thought differed from that of contemporary scientists. The eighteenth-century *philosophes* were transfixed with concern and curiosity as to what would happen when the blind person recovered sight. How will he grasp and interpret the visible world that has become available to him? It is the leap from blindness to vision that, in this question, is the theme of a great deal of eighteenth-century reflection. Diderot's subject is here different. He does not ask what will happen when the blind regain vision; he wants to map and understand the world and the experience of the blind as blind. What can the blind, in the state of full blindness, know of the world surrounding them, and how do they acquire this knowledge? And what are the philosophical implications of the blind person's knowledge of the world? These are the questions that occupy his mind in this discussion, including in the argument about Molyneux's problem.

The world of visual experience consists not only of things, of material objects, but also of relations between them. Can the blind person in some way construct in his mind not only the objects but also their interrelations? It shows Diderot's originality that he perceived this question and drew attention to it. The perception of relationships is the foundation of aesthetics. Diderot thus further sharpened the issue by asking whether the blind can grasp and judge beauty and particularly

symmetry.[4] Symmetry, obviously not a tangible object, is a relationship between objects or shapes or between the parts of a whole. Beauty in a general sense and symmetry in particular have always been understood as a pattern of relations perceived by the eye. Now, since symmetry is a relationship between shapes or between individual parts of a whole, it obviously can be grasped only when the different shapes or parts are perceived simultaneously. But simultaneous perception, it was almost an article of belief, can only be accomplished by the eye, and hence symmetry is based in visual experience. The blind, deprived of the ability to see different shapes simultaneously, cannot experience symmetry.

Here Diderot radically departs from the views prevailing in his time. "Our blind man," he says early in the *Lettre*, "judges symmetries quite well" ("fort bien").[5] To support this rather bold statement Diderot tries to show that the sense of touch, on which the blind have to rely in the absence of the sense of sight, is capable of providing the simultaneous experience of different objects, and mainly of different parts of a whole. He sings a song of praise to the sense of touch. It is the fingertips that constitute the main channel through which the sightless one perceives the world in which he lives. The person born blind is endowed with an exceptional sensitivity in his fingertips. The sense of touch, "weak in us [the seeing]," is strong in those born blind, and thus compensates for the loss of sight. The man born blind "places his soul in his fingertips."[6]

The sense of touch compensates the blind for the absence of sight—this is a leading idea in the *Lettre*. To show this, Diderot discusses some interesting examples. For the seeing, the mirror is indissolubly linked with visual perception. But the blind, Diderot claims, can also perceive a mirror. The difference is only that it will be a mirror of tactile rather than of visual experience. "I asked him," Diderot reports his imaginary conversation with the blind man, "what he means by a mirror; 'a machine,' he answered, 'that places things in relief away from themselves.'"[7] The blind man's use of the mirror shows that in the world of the sightless the sense of touch compensates for the absence of vision.

Another example is the blind person's supposed answer concerning the value of eyesight. Somebody, says the author, suggested that we ask

the blind if he would be pleased to have his eyes. "Were it not for the curiosity that informs me, he said, I would nothing like so much as having long arms."[8] The value of sight is that you perceive things placed at a distance. Were the blind to have arms long enough, their extended ability of touching would be an equivalent of sight.

The sense of touch, Diderot suggests, reveals qualities and characteristics that vision cannot show: "The beauty of the skin, the fitness, the firmness of the flesh, the advantages of stability, the sweetness of breath."[9] Near the end of the *Lettre* the author suggests that the seeing do not have such a highly developed sense of touch, and that this sense gives the blind abilities that the seeing do not have. Just ask the seeing person whether, when his eyes are covered, he will be able to recognize a body by touch.[10] Being dependent on the sense of touch, then, is not only a limitation. Tactile sensations enrich our experience.

Most important for the purpose of our present investigation is Diderot's belief that the sense of touch does not necessarily break up what we experience into countless splintered sensations. Continuity of perceptions can and does exist within the domain of touch. A series of tactile experiences can result in an unbroken, continuous perception. It is on this assumption that Diderot builds his doctrine of a geometry for the blind. To the blind, we read in the *Lettre*, "a straight line . . . is nothing else but the recollection of a series of tactile sensations, placed in the direction of an extended thread."[11]

What are the philosophical implications and the physiological foundations of the blind person's tactile perception of continuity? Contrary to the accepted view, taken for granted in the course of centuries, that the sensation of space is altogether grounded only in visual experience, Diderot suggests that tactile experience can produce the concept of space. By the movements of his body and by the "successive presence of his hand in different places," the person born blind creates the unbroken sensation of a body, and the "sense of direction."[12] It is a statement of far-reaching implications. The very notion of orientation, the "sense of direction," in space implicitly acknowledges that mere extension, that is, something that is not a body or an object, does have a structure. That structure of nonmaterial extension, Diderot suggests, can be

experienced by means of touch. The specific implement of such perception, it is interesting to note, is the "sliding hand."

What is the conclusion of all these observations? Diderot sums it up by saying that "the sensations he has perceived by means of touch are, as it were, the matrix of all his images."[13]

I have tried to present, in rough outline, some aspects of Diderot's views, as they were articulated under the impact of the stirring news about the cataract surgery. We now turn to the questions that have occupied us in following the history of how blindness was understood. In reading the *Lettre sur les aveugles* we are of course not concerned with whether or not Diderot's views are correct. What interests us is his understanding of what blindness is and how far the lack of vision impairs the overall human personality of the blind. In concluding our history, I shall summarize in a few points what we learn from the *Lettre*. Seeing these points in a broad historical perspective will make evident, I hope, the specific nature of Diderot's opinions.

The first point, of central importance for our subject, can be formulated with surprising simplicity. The blind person, Diderot tries to convince his readers, is different from the seeing, but not inferior to him. The conclusion to which the reader of the *Lettre* is led is that the blind can attain all, or almost all, the achievements that are within reach of the seeing. What the blind cannot attain (for instance, coloring) is counterbalanced by achievements of which only he is capable (such as an extremely high sensitivity to texture).

To appreciate this unusual view we shall have to come back for a moment to the problem posed by Molyneux. Can a man born blind upon gaining sight distinguish and identify at a distance the cube and the sphere that were familiar to him from touch? In the eighteenth century opinions on this issue were divided. It was widely believed that the blind recovering sight would *not* be capable of recognizing visually the objects he formerly knew only from touch. Great thinkers such as Locke, Voltaire, and Condillac considered it as a matter of course that the healed blind person would not recognize in vision what he knew only from touch. Diderot, however, without hesitation answers the

question in the affirmative. Yes, the blind man who is given back the sight of his eyes will immediately recognize the images of cube and sphere as the objects he formerly knew from tactile experience. In fact, as has been remarked, by giving such an answer he dissolves the problem.[14]

A modern philosopher may wonder how this translation from one sense to the other is at all possible. If one believes that nothing can be in the mind that was not before in the senses, it would seem consistent, at least at first glance, to infer that an instant transition from a shape perceived by touch to an image perceived by vision is not feasible. But Diderot's thought is more complex. It is in particular his philosophy of man that makes it possible for him to accept an instant transition from one sense to the other, from touch to vision. His concept of man, so far as it can be reconstructed from the *Lettre*, is that we have not only the "external senses" (mainly the regular five senses), but also "internal senses." Both take part in our spiritual life and in all other mental or psychic processes.

The doctrine of the "internal senses" goes back to Greek thought, to Aristotle and Galen; throughout the Middle Ages theories of psychology developed it further.[15] In its simplest form the system of the "internal senses" includes the three faculties of cogitation, memory, and imagination. It is not so clear how far Diderot was familiar with the ancient and medieval texts themselves,[16] but the idea that man has the two levels of senses, external and internal, obviously appeared self-evident to him. In fact, in the *Lettre* he discusses all three "inner senses" that tradition had formulated, and only them. This is not to suggest that Diderot was a typical scholar, or even that he was consciously referring to the philosophical tradition. It shows, however, how deeply steeped he was in the continuities of European culture. One may assume, therefore, that he was also acquainted with the views and beliefs concerning the nature of the blind.

If Diderot was indeed familiar with the doctrine of the internal senses, he freely adjusted it to his own speculations. One of his original departures from the venerable philosophical tradition is his belief, implicit rather than systematically put forward, that the "internal senses" have the power to increase the ability of the one or the other of

the "external senses." The blind person's perception of the world relies primarily on the "external sense" of touch. In this context Diderot says: "I know of nothing that would better demonstrate the reality of the internal sense than this faculty, feeble in us [the seeing] but strong in those born blind, to sense or to recall the bodily sensations, even of those [bodies] that are absent and no longer act upon them [the senses]."[17] The "internal sense," then, regulates the scope and activity of each "external sense." What the blind man misses in vision, he compensates in the subtlety of touch. This regulation assures adequate cognition of the reality surrounding us, also in the blind.

The other internal sense that forms part of the traditional system—memory—plays an important part in Diderot's doctrine of the blind person's inner world. As we have seen, continuity is a condition of knowing bodies and constructing shapes. In the blind person's mind it is memory that makes continuities possible. To him, we know, a straight line is the recollection of an uninterrupted series of tactile sensations. In constructing continuities, it emerges from Diderot's text, the "inner" sense of memory takes over the functions that for the seeing are performed by the "external" sense of vision. Foremost among these functions is the perception of continuities. So important is memory for the blind person that his ability to recall sensations is as highly developed as his ability to perceive by touch. The blind, says Diderot, can recall ("se rappeler") sensations of bodies even if they are not present.[18]

Memory or recollection leads us to the last of the "inner senses," the sense of imagination. In his views concerning the nature of imagination Diderot follows the empirical philosophy of his time. Imagination does not create something out of nothing this is taken for granted. Sense impressions are the materials the imagination employs. What Diderot tries to show is that the imagination of the blind is in no way different from that of the seeing. The data on which the imagination of the seeing draws are different from those which the blind person's imagination uses, but in its nature and the way it functions the imagination of both is identical. The blind person's imagination "is nothing else than the faculty to recall and to combine sensations of tangible points, and that of the person who sees is the faculty to recall and com-

bine visible points."[19] Except for the divergence in medium—touch for one, vision for the other—there is, then, no difference between the imagination of the blind and the seeing.

From all this it follows that the imagination of the blind is not poorer—or, as Diderot puts it, more abstract—than that of the seeing.[20] Abstraction, the author notes, is nothing but the separation of thoughts from the sensible qualities of the bodies. The blind person makes this separation as well as the seeing. In his mind he has no fewer "sensible qualities" from which to separate his thoughts than the seeing. He has, as Diderot would say, the same large store of *idées des figures*.[21] The meaning of this concept, *idées des figures*, is what we frequently, if somewhat loosely, call "mental images." The inner world of the blind, it turns out perhaps paradoxically, is full of images. It is the mental image that tells the blind man who has recovered his sight that a certain shape, a cube or a sphere, which he now sees with his eyes is the same as the shape he earlier perceived with the tips of his fingers. And it is this mental image that makes cognition, as we know it, the act of a full human being.

In the context of the present discussion we can sum up in two points Diderot's thoughts on our subject. First, he tried to show that in richness of mental imagery the blind person is not inferior to the seeing and that his mind works in the same way as the mind of the seeing. Second, by showing that the functioning of the blind person's mind can be rationally analyzed and studied no less than that of the seeing, he brings about the disenchantment of blindness. It is the close of a tradition that had prevailed for almost the whole duration of European culture.

Notes

Introduction

1. Julius Held, *Rembrandt's Aristotle and Other Rembrandt Studies* (Princeton: Princeton University Press 1969), p. 114.

2. Lise Manniche, *Music and Musicians in Ancient Egypt* (London: British Museum Press, 1991), p. 99.

3. Ibid., p. 100.

4. *Love's Labor's Lost* 5.2.402–5.

5. For a possible "iconography" of shadows in Rembrandt's work, see William S. Heckscher, *Rembrandt's Anatomy of Dr. Nicolaas Tulp: An Iconological Study* (New York: New York University Press, 1958), pp. 36ff., 41.

6. Manniche, *Music and Musicians*, p. 99, suggests four different models for deformed or destroyed eyes, but admits that in most cases they can either not be made out or are not employed at all.

1 Antiquity

1. I am not aware of any book-length monographic study of blindness in the Bible. An old essay by Adolf Rosenzweig, *Das Auge in Bibel und Talmud* (Berlin: Meyer und Müller, 1892) is still useful, but treats blindness only marginally. See also *Encyclopedia Judaica* (Jerusalem, 1971), s.v. "blindness."

2. 2 Kings 25:6–7. See also Jer. 52:1–11. I use the Authorized (King James) version throughout.

3. In view of later developments, to be discussed in this chapter (see the section on the blind seer), it should also be mentioned that in stories of both Eli and Ahijah the state of prophecy is in no way linked to the condition of blindness. Blindness is no prerequisite of prophecy, nor is it, as one concludes, preventing prophecy.

4. I borrow the formulation by Mary Douglas, "In the Wilderness: The Doctrine of Defilement in the Book of Numbers," *Journal for the Study of the Old Testament*, Supplement Series 158 (Sheffield, 1993): 24.

5. H. Freedman and M. Simon, eds., *Midrash Rabbah* (London: Soncino Press, 1961), p. 203.

6. Ibid., p. 657.

7. On some aspects of ritual perfection significant in our context, see Walter Burkert, *Greek Religion* (Cambridge, Mass.: Harvard University Press, 1985), p. 98. See also Mary Douglas, *Purity and Danger* (London: Routledge, 1966), p. 116.

8. Diodorus Siculus 1.59. See Diodorus of Sicily, trans. by C. H. Oldfather (Cambridge, Mass.: Harvard University Press, and London, 1966), I, p. 205. The "natural predisposition" however is only one possible cause of blindness. For other causes, given more attention, see the next section of this chapter, dealing with blindness and guilt.

9. Plutarch, *Timoleon* 37.

10. For the notion of disease in the Greco-Roman world, see L. Edelstein, "Greek Medicine in Relation to Religion and Magic," *Bulletin of Historical Medicine*, 5 (1937): 204ff.; Fridolf Kudlien, *Der Beginn des medizinischen Denkens bei den Griechen: Von Homer bis Hippokrates* (Zurich and Stuttgart: Artemis Verlag, 1967), pp. 48–75. Owsei Temkin, *Hippocrates in a World of Pagans and Christians* (Baltimore and London: The Johns Hopkins University Press, 1991), though concentrating mainly on the later centuries of antiquity, has much to say about the ancient concepts of disease. The study of primitive concepts of disease, even if not dealing with concept of the classical world, may be helpful. See Forrest E. Clements, "Primitive Concepts of Disease," *University of California Publications in American Archaeology and Ethnology* 32 no. 2 (Cambridge, 1932): 185–252.

11. Thucydides, *The Peloponnesian War* 2.49.

12. Kudlien, in *Der Beginn des medizinischen Denkens*, called attention to the fact that the later authors followed the description by Thucydides.

13. Homer, *Odyssey* 10:64. For the subject in general, see Robert Parker, *Miasma: Pollution and Purification in Early Greek Religion* (Oxford: Clarendon Press, 1983), esp. chap. 8.

14. Hesiod, *Works and Days* 90–104.

15. Waldemar Deonna, *Le symbolisme de l'oeil* (Paris: Edition E. de Boccard, 1965).

16. F. T. Straten, "Gifts for the Gods," *Faith, Hope and Worship: Aspects of Religious Mentality in the Ancient World*, ed. H. S. Versnel (Leiden: Brill, 1981), pp. 65–151.

17. See, e.g., Straten, "Gifts for the Gods," fig. 56.

18. Emma Edelstein and Ludwig Edelstein, *Asclepius: A Collection and Interpretation of Testimonies* (Baltimore: The Johns Hopkins University Press, 1945), p. 168.

19. Ovid, *Ibis* 260–72. I use the Loeb edition. See also Ovid, *The Art of Love and Other Poems*, trans. J. H. Mozley (London and Cambridge, Mass.: William Heinemann, 1939), p. 271.

20. The difference between the Greek view of "fault" (*hamartia* or pollution) and the Christian concept of "sin" is a well known problem, to which many studies have been devoted. See the entry "Sin," by Bultmann, in Kittel's *Dictionary of the New Testament*. Here we need not take up this great subject.

21. Ovid, *Metamorphoses* 13.561–664.

22. Apollodorus, *The Library*, 2.8.1. I use the English translation by James G. Frazer in the Loeb edition (London and New York: William Heinemann, 1921). For the expression quoted, see p. 279.

23. For an attempt to analyze Oedipus's "character," see G. M. Kirkwood, *A Study of Sophoclean Drama* (Ithaca: Cornell University Press,), pp. 127–35, 150–57.

24. Appolodorus, *The Library* 3.13.8; p. 75 in the Loeb edition.

25. *Anthologia Graeca* 3.3. The text seems to be late; it was composed probably between the fourth and sixth century A.D.

26. Apollodorus, *The Library* 3.15.3; p. 107 of the English translation. Hyginus, *Fabulae* 19. For an English translation, see *The Myths of Hyginus*, trans. and ed. Mary Grant (Lawrence: University of Kansas Publication, 1960), p. 40.

27. For the Prometheus story in European literature, see Jacqueline Duchemin, *Prométhée: Histoire du Mythe, de ses Origines orientales et ses Incarnations modernes* (Paris: Belles Lettres, 1974). See also Karl Kerenyi, *Prometheus: Archetypal Image of Human History* (Princeton: Princeton University Press, 1997). It should be noted, however, that the attempts to trace the story of Prometheus through the ages usually concentrate on antiquity and the modern time (nineteenth and twentieth centuries).

28. Albert M. Esser, *Das Antlitz der Blindheit in der Antike: Eine medizinisch-kulturhistorische Studie* (Stuttgart: Ferdinand Enke Verlag, 1939).

29. O. Gruppe, *Griechische Mythologie und Religionsgeschichte* (Munich: Beck, 1906), p. 198, n. 10. See also Pauly-Wissowa, *Realenzyklopädie der klassischen Altertümer*.

30. Plutarch, *Alexander*.

31. For the problem of visibility and invisibility in Greek culture, see Louis Gernet, "Things Visible and Invisible," in his *The Anthropology of Ancient Greece* (Baltimore and London: The Johns Hopkins University Press, 1968),

pp. 343–51. The original French version of this article appeared in *Revue Philosophique* 146 (1956): pp. 79–86.

32. Homer, *Iliad* 20:131.

33. Jean-Pierre Vernant, *La mort dans les yeux: Figures de l'Autre en Grece ancienne* (Paris: Hachette, 1985), touches on the problem, but he stresses other aspects. For an English translation, see Jean-Pierre Vernant, *Mortals and Immortals: Collected Essays*, ed. Froma I. Zeitlin (Princeton: Princeton University Press, 1991), pp. 111–38.

34. Plutarch, *De Iside et Osiride*, Loeb edition p. 354, chapters 8ff. For the inscription, and its afterlife, see Jan Assmann, *Moses the Egyptian: The Memory of Egypt in Western Monotheism* (Cambridge, Mass.: Harvard University Press, 1997), pp. 117ff.

35. Plutarch, *Greek and Roman Parallel Stories* 17. "When the shrine of Athena in Ilium was in flames, Ilus rushed up and seized the Palladium, a statue which has fallen from heaven, and was blinded: for the Palladium might not be looked upon by man." See *Plutarch's Moralia*, English translation by Frank I. Babbitt, vol. IV (Cambridge, Mass., and London: Harvard University Press, 1936), p. 283.

36. For the terms employed and their connotations, see Ruth Padel, *In and Out of the Mind: Greek Images of the Tragic Self* (Princeton: Princeton University Press, 1992), pp. 72–75.

37. For Thamyris, see Euripides, *Rhesus* 916–25.

38. Appolodorus, *The Library* 3.5.7. I am not aware of any monographic treatment of Teiresias, neither in literature nor in art. The interpretation offered by Nicole Loraux, *The Experiences of Teiresias: The Feminine and the Greek Man* (Princeton: Princeton University Press, 1998), while interesting and thought provoking, does not attempt to follow the historical development of the figure.

39. For Teiresias in Hades, see Homer, *Odyssey* 10.493ff.

40. 5.115ff. For the English translation, see *Callimachus and Lycophron*, trans. G. R. Mair (London and New York: W. Heinemann, 1921), p. 119.

41. Fulgentius, *The Mytholgies* 1.5. For an English translation, see *Fulgentius the Mythographer*, trans. Leslie George Whitbread (Ohio: Ohio State University Press, 1971), p. 70.

42. Sophocles, *Antigone* 1002ff. See also Euripides, *Phoeniss* 845.

43. Pliny, *Natural History* 7.57.

44. Pausanias 9.16. 1. See Halliday, *Divination* (London: Macmillan, 1913), pp. 209, 269.

45. Richard E. Doyle, *Ate, Its Use and Meaning: A Study in the Greek Poetic Tradition from Homer to Euripides* (New York: Fordham University Press,

1984). E. R. Dodds, *The Greeks and the Irrational* (Berkeley: University of California Press, 1951), chap. 2. See also R. D. Doyle, "Some Reflections on Ate and Hamartia," *Harvard Studies in Classical Philology* 72 (1967): pp. 89–123.

46. According to Homer, Ate is the daughter of Zeus (see *Iliad* 9:504 and 19:880), though, according to Doyle, *Ate, Its Use and Meaning*, p. 20, n. 15, this is an allegorical reading rather than a personification.

47. Homer, *Iliad* 16:805.

48. Ibid., 19:270.

49. Doyle, *Ate, Its Use and Meaning*, pp. 3ff.

50. Homer, *Odyssey* 4:271.

51. Padel, *In and Out of the Mind*, p. 129.

52. The significance of darkness as an attribute of blindness has been analyzed by Bernidaki-Aldous, *Blindness in a Culture of Light* (New York: Peter Lang, 1990), p. 35.

53. Raymond Klibansky, Erwin Panofsky, and Fritz Saxl, *Saturn and Melancholy* (London: Nelson, 1964).

54. Ruth Padel, *Whom Gods Destroy: Elements of Greek and Tragic Madness* (Princeton: Princeton University Press, 1995), pp. 49ff.

55. See, e.g., Sophocles, *Oedipus at Colonus* 1549–52.

56. Herodotus 6:84. Herodotus himself believes that heavy drinking, which Cleomenes learned from the Scythians, is the cause of his disease.

57. See Hippocrates, *Epidemics* 2.5.11. Also see Owsei Temkin, *The Falling Sickness: A History of Epilepsy from the Greeks to the Beginning of Modern Neurology*, 2nd ed. (Baltimore and London: The Johns Hopkins University Press, 1971), p. 45.

58. Temkin, *The Falling Sickness*, esp. pp. 3–27.

59. In this context I should like to particularly mention the studies by Carl Robert which, though written almost a century ago, are still of considerable value. See mainly his *Bild und Lied: Archäologische Beiträge zur Geschichte der griechischen Heldensage* (Berlin, 1881) and his work on *Archäologische Hermeneutik: Anleitung zur Deutung klassischer Kunstwerke* (Berlin, 1919).

60. The amphora is now in the Museum in Eleusia, Greece. See H. Groenewegen-Frankfort and Bernard Ashmole, *The Art of the Ancient World* (New York: Abrams, n.d. [1977]), fig. 208. Another representation of the same scene, somewhat different in composition, is seen on a fragment of a bowl in the Museum of Argos. See *Art of the Ancient World*, color plate 23. This painting was done in Argus, c. 650 B.C.

61. Salomon Reinach, *Répertoire de Reliefs Grecs et Romains*, III (Paris: Editions Ernest Leroux, 1912), p. 372. See also Carl Robert, *Oidipus: Geschichte*

eines poetischen Stoffs im griechischen Altertum (Berlin: Weidnann, 1915), I, pp. 306ff.

62. For the Euripidean version of the Oedipus story, see Robert, *Oidipus*, pp. 305–31.

63. For Aby Warburg's concept of "energetic inversion," a much discussed concept, see Fritz Saxl's study "Rinascimento dell'Antichità: Studien zu den Schriften A. Warburgs," reprinted in *Aby M. Warburg: Ausgewählte Studien und Würdigungen*, ed. Dieter Wuttke (Baden-Baden: Verlag Valentin Koerner, 1979), pp. 347–99, esp. pp. 384ff.

64. Robert, *Oidipus*, I, pp. 308ff., II, p. 108, fig. 108.

65. Ancient descriptions of the staff in the hands of the blind are discussed by Esser, *Das Antlitz der Blindheit in der Antike*, p. 83.

66. Apollodorus, *The Library* 3.6.7. In his edition of Apollodorus (I, p. 363, n. 2) Frazer adds that according to some manuscripts it was a blue staff.

67. In Sophocles's *Antigone* Teiresias says, "Elders of Thebes, we two have come one road, / two of us looking through one pair of eyes. / This is the way of walking for the blind" (988–90). Euripides in *The Phoenician Women* makes Teiresias say, "Now lead me on, my daughter. You're the eye / for my blind steps, as star is to the sailor" (834–35). Many centuries later, Nonnus (*Dionysiaca* 21:165ff.) tells of another blind man: "Father Zeus made Lycurgos a blind wanderer; to tramp round and round in the city which he no longer knew, to seek some guide for the path he must tread, or often on lonely travels with stumbling feet."

68. The ivory fragment is here reproduced from Margarete Bieber, *The History of the Greek and Roman Theater* (Princeton: Princeton University Press, 1939), fig. 833.

69. See Robert, *Oidipus*, I, pp. 453ff.

70. Thucydides, *The Peloponnesian War* 3.104.5. Also see the *Homeric Hymns* (3:171–72). On Homer's blindness, see Robert Lamberton, *Homer the Theologian: Neoplatonist Allegorical Reading and the Growth of the Epic Tradition* (Berkeley: University of California Press, 1986), pp. 8–10, 199ff.

71. Thus Pausanias 5.26.2 mentions the portraits of famous men, among them those of the "poets Homer and Hesiod"; he does not say, however, that the Homer portrait showed a blind bard.

72. Socrates, *Phaedrus* 43 a–b.

73. Homer portraits have, of course, been frequently discussed. For this particular head, see Martha Weber, "Das früheste Homerporträt als Kunstkopie und als Römisches Gerät," *Mitteilungen des Deutschen Archaeologischen Instituts: Römische Abteilung* 98 (1991): 199–219.

74. Ibid., p. 205. That this head represents the blind Homer has already

been suggested by F. Winter in a well-known study published in the *Jahrbuch des Instituts*, V (Berlin: Deutsches Archäologisches Institut, 1890), pp. 163ff.

75. In addition to Martha Weber's article, see also Karl Schefold, *Die Bildnisse der antiken Dichter, Redner und Denker* (Basel: B. Schwage, 1943), p. 62.

76. Early in the *Alcestis*, where she is going to die, Admetus asks her: "Lift yourself up, Alcestis! Do not give in . . . " while she replies: "Let me go, down to the house of the dead!" See Bernidaki-Aldous, *Blindness in a Culture of Light*, p. 20, for some interesting stage directions of this scene.

77. Euripides, *Hecuba* 499–500, English translation by William Arrowsmith. See Bernidaki-Aldous, *Blindness in a Culture of Light*, pp. 20ff.

2 The Blind in the Early Christian World

1. Ambrose, *Cain and Abel* 2.416.

2. St. Jerome, Epistle 97:19.

3. Arnobius, *Adversus nationes Libri VII (Agaist the Heathen)* 7.29.

4. "Or will some one carry so wonderful a blindness to the extent of wildly attempting, in the face of evident truth, to contend that . . . " I quote from Saint Augustine, *The City of God*, trans. Marcus Dods (New York: Modern Library, 1950), p. 20.

5. The "Letter of Jeremiah" was probably composed in the first century B.C., and is thus close in time to the New Testament.

6. Diodorus Siculus, *Library* 1.25.3.

7. Tacitus, *Histories* 4.81. This story is also mentioned by Suetonius, *Lives*, Vespasian 7.

8. See Aelian, *The Characteristics of Animals* 9.15, and Macrobius, *The Saturnalia* 1.20.2–3.

9. Otto Weinreich, "Antike Heilungswunder: Untersuchungen zum Wunderglauben der Griechen und Römer," *Religionsgeschichtliche Versuche und Vorarbeiten* 8, no.1 (Giessen, 1909): 107f.

10. The exception I have in mind is an ivory pyxis in the Museo Sacro in Rome. It was a physician's medicine box, and on its lid the Healing of the Blind is carved. See Charles Rufus Morey, *Early Christian Art* (Princeton: Princeton University Press, 1942), fig. 91 and pp. 94ff.; Andre Grabar, *Christian Iconography: A Study of Its Origins* (Princeton: Princeton University Press, 1968), fig. 246 and p. 97. The fine carving technique and the fully developed style suggest that the precious object was produced in the early sixth century.

11. Morey, *Early Christian Art*, p. 62.

12. Ludwig von Sybel, *Christliche Antike: Einführung in die altchristliche Kunst* (Marburg: N. G. Elwertsche Verlagsbuchhandlung, 1906), p. 227.

13. It is worth noting that in the literary descriptions of Christ healing the leper, some gesture of imploring or adoration *is* suggested. Thus Matthew (8:2) says: "And behold, there came a leper and worshipped him, saying, Lord, if thou wilt, thou canst make me clean." In Luke (5:12) it reads: "And it came to pass, when he was in a certain city, behold a man full of leprosy: who seeing Jesus fell on his face, and besought him, saying, Lord, if thou wilt, thou canst make me clean." In the stories of the blind, no gesture or posture of the healed is indicated.

14. See Weinreich, "Antike Heilungswunder," pp. 14ff. One of the most famous references in ancient literature is found in Ovid's *Metamorphoses*, 10.510ff., where Lucina touches Leto who is in labor pains.

15. Weinreich, "Antike Heilungswunder," p. 30.

16. See *Vita S. Eligii* 2.51. (Migne, *Patrologia Latina*, vol. 87, col. 570 A.)

17. Gregory of Tours, *In gloria martyrum*.

18. Schiller, *Iconography of Christian Art* (London: Lund and Humphries, 1971), fig. 246. Schiller gives a list of many other examples, without however dividing between emblematic and narrative representations.

19. Ibid., fig. 430.

20. Ibid., fig. 509.

21. Ibid., fig. 514.

22. I should stress here that I do not use the concept of religion of salvation in a strict terminological sense. For the history of defining the concept, see Hans G. Kippenberg, *Die Entdeckung der Religionsgeschichte: Religionswissenschaft und Moderne* (Munich: Verlag C. H. Beck, 1997), pp. 172ff., 239ff.

23. The reading is according to a restored manuscript. The restored version reads: "De sacramento aquae nostrae, qua ablutis delictis pristinae caecitatis in vitam aeternam liberamur." See Franz Joseph Dölger, "Die Sünde in Blindheit und Unwissenheit: Ein Beitrag zu Tertullian *De baptismo*," in Dölger, *Antike und Christentum: Kultur- und religionsgeschichtliche Studien*, 2nd ed., II (Münster: Aschendorf, 1974), pp. 222–29.

24. For a comparison of the three versions with regard to the light, see Volker Stolle, *Der Zeuge als Angeklagter: Untersuchungen zum Paulusbild des Lukas* (Stuttgart: Kohlhammer, 1973), pp. 171–74.

25. One edition of the King James Bible has it that when Paul arose, "he saw no man." The recent *Cambridge Bible Commentary* (see *The Acts of the Apostles*, Commentary by J. W. Packer [Cambridge: Cambridge University Press, 1966]) has correctly "but when he opened his eyes he could not see." The Vulgata also shows that this is how the sentence was understood. Acts 6:8 reads: "Surrexit autem Saulus de terra; apertisque oculis, nihil videbat."

26. See, e.g., Hans Conzelmann, *Die Apostelgeschichte* (Tübingen: Mohr,

1972), p. 65. Conzelmann adduces the sentence of Acts 22:11, where Paul says : "And when I could not see for the glory of that light, being led by the hand of them that were with me, I came into Damascus." Here, then, the blindness is "for the glory," not a punishment for sins.

27. Theologians have, of course, devoted a great deal of attention to Paul, including his conversion. One cannot hope now to read through the whole literature devoted to the apostle. Not being a theologian, I certainly cannot claim to have mastered it. Nevertheless, it is my impression, which I dare to state here, that the theological commentators did not consider the specific episode of the apostle's blindness as a significant subject in itself. In discussing his conversion, even some of the most serious students hardly mention the blindness, though they study other aspects in great detail.

28. Bernard McGinn, *The Growth of Mysticism: Gregory the Great through the Twelfth Century (The Presence of God: A History of Western Mysticism, II)* (New York: The Crossroad Publishing Co., 1992), p. 103.

29. For "negative theology" in general, and particularly for its extensive use of metaphors of blindness, see *The Mystical Theology* by Dionysius Areopagita. See *Pseudo-Dionysias* trans. C Luibheid, Paul Rorem (London, SPCK, 1987), pp. 135–41.

30. *Corpus Hermeticum* 10. See *Hermetica: The Greek Corpus Hermeticum and the Latin Asclepius,* trans. Brian P. Copenhaver (Cambridge: Cambridge University Press, 1992), p. 31.

31. Hans Lewy, "Sobria ebrietas: Untersuchungen zur Geschichte der antiken Mystik," *Beihefte zur Zeitschrift für die Neutestamentliche Wissenschaft* 9 (Giessen, 1929).

32. Andre Grabar, *Christian Iconography* (Princeton: Princeton University Press, 1968), figs. 163, 166.

33. For the historical and textual problems of the work, see Wanda Wolska, *Recherches sur "Topographie Chrétienne" de Cosmas Indicopleustes* (Paris: Presses Universitaires de France, 1962).

34. Vatican, Cod. Gr. 699, Fol. 83 verso; Mount Sinai, Cod. 1186, Fol. 128 verso.

35. Kurt Weitzmann, *Illustrations in Roll and Codex: A Study of the Origin and Method of Text Illustration* (Princeton: Princeton University Press, 1970; original edition, 1947), p. 142.

36. See mainly Andre Grabar, *L'empereur dans l'art byzantin* (London: Variorum Reprints, 1971; original edition, Paris 1936). See also Richard Brilliant, *Gesture and Rank in Roman Art: The Use of Gestures to Denote Status in Roman Sculpture and Coinage* (New Haven: Connecticut Academy of Arts and Sciences, 1963), esp. pp. 85–87.

3 The Middle Ages

1. There seems to be no comprehensive study of the blind in medieval imagery. Some aspects are occasionally referred to, and even this only sparingly. Bibliographical references to individual studies will be given in the course of our discussion.

2. The literature dealing explicitly with the Antichrist, though not very large, is intricate, and usually does not provide answers to our specific questions. A good and thorough overview of the subject is found in Bernard McGinn, *Antichrist: Two Thousand Years of the Human Fascination with Evil* (San Francisco: Harper, 1994). McGinn gives a comprehensive bibliography of the subject. Of undiminished interest is the old work by W. Bousset, *The Antichrist Legend: A Chapter in Christian and Jewish Folklore*, trans. A. H. Keane (New York, AMS Press, 1982; original German edition, 1895).

3. McGinn, *Antichrist*, p. 24.

4. Pss. 77:16–19, 74:14–15, and 104:26 (the monster named Leviathan); 89:9–10 (the monster named Rahab); Is. 51:9–10, a combination of God's deliverance of his people with a cosmic struggle.

5. Alfons Kurfess, *Christliche Sybillen* (Munich: Heimeran, 1951), pp. 262ff.

6. Tertullian, *De ieiubiis, Adversus psychicos* 11.

7. Tertullian, *De praescriptionibus adversus omnes haereses* 4.

8. Gregory the Great, *Moralia in Job* 25.15.34. See Migne, *Patrologia Latina*, vol. 76, col. 343.

9. Origen, *Commentary on John* 2:36. I follow the translation by McGinn, *Antichrist*, p. 60.

10. Edgar Hennecke and Wilhelm Schneemelcher, *Neutestamentliche Apokryphen in deutscher Übersetzung*, II (Tübingen: Mohr, 1971), p. 442.

11. See McGinn, *Antichrist*, p. 98.

12. Ibid., p. 68.

13. Arthur J. McLean, *The Testament of the Lord* (Edinburgh: T. P. T. Clark, 1902), chap. 11.

14. Pliny, *Natural History* 7:18.

15. Bousset, *Antichrist Legend*, pp. 156–57.

16. This apocalypse is edited by Martin McNamara, *The Apocrypha in the Irish Church* (Dublin: The Institute for Advanced Study, 1975), pp. 299–338.

17. Wilhelm Neuss, *Die Apokalypse des Hlg. Johannes in der altspanischen und altchristlichen Bibel-Illustration* (Münster: Aschendorf, 1931), pp. 176ff., stresses the significance of royal imagery in the depiction of the Antichrist. Neuss's work is of lasting importance for the understanding of the medieval imagery of the Antichrist.

18. El Escorial, Real Biblioteca del Monasterio, Cod. & II. 5.

19. Neuss, *Die Apokalypse*, p. 179.

20. Jessie Jean Poesch, "Antichrist Imagery in Anglo-French Apocalypse Manuscripts" (diss., University of Pennsylvania, 1966), p. 87.

21. Jean Hubert, Jean Porcher, and W. F. Volbach, *Europe of the Invasions* (New York: Braziller, 1969), p. 196, fig. 205. See also McGinn, *Antichrist*, pp. 104f.

22. A rich and very interesting collection of materials and references, on which I here rely, is given by Meyer Schapiro in his well-known article "From Mozarabic to Romanesque in Silos," mainly in note 48. Originally this article appeared in the 1939 *Art Bulletin*, but it is now best available in Meyer Schapiro, *Romanesque Art (Selected Papers, I)* (New York: Braziller, 1977), pp. 28–101; n. 48 on pp. 75ff.

23. K. Preisendanz, *Akephalos: der kopflose Gott* (Beihefte zum "Alten Orient," 8) (Hinrichs, 1926).

24. See the entry "Einäugigkeit" in the *Handwörterbuch des deutschen Aberglaubens* (Berlin: De Gruyter, 1935) II, pp. 694, 695.

25. Waldemar Deonna, *Le symbolisme de l'oeil* (Paris: Editions de Boccard, 1965), pp. 120–21.

26. An instructive example is found in the mid-thirteenth-century Harley Ms. 1527 (in the British Museum), fol. 127 recto. It is worth noting that, while the Antichrist is here three-headed, the demon at the other end of the illumination is seen in profile, and hence displays only one eye.

27. McGinn, *Antichrist*, pp. 148–49, and fig. 12.

28. It is difficult even to outline the scholarly literature dealing with this juxtaposition and its many ramifications. For the motif in medieval literature, see Friedrich Ohly, "Synagoge und Ecclesia. Typologisches in mittelalterlicher Dichtung," reprinted in Ohly, *Schriften zur mittelalterlichen Bedeutungsforschung* (Darmstadt: Wissenschaftliche Buchgesellschaft, 1977), pp. 312–13. The literary genre within which such juxtapositions and encounters were written and performed in the Middle Ages is surveyed by H. Walther, *Das lateinische Streitgedicht des Mittelalters* (Munich: C. H. Beck, 1920).

29. For a lucid introductory discussion of the subject in the works of the visual arts, see Emile Mâle, *The Gothic Image: Religious Art in France of the Thirteenth Century* (New York: Harper, 1958), pp. 140ff. The theme has been frequently studied.

30. On the pedestal of the figure in the Cathedral of Strasbourg the crown was to be seen, but it has disappeared in the course of time.

31. Paul Weber, *Geistliches Schauspiel und kirchliche Kunst in ihrem Verhältnis erläutert an einer Ikonographie der Kirche und Synagoge: Eine kunstgeschichtliche*

Studie (Stuttgart: Ebner a Seubert, 1894), p. 87; Joseph Sauer, *Die Symbolik der Kirchengebäudes und seiner Ausstattung in der Auffassung des Mittelalters* (Freiburg: Herder, 1902), p. 355.

32. In the Metten Codex in the Court Library in Munich. See Sauer, *Die Symbolik*, p. 254.

33. Mss of the Missale in Düsseldorf and in the Passion plays in Alsfeld. See Sauer, *Die Symbolik*, p. 254.

34. Isaiah Shachar, *The Judensau: A Medieval Anti-Jewish Motif and Its History* (London: Warburg Institute, 1974), pp. 19–20 and pls. 13, 14.

35. See *De altercatione Ecclesiae et Synagogae dialogus*, available in Migne, *Patrologia Latina*, vol. 42, cols. 1131–40. Also see Hans Liebeschütz, *Synagoge und Ecclesia: Religionsgeschichtliche Studien über die Auseinandersetzung der Kirche mit dem Judentum im Hochmittelalter* (Heidelberg: Lambert Schneider, 1983). See also the older study by H. Pflaum, *Die religiöse Disputation in der europäischen Dichtung des Mittelalters, 1: Der allegorische Streit zwischen Kirche und Mittelalter* (Geneva-Florence: L. S. Olschki, 1935).

36. Augustine, *Tractatus adversus Iudaeos* 5.6. From the literature devoted to this text I shall quote only Bernhard Blumenkranz, *Die Judenpredigt Augustins: Ein Beitrag zur Geschichte der jüdisch-christlichen Beziehungen in den ersten Jahrhunderten* (Paris: Etudes augustinennes, 1974).

37. Erwin Panofsky, *Studies in Iconology: Humanistic Themes in the Art of the Renaissance* (New York: Oxford University Press, 1939), pp. 95–128, esp. p. 110.

38. I have discussed some of the shapes of these semiritual actions in two earlier essays, "The Veil: Representations of the Secret in the Visual Arts" and "How the Hidden Becomes Visible," reprinted in Moshe Barasch, *The Language of Art: Studies in Interpretation* (New York: New York University Press, 1997), pp. 266–301.

39. Albert the Great, *De sacram. Altaris* 31.

40. Richard of St. Victor, *In cant.* See Migne, *Patrologia Latina*, vol. 196, col. 465c.

41. See for instance Lilian M. C. Randall, *Images in the Margins of Gothic Manuscripts* (Berkeley and Los Angeles: University of California Press, 1966), fig. 282 (pl. 59), and also fig. 281 (pl. 58).

42. Mechthild von Magdeburg, *Offenbarungen oder Das fliessende Licht der Gottheit* (Leipzig, Insel Verlag, 1921), p. 125.

43. Quoted by Johannes Rothe, *Lob der Keuschheit*, pp. 532ff. See Gudrun Schleusner-Eichholz, *Das Auge im Mittelalter* (Munich: Wilhelm Fink Verlag, 1985), p. 351.

44. Paris, Bibliotheque Nationale, manuscrit latin 9428. See *Drogo Sacra-*

mentar, Faksimile und Kommentar (Graz: Akademische Druck-und Verlagsanstalt, 1974).

45. See Adolf Goldschmidt, *German Illunmination,* II (New York: Harcourt & Brace, 1928), pl. 107. In the following comment I largely follow Panofsky's observations in his *Studies in Iconology,* pp. 110–11.

46. G. Swarzenski, *Die Regensburger Buchmalerei* (Leipzig: K. W. Hirsemann, 1901), pl. xiii; Panofsky, *Studies in Iconology,* fig. 78.

47. Amiens, Bibliotheque Municipale, Codex 108, folio 43 v.

48. Louis Grodecki, *Etudes sur les vitraux de Suger a Saint-Denis* (Paris: Musees des arts decoratifs, 1995), fig. 27.

49. Ibid., fig. 29.

50. G. Haarsdörfer, *Poetische Trichter* (Darmstadt: Wissenschaftliche Buchgesellschaft, 1969), III, pp. 227f.

51. The blindfold figure of Death in Notre Dame in Paris is frequently reproduced. See, e.g., Viollet-le-Duc, *Dictionnaire raisonne d'architecture francaise du Xie au XVIe siècle* (Paris: V. A. Morel, 1858–1868), III, fig. 20. For a similar figure in the Cathedral of Reims, see P. Vitry, *La Cathedrale de Reims: architecture et sculpture* (Paris: Librairie centrale des beaux arts, 1919), pl. 82.

52. Panofsky, *Studies in Iconology,* p. 112.

53. I use the edition by Felix Genzmer. See Johannes von Tepl, *Der Ackermann aus Böhmen,* chap. 16 (Stuttgart: Reclam, 1981), p. 57.

54. Jean Dufournet, *Le garcon et l'aveugle* (Paris: Honore Champion, 1982), p. 53.

55. Schleusner-Eichholz, *Das Auge,* p. 504.

56. See, for instance, the story of St. Apollinaris in the *Legenda aurea.* For an English translation, see *The Golden Legend of Jacobus de Voragine,* trans. E. Ryan and H. Kipperberger (New York: Arno Press, 1969), pp. 364ff.

57. See, e.g., the life of St. Anastasia in *The Golden Legend,* pp. 51–53.

58. Reinmar von Zweter, *Die Gedichte* (Amsterdam: Gustav Röthe, 1967), p. 111. Quoted after Schleusner-Eichholz, *Das Auge,* p. 496.

59. *De vitis patrum, X: Pratum spirituale.* Reprinted in Migne, *Patrologia Latina,* vol. 74, col. 156b, c.

60. Bronislaw Geremek, *Les Marginaux parisiens aux XIVe et XVe siecles* (Paris: Flammarion, 1976), p. 215; Dufournet, *Le garçon et l'aveugle,* p. 65.

61. *Journal d'un bourgeois de Paris,* p. 389. Quoted after Dufournet, *Le garçon et l'aveugle,* p. 83, n. 52.

62. Schleusner-Eichholz, *Das Auge,* p. 494, n. 74, lists three medieval chess manuals in which the blind figures are embodiments of cunning.

63. Adolf Rosenzweig, *Das Auge in Bibel und Talmud* (Berlin: Mayer und Müller, 1892), p. 28; Schleusner-Eichholz, *Das Auge,* p. 495.

64. Günter Lange, "Das Gerichtsverfahren gegen den jungen Helmbrecht. Versuch einer Deutung nach dem kodifizierten Recht und den Landfriedensordnungen des 13. Jahrhunderts," *Zeitschrift für deutsches Altertum und deutsche Literatur,* vol. 99 (1970), pp. 222–34, esp. p. 224. See also Schleusner-Eicholz, *Das Auge,* p. 495.

65. Steven Rappaport, *Worlds Within Worlds: Structures of Life in Sixteenth Century London* (Cambridge: Cambridge University Press, 1989). See also Hans J. Hillebrand, "The 'Other' in the Age of the Reformation: Reflections on Social Control and Deviance in the Sixteenth Century," in *Infinite Boundaries: Order, Disorder, and Reorder in Early Modern German Culture,* ed. Max Reinhart (Kirkville, Mo.: Journal Publishers, 1998), pp. 245–69, especially pp. 260ff.

66. Dufournet, *Le garçon et l'aveugle,* pp. 139–41.

67. Hillebrand, "The 'Other' in the Age of Reformation," p. 261.

68. Quoted by Hillebrand, p. 261, from an unpublished Oxford dissertation by Christopher Thomas Daly, 1993.

69. We have to exclude from this characterization the stories that eventually lead to conversion. In them the religious tendency shapes the image of the blind.

70. See verses 28–32 of the poem.

71. Dufournet, *Le garçon et l'aveugle,* pp. 31ff.

72. The subject is far from being sufficiently explored. For some aspects and stages of the story, see E. Tietze-Conrat, *Dwarfs and Jesters in Art* (London: Phaidon Press, 1957).

73. For a lengthy, and by now famous, discussion of grotesque body imagery in literature, see Mikhail Bakhtin, *Rabelais and His World,* trans. Helene Iswolsky (Bloomington, Ind.: Indiana University Press, 1984), esp. chap. 5, pp. 303–67.

74. For Velasquez's portraits of "comic personages" and dwarfs, see the still interesting discussion by Carl Justi, *Velasquez und sein Jahrhundert* (Vienna: Phaidon, n.d.), pp. 686–93, 701–6.

75. Bakhtin, *Rabelais,* p. 316.

76. See chapter 1, The Blind Seer, p. 28.

77. Heinrich von Mügeln, *Der meide kranz* 765ff, reprinted in *Lehrhafte Literatur des 14. Und 15. Jahrhunderts,* ed. Ferdinand Vetter (Berlin/Stuttgart: W. Speemann, n.d.), II, pp. 49, 97f. See also Schleusner-Eichholz, *Das Auge,* p. 508.

78. Dietrich Schmidtke, *Geistliche Tierinterpretationen in der deutschsprachigen Literatur des Mittelalters* (1100–1500) (Berlin, 1968), p. 318. This study was not available to me, and I quote after Schleusner-Eichholz, *Das Auge,* p. 508, n. 150.

79. Walters Art Museum, Ms. 82, fol. 207. See Lilian M. Randall, *Images in the Margins of Gothic Manuscripts* (Berkeley and Los Angeles: University of California Press, 1966), fig. 82 and p. 38.

80. I am not aware of a comprehensive monograph on the Book of Tobit that pays careful attention to the problem of the blind figure's way of acting. Medieval exegesis does not seem to have offered an established explanation for the blind father's missing the door or hitting himself against the doorframe. A history of the illustrations of the Book of Tobit could probably show how the different ages understood and imagined the relationship between the blind man and the physical world around him.

81. Julius S. Held, *Rembrandt's Aristotle and Other Rembrandt Studies* (Princeton: Princeton University Press, 1969), p. 114. Though the Book of Tobit has often been commented on (by theologians in all ages as well as by scholars of other disciplines), as far as I know, Tobit's actions as described in it have not been considered as an example of the blind person's behavior and his orientation in the material world around him.

82. Harsdörffer, *Der Geschichtspiegel*, II, p. 726.

83. The original version has often been edited. See *Le garçon et l'aveugle: Jeu du XIIIe siecle*, ed. Mario Roques (Paris: H. Champion, 1965). For a translation into modern French, see Dufournet, *Le garçon et l'aveugle*, pp. 87–97.

84. For the different genres of such (primarily oral) poetry in the thirteenth century, see Edmond Faral, *Les jongleurs en France au Moyen Age* (Paris: Honoré Champion, 1964), pp. 167–221. This is the second edition of Faral's work. The original edition appeared as the 187th contribution to the *Bibliotheque de L'ecole des hautes Etudes* (Paris, 1909). See also E. K. Chambers, *The Medieval Stage* (Oxford: Oxford University Press, 1925) and Heinz Kindermann, *Theatergeschichte Europas*, I (Salzburg: Otto Müller, 1957).

85. Johann Huizinga, *Der Herbst des Mittelalters* (Munich: Drei Masken Verlag, 1924), p. 419.

86. See Robert Jütte, *Poverty and Deviance in Early Modern Europe* (Cambridge: Cambridge University Press, 1994).

87. See the materials adduced in Jütte, *Poverty and Deviance*.

88. Dufournet, *Le garçon et l'aveugle*, p. 21. Geremek, *Les Marginaux parisiennes*, p. 211.

89. Ernst Robert Curtius, *European Literature and the Latin Middle Ages*, trans. W. R. Trask (New York: Pantheon Books, 1853), pp. 94 ff.

90. Erwin Panofsky, *Hercules am Scheidewege und andere antike Bildstoffe in der neuern Kunst*, Studien der Bibliothek Warburg, 18 (Leipzig-Berlin: B. G. Teubner, 1930) fig. 101 and pp. 158ff.

91. Dufournet, *Le garçon et l'aveugle*, p.12.

92. All descriptions of the fresco stress the poor and ragged dress of Sancta Paupertas. The very fact that she is known as "Holy Poverty" shows the attitude of awe toward her.

93. Panofsky, *Hercules am Scheidewege*, pp. 56 ff.; Sebastian Brant, *The Ship of Fools*, trans. Edwyn H. Zeydel (New York: Dover Publications, 1944), pp. 271–75.

4 The Renaissance and Its Sequel

1. Ernst Cassirer, *The Individual and Cosmos in Renaissance Philosophy*, trans. Mario Domandi (New York: Harper and Row, 1964), p. 157. The work originally appeared as "Individuum und Kosmos in der Philosophie der Renaissance" in *Studien der Bibliothek Warburg*, vol. X (Leipzig and Berlin, 1927).

2. Leonardo da Vinci, *Treatise on Painting*, trans. A. Philip McMahon (Princeton: Princeton University Press, 1956), p. 17, # 27.

3. V. P. Zubov, *Leonardo da Vinci*, translated from the Russian by David H. Kraus (Cambridge, Mass.: Harvard University Press, 1968), chap. 4, titled "The Eye, Sovereign of the Senses."

4. For this particular meaning (usurer), cf. Jacques Le Goff, *Your Money or Your Life: Economy and Religion in the Middle Ages* (New York: Zone Books, 1988). The original French edition, *La bourse ou la vie*, appeared in Paris, 1986.

5. See Robert Davidsohn, *Die Frühzeit der Florentiner Kultur*, IV (Berlin: E. S. Mittler, 1927), p. 261.

6. Earlier in this volume (see the section on visual representations in chapter 1, and fig. 9) I have briefly mentioned some Egyptian images in which blindness is expressed by gesture.

7. Canto 13. 61–66. For the English translation here used, see *The Purgatorio*, a verse translation for the modern reader by John Ciardi (New York: Modern Library, 1967), p. 141. And cf. the commentary in Dante Alighieri, *The Divine Comedy*, translated, with a commentary, by Charles Singleton, II, *Purgatorio* (Princeton: Princeton University Press, 1973), pp. 275ff.

8. In his *Ordres de Paris*. For the reflection of social customs in Rutebeuf's work, see the interesting observations by Bronislaw Geremek, *Les Marginaux parisiens aux XIVe et XVe siècles* (Paris: Flammarion, 1976), esp. chap. 6, pp. 189ff.

9. In novel 140. I use Franco Sacchetti, *Il Libro delle Trecentonovelle*, ed. Ettore li Gotti (n.d., n.p.). The blind, Sacchetti says, were "inebriati"(see p. 348). See also story 159, pp. 416ff., esp. p. 418, where he tells of blind beggars who simply sit at the "pilaster" of Or San Michele in Florence. For Sacchetti,

see Natalino Sapegno, *Compendio di Storia della Letteratura Italiana* (Florence: La Nuova Italia, 1963), I, pp. 226–27.

10. See Sacchetti, *Il Libro*, p. 346, and the explanatory notes by the editor.

11. "Abbiam noi demoni in sopra?" asks the woman who lives on a lower floor. See Sacchetti, *Il Libro*, p. 348.

12. Ibid.

13. I have not been able to consult the many, especially the earliest, editions of Alciati's work, and therefore I cannot say when the emblem first appears. It is found in the Paris edition of 1542, where it is emblem XXXII. With a more refined illustration it appears in the edition published in Basel, 1582.

14. I shall only mention the most important and best-known studies. A. Doren, "Fortuna im Mittelalter und in der Renaissance," *Vorträge der Bibliothek Warburg*, 1922–1923/I. Teil (Leipzig and Berlin, 1924), pp. 70–144; H. R. Patch, *The Tradition of the Goddess Fortuna in Medieval Philosophy and Literature* (Cambridge, Mass.: Harvard University Press, 1927); Klaus Reichert, *Fortuna oder die Beständigkeit des Wechsels* (Frankfurt am Main, 1985).

15. *Civitas Dei* 4.18. For an English translation, see Saint Augustine, *The City of God*, trans. Marcus Dods (New York: The Modern Library, 1956), pp. 124ff.

16. Ibid., 4.19, p. 125.

17. Boethius, *The Consolation of Philosophy* 2. 2.

18. Ibid., 2. 4. For the influence of this work in the Middle Ages and in the Renaissance, see P. Courcelle, *La Consolation de la philosophie dans la tradition litteraire. Antecedents et posterite de Boece* (Paris: Etudes Augustinennes, 1967).

19. Alan of Lille, *Anticlaudianus or The Good and Perfect Man*, trans. James J. Sheridan (Toronto: Pontifical Institute of Medieval Studies, 1973), pp. 189ff. For Alan's intellectual and poetic nature, see the interesting (but not well known) discussion by Johan Huizinga, *Über die Verknüpfung des Poetischen mit dem Theologischen bei Alanus de Insulis* (Amsterdam: Kininklijke Akademie, 1932).

20. All three passages occur in the *Inferno*. See, mainly, *Inferno* 7.61–97, Dante's central description of Fortuna. Here it is said that she "wheels her sphere." See also *Inferno* 15.91 ("Let Fortuna turn her wheel as she pleases"), and *Inferno* 30.13, where Fortuna "brought low the all-daring pride of the Trojans," thus again suggesting the movement of a wheel.

21. *Inferno* 7.61ff.

22. I use the recent reprint of the Venice edition of 1647. See Vincenzo Cartari, *Imagini delli Dei de gl'Antichi* (Graz: Akademische Druck-und Verlag Sanstalt, 1963). For the chapter titled Fortuna, see pp. 237–56.

23. See the edition of Petrarch's *De remediis utriusque fortunae* published in

Paris, 1532. An easily accessible reproduction of this illustration is found in Doren's study, fig. 15.

24. The text of the short publication is political, though dressed in the then usual humanistic formulae. See Ulrich von Hutten, *Ad Caesarem Maximilianum* (Augsburg, 1519). I have not seen the original publication.

25. Erwin Panofsky, *Studies in Iconology: Humanistic Themes in the Art of the Renaissance* (New York: Oxford University Press, 1939), pp. 95–128.

26. Ibid., p. 115.

27. Erwin Panofsky, *Renaissance and Renascences in Western Art* (Stockholm: Almquist & Wicksell, Gebers Förlag, 1960), pp. 202–5, and the literature mentioned there.

28. For the history of the Parnassus before Raphael, see E. Schröter, *Die Ikonographie des Themas Parnass vor Raffael: Die Schrift- und Bildtradition von der Spätantike bis zum 15. Jahrhundert* (Hildesheim–New York: Olms, 1977).

29. That the figure is nowhere overlapped by others has been noted by Herbert von Einem, *Das Programm der Stanza della Segnatura im Vatikan* (Rheinisch-Westphälische Akademie der Wissenschaften, Vorträge 169) (Opladen, 1971), p. 33.

30. For the *Hymn to Apollo* (verse 172), see *The Homeric Hymns*, ed. Athanassakis (Baltimore: The Johns Hopkins University Press, 1978) p. 20. "Do tell him in unison that I am he, a blind man, dwelling on the rocky islands of Chios." Also see Robert Lamberton, *Homer the Theologian: Neoplatonist Allegorical Reading and the Growth of the Epic Tradition* (Berkeley: University of California Press, 1989), pp. 9ff.

31. According to Kirchner (Pauly-Wissowa, *Realencyklopädie der klassischen Altertumswissenschaft*, s.v. Demodocus), the blind Demodocus, as he appeared in the *Odyssey*, exerted an influence on the legend of the blind Homer. See also Lamberton, *Homer the Theologian*, p. 10.

32. Homer, *Odyssey*, 8.44–45.

33. Ibid., 8.489–91.

34. Ibid., 8.61–63.

35. Plato, *Phaedrus* 243 a.

36. Proclus, *In Platonis Rem publicam commentarii* 1.193–94. I use the French translation by A. J. Festugière, *Commentaire sur la Republique* (Paris: J. Voini, 1970).

37. For the engraving, see Bartsch, *Le peintre graveur* (Leipzig: A. J. Bartsch, 1843–1876), XV, p. 406, #58.

38. See *The Dark Cloud of Unknowing*, ed. James Walsh, S. J. (New York: Doubleday, 1981); St. John of the Cross, *Dark Night of the Soul*, trans. E. Allison Peers (New York: Doubleday, 1980).

39. These developments are too well known to require detailed bibliographical references. For the developments in religion, see the survey of Ronald A. Knox, *Enthusiasm: A Chapter in the History of Religion* (Oxford, 1950; I use the reprint Notre Dame, Ind.: University of Notre Dame Press, 1994).

40. See the classic study by Erwin Panofsky, *Idea: A Concept in Art Theory* (New York: Harper and Row, 1968), chap. 5. The original edition appeared in 1924.

41. This text is frequently quoted and reprinted. I use the quotation in Panofsky, *Idea*, pp. 59ff. See also Baldassare Castiglione, *The Book of the Courtier*, trans. Charles S. Singleton (Garden City, N.Y.: Doubleday, 1959).

42. Ficino translated Plato's *Phaedrus* into Latin. In principle, then, the text was within reach of educated readers. I was unable, however, to find in Renaissance literature any trace of the particular passage from the *Phaedrus* dealing with the poet's blindness.

43. Jose Antonio Maravall, *Culture of the Baroque: Analysis of a Historical Structure* (Manchester: University of Manchester Press, 1986), pp. 251ff. The original Spanish of the book appeared in 1975.

44. It is interesting that Cesare Ripa in his *Iconologia* (Rome, 1603) imagines *inganno* with open eyes.

45. Craig Felton and William B. Jordan, eds, *Juseppe de Ribera, lo Spagnoletto 1591–1652,* (Fort Worth: Kimbell Art Museum, 1982), fig. 12.

46. It may be interesting to note that about three years before Ribera painted the picture now in Pasadena, the great physicist Galileo Galilei was asked by his friend, the painter Ludovico Cigoli, for his views in the ongoing dispute about the specific position of the arts, especially painting and sculpture. Galilei supported the superiority of painting. Though he extolled painting, based on the sense of vision, over sculpture, based on the sense of touch, he, perhaps without intention, discussed in an original manner the possibilities of cognition inherent in the latter sense. That touching can inform us about the "projections and depressions" of a statue, or any other material object, was common wisdom. In addition, Galilei greatly emphasized texture as a domain of the material world that can be learned by the sense of touch. Not only projections and depressions, says Galilei, "come within the province of this sense [of touch] but also softness and hardness, warmth and coolness, smoothness and roughness, heaviness and lightness." See Erwin Panofsky, *Galileo as a Critic of the Arts* (The Hague: Nijhof, 1954).

47. Emile Mâle, *L'art religieux de fin du XVIe siècle, du XVIIe siècle et du XVIIIe siècle*, 2nd ed. (Paris: Armand Colin, 1951), pp. 109–49.

48. C. S. L. Davis, "Revoltes populaires en Angleterre," *Annals* (Paris,

Armand Colin, 1969), pp. 46–48. Also see Jean Delumeau, *Le peur en Occident (XIV–XVIIIe siècle): Une cité assiegèé* (Paris: Fayard, 1978), p. 269.

49. Geremek, *Les Marginaux parisiens*, p. 217.

50. To mention a single example: In England, Protestants recounted in 1679 that a Catholic woman who wished a judgment upon herself if there was any truth of a popish plot, was mysteriously deprived of her sight two days later. See Keith Thomas, *Religion and the Decline of Magic* (London: Penguin Books, 1971), p. 123.

51. Geremek, *Les Marginaux parisiens*, p. 192. For Louis IX relations with the city of Paris, see Jacques Le Goff, *Saint Louis* (Paris: Gallimard, 1996), pp. 233ff. Though not dealing specifically with the blind, the discussion is useful for the historical background.

52. Thomas, *Religion*, pp. 149, 239.

53. See chapter 1.

5 The Disenchantment of Blindness

1. Ernst Cassirer, *Die Philosophie der Aufklärung* (Tübingen: Mohr, 1932), pp. 98ff.

2. Jacques Chouillet, *La formation des idées esthétiques de Diderot 1745–1763* (Paris: A. Colin, 1973), I, p. 173; Jeffrey Mehlman, *Cataracts: A Study in Diderot* (Middletown, Conn.: Wesleyan University Press, 1979), pp. 7ff.

3. Chouillet, *La formation*, pp. 124ff. For a good and concise survey of the historical background to Diderot's *Lettre sur les aveugles*, see Arthur M. Wilson, *Diderot* (New York: Oxford University Press, 1972), pp. 92–102. However, Wilson does not touch on the problems we discuss in the present study.

4. I use *Oeuvres philosophiques de Denis Diderot* (Brussels: Librairie Philosophique, 1829), I, pp. 130ff. The translations are mine.

5. Ibid., p. 130.

6. Ibid., p. 147.

7. Ibid., p. 131.

8. Ibid., p. 136.

9. Ibid., p. 138.

10. Ibid., p. 202.

11. Ibid., p. 144.

12. Ibid., p. 143.

13. Ibid., p. 148. I translate Diderot's *idées* as "images." The sentence reads: " . . . les sensations qu'il aura prises par le toucher seront, pour ainsi dire, le

moule des toutes ses idees." I shall shortly come back to a brief discussion of this translation.

14. Mehlman, *Cataracts*, p. 13.

15. Harry A. Wolfson, "The Internal Senses in Latin, Arabic, and Hebrew Philosophic Texts," *Harvard Theological Review* 28 (1935): 69–133.

16. Mehlman, *Cataracts*, chap. 1, shows striking parallels between Lucretius's famous *De rerum natura* and the *Lettre sur les aveugles.* These parallels are often so detailed and precise that we have to assume Diderot's close familiarity with the classical text. A similar acquaintance with the classical texts of psychology, mainly Aristotle's *De anima* and *De memoria et reminiscentia* and Galen's writings, may safely be assumed.

17. *Oeuvres philosophiques*, p. 146.

18. Ibid.

19. Ibid., p. 148.

20. Ibid.

21. Ibid., p. 143.

Index